Heretical Aesthetics

Pier Paolo Pasolini (1922–1975) was an Italian film director, poet, writer, art critic and one of the most controversial and provocative intellectuals of his time. Most well known for his first and last films, *Accattone* and *Salò*, as well as *The Gospel According to St. Matthew* and *Decameron*, he was also a prolific essayist and activist. He was murdered in 1975.

Ara H. Merjian is Professor of Italian Studies at New York University, where he is an affiliate of the Institute of Fine Arts and the Department of Art History. He is the author of *Giorgio de Chirico and the Metaphysical City: Nietzsche, Paris, Modernism* (Yale University Press, 2014) and *Against the Avant-Garde: Pier Paolo Pasolini, Contemporary Art and Neocapitalism* (University of Chicago Press, 2020), which won an Andy Warhol Foundation/Creative Capital Writer's Grant.

Alessandro Giammei is Assistant Professor of Italian Studies at Yale University. He is the author of *Nell'officina del nonsense di Toti Scialoja* (Edizioni del Verri, 2014), *Una serie ininterrotta di gesti riusciti* (Marsilio, 2018) and *Ariosto in the Machine Age*, which is forthcoming for the University of Toronto Press.

Heretical Aesthetics

Pasolini on Painting

Edited and translated with an introduction by

Ara H. Merjian and Alessandro Giammei

Foreword by T. J. Clark

VERSO

London • New York

For our teachers

Verso gratefully acknowledges the support of a Madge Miller Research Fund Award from Bryn Mawr College towards the publication of this book

First published by Verso 2023
Collection © Verso 2023
Contributions and translations © Contributors 2023

1 3 5 7 9 10 8 6 4 2

Verso
UK: 6 Meard Street, London W1F 0EG
US: 388 Atlantic Avenue, Brooklyn, NY 11217
versobooks.com

Verso is the imprint of New Left Books

ISBN-13: 978-1-80429-128-3
ISBN-13: 978-1-80429-129-0 (UK EBK)
ISBN-13: 978-1-80429-130-6 (US EBK)

British Library Cataloguing in Publication Data
A catalogue record for this book is available from the British Library

Library of Congress Cataloging-in-Publication Data
Names: Pasolini, Pier Paolo, 1922-1975, author. | Merjian, Ara H., 1974-
 editor. | Giammei, Alessandro, 1988- editor.
Title: Heretical aesthetics : Pasolini on painting / edited, introduced,
 and translated by Ara H. Merjian and Alessandro Giammei ; foreword by
 T.J. Clark.
Description: London ; New York : Verso, 2023. | Includes bibliographical
 references and index.
Identifiers: LCCN 2023006032 (print) | LCCN 2023006033 (ebook) | ISBN
 9781804291283 (trade paperback) | ISBN 9781804291306 (ebook)
Subjects: LCSH: Painting.
Classification: LCC ND27 .P37 2023 (print) | LCC ND27 (ebook) | DDC
 858/.91409—dc23/eng/20230324
LC record available at https://lccn.loc.gov/2023006032
LC ebook record available at https://lccn.loc.gov/2023006033

Typeset in Minion by Hewer Text UK Ltd, Edinburgh
Printed and bound by CPI Group (UK) Ltd, Croydon CR0 4YY

Contents

Figures

17. Andrea Mantegna, *The Lamentation over the Dead Christ*, 1490.
18. Piero della Francesca, *Constantine's Dream* (detail from the 'la leggenda della Vera Croce' cycle), 1452–66.
19. Renato Guttuso, plate 18 from *Gott mit uns*, 1945.
20. Renato Guttuso, *Lamento per Pablo Picasso*, 1973.
21. Massimo Listri, photograph of Pier Paolo Pasolini before his *Autoritratto col fiore in bocca* (1946–47).
22. Pier Paolo Pasolini, *Autoritratto col fiore in bocca*, 1947.
23. Pier Paolo Pasolini, *Autoritratto con la vecchia sciarpa*, 1946.
24. Giacomo Manzù, *David*, 1938.
25. Giuseppe Zigaina, *Assemblea di braccianti sul Cormôr*, 1950–52.
26. Paolo Monti, photograph of Giuseppe Zigaina before his painting, 1982.
27. Pier Paolo Pasolini, *Boy with a Chair*.
28. Pier Paolo Pasolini, *Sandbanks beneath a Gray Sky*, 1969 or 1970.
29. Pier Paolo Pasolini in *Il tempo*, 25 June 1972, with image from Gino De Dominicis, *Seconda soluzione d'immortalità (l'universo è immobile)*, 1972.
30. Pier Paolo Pasolini, *Roberto Longhi*, 1975.
31. Pier Paolo Pasolini, untitled, undated (1940s).
32. Pier Paolo Pasolini, *Figures*.
33. Sanford H. Roth, *Carlo Levi in his studio*, c. 1950.
34. Lorenzo Tornabuoni, *Untitled*.
35. Renzo Vespignani, *Untitled ('Milano Metropolitana')*, 1970.
36. Andy Warhol, *Ladies & Gentlemen*, 1975.
37. Still from *La Rabbia*, directed by Pier Paolo Pasolini, 1963, of Renato Guttuso, *Ragazzo che urla con bandiera rossa*, 1953, detail.

Foreword
by T. J. Clark

What goes into the making of a movie? By 'movie', in Pasolini's case, I take it we mean a distinctive, unprecedented, unforgettable way of seeing, in which the world is turned toward us and shown in a new light. And the new light is not merely glittering and irresistible (though in Pasolini it is regularly both) but necessary. Necessary to its subject: in this instance, in the films Pasolini made in the early 1960s, the face and temper and desperation – the disintegrating identity – of the proletariat as the long epic of class struggle drew to an end.

What goes into such a moment of form – such a making of a *style*? The texts gathered in the present volume provide part of the answer. They help us to look again at the pace of a typical Pasolini tracking shot – I summon up a memory from near the beginning of *Accattone*, whose opening sequences are stamped on my mind – or his choice of distance between moving face and moving camera, his unforgiving lighting, his shallow depth of focus, the brittle staccato of his soundtrack. Start almost anywhere in these early movies, or in the scenes from Fellini's *Notte di Cabiria* where Pasolini's imprint is unmistakable; open a page at random in *The Ragazzi* or *A Violent Life* or *A Night on the Tram*; and immediately

you are in a working-class world that very few others have touched. A savage and absolute grandeur greets you, touched with (undercut by) bitterness and compassion, and above all by a determination to destroy – at last, in agony, against one's own deepest wishes – the great myth of the twentieth century.

English-speaking readers have been told the story of Pasolini's life many times, and often very well. The aspects of the writer and filmmaker's life that seem most obviously to have fed into his work – his childhood in Friuli and his continuing attachment to the rural society in which he grew up, his youthful experience of fascism, his immersion in the 'neorealist' moment following 1945, his Marxism, his sexuality, his tortured relations with the Italian Communist Party, his love of Rome, his horror at the first emerging reality of 'consumerism' (no one had a more chilling premonition of the age of Berlusconi to come, and of the way that the Italian model of politics would infect the world) – these things have been written about with passion.

But they are not quite enough to help us with his art. A movie, in Pasolini's hands, is a *vision*. At the centre of its making is a set of decisions, or a tissue of visual assumptions (perspectives, spatial intervals, kinds of grounding and uprightness, kinds of stillness and movement), that go to give the world a shape, a form. What informed the decisions (the assumptions) in Pasolini's case? Here's where the texts translated in this book, and introduced so meticulously by Ara H. Merjian and Alessandro Giammei, add a new dimension to our understanding. For, now, we have in hand some measure in English of Pasolini's long love affair with painting – and even (oddly) with art history.

What other moviemaker, for instance, writing about his work for a newspaper audience, would move from sentence one to sentence two in the paragraph I quote below – let alone from sentence three to sentence four? (He is commenting on his 1962 film *La Ricotta*, whose blasphemies had initially earned him a four-month prison term, only later quashed on appeal.)

In addition to the kind of rigorously simple technical selectivity afforded by 50 and 75mm cameras, with *La Ricotta* I added a 'Pan Cinor' lens for my basic panning shots and wobbly tracking shots – not so much for its zoom movements (still very limited) as for the grade of the lens, from 100 up. This obtains effects even more dear to the eyes of an apprentice in the studio of Masaccio: it flattens the images, making them warmer and coarser. You leaven them like loaves of bread, solid but . . . light. As light as a paintbrush is light, even frothing, as it invents the massive play of shadows in three dimensions, with Man at its centre and the Eternal Light as its source of illumination.

Partly, yes, the invocation of Masaccio here is polemical. The appalling homosexual blasphemer is conjuring a figure from the sacred (Old Master) past of Italy as one further thumb in his reader's eye. But this is just the surface of things. For Pasolini really did consider himself an apprentice in Masaccio's studio, constantly – and in that of Piero, Angelico, Caravaggio, Romanino, Picasso, Morandi, Guttuso, Cézanne. He never recovered from the effect of hearing, at age seventeen, the great art historian Roberto Longhi lecturing in Bologna on the eve of the Second World War, flashing up on the screen the details – the visual 'facts' – that were to issue in his 'Fatti di Masolino e di Masaccio' a year or so later. Those facts defined what seeing *was*, for Pasolini. Or what it ought to be – had to be – still, again, more and more insistently – however much the odds were stacked against it.

There is no judgement that gets us closer to the centre of Pasolini's aesthetic, I feel, than the one he passed in 1965 on the painter Romanino (a 'marginal' figure in the history of the Renaissance who had roared back to the centre of things in Italy in the 1960s): 'Romanino was what his culture did not allow him to be . . . This is the crux of my talk.' Here was a painter, Pasolini believed, who had taken advantage of his provincial distance from orthodoxy (and sophistication), in order to find his way back to

religion – to a truly religious painting, a painting that established the sacred in the world – in an age of counterfeit.

'People talk,' said Pasolini on another occasion, 'about my movie *Accattone*'s "religiosity". They may be right. But religiosity lies not in the need for personal salvation . . . not in the fatality that determines the entire story . . . It is found in [the film's] very mode of seeing the world, in the technical sacrality of seeing itself.'

Pasolini lived among painters, and formed some of his most precious friendships with them. One or two of the figures he revered are known outside Italy – Renato Guttuso, for instance, and Carlo Levi (though hardly as a painter as opposed to a writer) – others are not. The names Toti Scialoja, Giuseppe Zigaina, Federico De Rocco or Renzo Vespignani meant little or nothing to me before I read Merjian and Giammei's translations of Pasolini's tributes. But in the age of Wikimedia (long may it last) it is easy enough to find images to match the unfamiliar names, and well worth it. I found myself back in the strange splendid world of neorealism, looking at painters trying to find an equivalent – or at least an accompaniment – to the power and humility of *Paisà* and *Il Grido* and *House on the Hill* and *Path to the Nest of Spiders*. I realized again – looking at Zigaina's sickles and cycles thrown down by the side of a Friuli irrigation ditch, or even at his more dutifully communist *Assemblea di braci* from 1950 – what Pasolini so wished to hang onto in his passion for the local and 'dialectal'. I saw what Guttuso's high Mexican-muralist rhetoric kept alive for his admirers. I glimpsed the ghosts of Levi's peasants in the streets of *Gospel According to Matthew*.

The antinomies of Pasolini's art and politics are spelled out most dramatically, I think, in the long poem 'Picasso', written in 1953. 'Picasso' is given a heroic translation here by Merjian and Giammei – the first time it has appeared in English – but they would be the first to admit that the poem's mixture of anger and insolence and dignity is hard, going on impossible, to transpose from Pasolini's terse and sonorous *terza rima*. Many a dissident Marxist has sneered, justifiably, at Picasso's postwar service to

the Communist Party – his dreadful peace doves, his portraits of Stalin, his 'discretion' over the crushing of the Hungarian revolution. Only Pasolini found an idiom appropriate to the Fall.

Here he is toward the end of 'Picasso', face to face with the master's new giant murals of *War* and *Peace*. *War* he has nothing to say about. (Even Pasolini can be charitable.) *Peace* – the horrible false optimism of Picasso's strip cartoon – elicits his full *Inferno* roll of drums:

> . . . Ah, non è nel sentimento
> del popolo questa sua spietate Pace,
> quest' idillio di bianchi uranghi. Assente
>
> è da qui il popolo: il cui brusio tace
> in queste tele, in queste sale . . .

[Ah, this is not the way the people feel, this pitiless Peace of his, this idyll of white orangutans. Absent from this is the people: the people whose buzzing voices fall silent in these canvases, in these galleries . . .]

And if the people are not *there* in a work, their proximity threatening the illusion – this is Pasolini's message – no amount of good will or ideological purity will fill the gap.

> . . . La via d'uscita
>
> verso l'eterno non è in quest' amore
> volute e premature. Nel restare
> dentro l'inferno con marmorea
>
> volontà di capirlo, è da cercare
> la salvezza . . .

[The way out toward eternity does not lie in this wished-for premature love. We shall stay inside the inferno with an unflinching will to understand it, and seek salvation there . . .]

All this, I remind you, in response to a great Roman celebration of Picasso-the-Party-Member, organized by Pasolini's communist friends.

Needless to say – but are such things worth dwelling on any longer? – Pasolini's Marxism proved, in his lifetime, hardly more popular on the left than on the right. Processions of Marxist mediocrities reassured the faithful that the filmmaker was a 'bad Marxist'. They still do. As if badness has not always been the point. As if Marxism had not, from the very start of its Party petrification, been obliged to be bad – hybrid, contaminated, mystical, chiliastic, ironic, despairing, anti- or ultra-materialist – in order to remake the Marxist impulse, the Marxist *facts*, in the face of those waving the little red book.

I know, finally, that Pasolini's sense of history – his picture of hell and salvation, his very obsession with the 'people' – will strike many readers as antiquated. The poet, lucky being, could only half anticipate the great work of sterilizing and infantilizing the imagination that his hated 'consumerism' would set in motion. He never looked down into an iPhone mirror. He only saw the first clumsy adumbrations of our present image-world. He was spared the debacle of the Italian and European Left. But his badness – his old-fashioned absolutism – lives on.

Notes on the Texts and Their Translation

Allusions to painting – and to the visual arts more broadly – appear in the full range of Pasolini's writings, from journalistic essays, to poetry, to work for the theatre and film. We have chosen to include here only those texts which engage more or less explicitly with painting as an autonomous phenomenon in its own right. Conversely, the passages we have excerpted from longer essays (such as 'Observations on Free Indirect Discourse' and 'Technical Confessions') aim to shed light on the abiding metaphorical, stylistic, and philosophical consequences of painting in Pasolini's work and worldview.

Notwithstanding Pasolini's uninterrupted editorial presence across the globe, most of the texts included in this volume have never before been translated into English. Some have never appeared in any language other than Italian. The reason is not merely cultural; nor does it stem uniquely from Pasolini's overwhelming association with the cinema (and only secondarily with fiction and poetry). It is also linguistic and, in a sense, material.

Pasolini's pen was preternatural in its output. Collected by the publishing house Mondadori in their prestigious 'Meridiani' series, his complete works in the original Italian fill ten densely

printed volumes (excluding private documents such as diaries, and his immense, largely unpublished, epistolary exchanges in various languages). The 20,000 or so pages of this gargantuan oeuvre suggest that, in the course of his short adult life, Pasolini must have written thousands of words every day, without fail. The result is a characteristically varied, 'magmatic' (to use a word dear to him) corpus of texts in which no distinct authorial voice emerges, particularly in his argumentative and essayistic writings. The precocious young student imitating the grandiose prose of his anti-fascist professors – who veiled a certain cultural heterodoxy under a thick layer of sophisticated obscurity – proves quite different, in terms of style and lexicon (and sometimes basic arguments), from the mature communist intellectual who, in the rapidly industrializing context of a new-born Italian Republic, aspired single-handedly to produce an alternative cultural hegemony by force of sheer writerly will. Even synchronically, at any given moment, Pasolini dispatched radically disparate texts in different voices: turgid articles inflected with scholarly affectations; lyrical, quixotic presentations of books and exhibitions; symbolic poems *à clef*; and often indecipherable reactions to Italy's postwar *faits divers*. Clarity and concision, in short, were never his chief preoccupations.

In presenting these texts as a collection, we have not sought to homogenize them. Their polyphonic variety is representative of Pasolini's larger, often fitful oeuvre. We have, however, tried to make them readable. The primary obstacle proved to be syntactical: how to disentangle the involution of subordinate clauses in Pasolini's prodigiously long and composite sentences, further distended with an often arbitrary and indiscriminate use of colons and quotation marks? This sort of *bravura* is still rewarded in much Italian academic prose of Ciceronian descent: a genre whose goal is not to defend an argument per se, but rather to persuade the reader by leading them through the labyrinthine echelons of a syntactical house of cards. This wilful intricacy renders some of Pasolini's texts (particularly his early essays and his reviews of exhibitions) hard to follow in their original form, even for Italian readers. We have tried,

as best as we could, to strike a balance between achieving clarity of expression and retaining something of the original's mix of fastidious precision and parenthetical excursus.

Pasolini's writings on painting lean upon linguistic choices that will not be transparent to many readers, drawing as they do on the idiolect of disciplines other than art criticism, such as dialectology, semiology, and philology. Gianfranco Contini's formidably nuanced literary criticism had a crucial influence on Pasolini's prose. His writing draws in turn upon the ideological obscurity of Hermetic poetry, Proust's and Carlo Emilio Gadda's dizzying semantic involutions, and an almost mystical aspiration to scientific exactitude. For instance, when Pasolini discusses 'expression' (expressivism, expressionism, expressivity, and so on) he is thinking not first and foremost of the German-born avant-garde, but rather of the homonymous stylistic category theorized by Contini to talk about Dante and his modern heirs – a literary keyword still widely discussed among Italian philologists, and lacking a clear definition. Concepts like 'dialectal' and 'vernacular', meanwhile – recurrent in Pasolini's reviews and presentations, but also in his poetry about painting – are imported into the realm of art criticism from the field of linguistic analysis. Reading the book chronologically, one may note the increasing salience of structuralism and semiotics, along with Pasolini's (not always successful) attempts to apply them to images.

Another key model for Pasolini's language is, of course, the writing of Roberto Longhi. Like Contini's, Longhi's essays are characterized by the typical Latinate syntax of refined academic prose, but also by structures often more akin to the *roman policier* than to the expository essay; the 'point' is continuously deferred, and emerges as a revelation only after a series of apparently irrelevant clues, conjectures, and asides. It is impossible fully to convert the rhetorical deferral of this kind of writing into a typically explicit English text.

Curiously, poetry proved the easiest genre to work with. The three most ambitious poems included in the volume are not

addressed especially to intellectuals or bourgeois readers, and their ecumenical aspirations make them more ductile to a translator's toolkit. At the same time, they present challenges of their own. When we compared our versions with extant translations in other languages (in two cases, with other English translations), we noticed that our reading differed from that of other translators. Our choices were based on a philological appreciation of the author's visual sources and of his literary and philosophical culture. In 'Piero's Frescoes in Arezzo', for instance, we decided to translate *dissanguati* as 'bled dry' (rather than 'bloody' or 'bleeding') because of the pallor of the figures in question. We likewise chose to read the adjective *padrona* in Marxist terms, in the sense of property and propriety, rather than in terms of a notion of *padronanza* as 'competence'. Such decisions are interpretative, and hence open to debate.

Some expressions adopted in Pasolini's prose remain mysterious. Even a reader familiar with his works (and the linguistic context in which he operated) would be hard-pressed to say what a *Delikatessen coloristica* (literally, a 'coloristic delikatessen') or a *raggricciata emblematicità* (wrinkled emblematicness) might be, or where in Carlo Levi's painting one is to look to find the *madre cannibala* (mother she-cannibal) that Pasolini describes as beautiful and extraordinary. We find, ultimately, a nearly untranslatable lexical audacity in many of the texts: the arrogant but also wounded tone of an erudite outsider, at once confident in his authority as a poet, and aggrieved as the subject of frequently *ad hominem* attacks. In some texts we find, too, a kind of feverish coarseness: a brisk nonchalance, at times bordering on a certain insouciance (or simply a lack of editing) on the part of an individual who spent much of his waking life writing. Many of his peers, like Italo Calvino or Cesare Pavese, devoted a good deal of time to the care of other writers' texts, whether as translators or editors. Pasolini was, instead, a Stakhanovite servant of his own quick wit and massive production. From that forest of texts emerge, inevitably, some imperfect, uninspired, and underworked results. Consistent

throughout them, however, is a veneration of painting as being as much the stuff of the future as of an Edenic past or embattled present.

All texts by Pasolini were co-translated by us, except for the following: 'Notes on George Besson's "French Painting 1900–1940"' (Taylor Yoonji Kang); 'Dialectal Painting' (Lucas René Ramos); 'Fabio Mauri' (Rachel Kline); 'Renzo Vespignani' (Peter Kurtz); 'From "Observations on Free Indirect Discourse"' (Sarah Atkinson).

Alessandro Giammei and Ara H. Merjian
2023

Introduction: 'A Force of the Past' by Ara H. Merjian and Alessandro Giammei

Regret for the past is not the same as nostalgia. Pretending it is [the same] has always been the first and cheapest move of the present's apologists. Regretting the past is . . . a way of steeling oneself for the fact that the past really is lost, and therefore maybe having a chance of looking the future accurately in the face.

T. J. Clark, 'All the Things I Said about Duchamp'[1]

The most influential Marxist thinker of postwar Italy was not a thinker, *in sensu stricto*. He was not a Marxist either, at least not in any orthodox sense. When, in 1972, Pier Paolo Pasolini collected his contributions toward a theory of engaged culture into a single volume, he placed them under the aegis of a (communist) heterodoxy, from which he was by then indissoluble in name and spirit: *Heretical Empiricism*. Following a section devoted to linguistics, the

1 T. J. Clark, 'All the Things I Said about Duchamp: A Response to Benjamin Buchloh', in *The Duchamp Effect: Essays, Interviews, Roundtable*, ed. Martha Buskirk and Mignon Nixon (Cambridge, MA: MIT/October Books, 1996), p. 143.

book anthologizes a decade of close analytical reading and mania-
cal making of literature and cinema – the two disciplines for which
Pasolini remains most widely celebrated. Yet the essays' true legacy
stems from a particular rhetorical and ideological posture: a way of
being an artist and an active spectator (a witness: etymologically, a
martyr) without ever abjuring the responsibility of ideology, criti-
cism, didacticism, even at the expense of contradiction, paternal-
ism, approximation, self-referentiality, persecution, and, ultimately,
immolation. While they do not constitute a coherent system of
Marxist thought – along the lines, say, of the rhizomatic Gramscian
notebook – the essays which form *Heretical Empiricism* offer, like
those we present in the following pages, an articulate image of what
it meant to self-identify as a Marxist intellectual in Italy during the
Cold War: a period when armed groups and elected officials, politi-
cians and terrorists, musicians and priests, painters, students, work-
ers, academics, and activists genuinely believed that a revolution
could have, at any moment, subverted the status quo in the country
and perhaps the continent.

A moment of doubt and disenchantment – or rather, a series of
moments, gathering momentum into an apodictic assurance of its
own – gradually drained the certainty of revolution from Pasolini's
horizon. By the early 1960s, in fact, revolution seemed to him
already to have happened, in slow, insidious motion: a 'passive
revolution' of which Gramsci had warned decades earlier, a revolu-
tion from above – assimilating to the swollen contours of bour-
geois consumerism the nonconformities of (proletariat and
subproletariat) class and (dialectal and peasant) language. Yet
Pasolini was no party hack. His supplications and warnings and
maledictions issue as much from the body (his own, those of
others) as from reasoned argument. They come by way not simply
of ratiocination – rendered sclerotic and coercive, in any case, by
the technocracy of Italy's economic 'miracle' – but lyricism, drama,
dream, parable (cinematic and literary), (journalistic) screed, and
(documentary) eulogy. In presenting the author of *Heretical
Empiricism* to a twentieth-century Anglo-American audience

some years ago, translator Ben Lawton was obliged to combine a
number of incongruous foils, a mélange of comparisons and coun-
terparts, which remains a synthetic touchstone for Pasolini's trans-
atlantic readers: 'If Norman Mailer, Truman Capote, Gore Vidal,
Camille Paglia, Madonna, Martin Scorsese, Spike Lee, Michael
Moore, and Noam Chomsky were rolled up into a single person,
one might begin to get some idea of the impact Pasolini had on
Italian society.'[2]

The book you are now reading attempts to revisit and revive
(indeed, to translate) that impact, a hundred years after Pasolini's
birth in 1922 – the year of Mussolini's March on Rome and the
formation of the first openly fascist government in what we call
'the West'. In the present time and place, as the visual arts turn
increasingly into a kind of cryptocurrency on blockchain ledgers,
and some of the more consequential political actors in the nation
take the form of mythological pseudonyms on anonymous forums
and message boards, it feels especially urgent to remember a
vanished, yet still vital, phenomenon. Namely, how the most
superstructural of bourgeois expressions – painting and its criti-
cism – could provide, at not so distant cultural latitudes, the para-
digm for a concrete ideological struggle, lived in the biographical
and biological reality of what we used to consider a militant
intellectual.

Prehistoric Origins

Pasolini's heretical Marxism, one could argue, only makes sense in
the form of poetry. As soon as one tries to articulate it as a cogent
doctrine or political theory, it reveals the disquieting face of its
paternalistic narcissism. Its fragile, queer metaphysical essence,

2 Ben Lawton, 'Preface to the 2005 Edition of Pasolini's *Heretical Empiricism*',
in Pier Paolo Pasolini, *Heretical Empiricism*, trans. Ben Lawton and Louise K.
Barnett (Washington, DC: New Academia Publishing, 2005 [1972]), p. vii.

rooted in fetishism, only thrives in the speculative dimension of lyricism and figural fiction, especially in the generous breath of stanzas conceived for epic narration. Indeed, it assumes its most memorable, scintillating shape in the Dantesque tercets of a long elegy directly addressed to Antonio Gramsci – more specifically, to his cinerary urn in Rome's only non-Catholic cemetery, in the ancient heart of the (then) working-class area of Testaccio; and to his spectre, haunting post-fascist Italy, a new-born democracy torn between two hegemonic empires. A scandalous contradiction forms the vital core of that poem's melodiously convoluted self-consciousness, in which Pasolini declares both a lucid allegiance and an irrational antagonism toward his silent interlocutor. What separates him from this fraternal mentor ('less reckless and impurely healthy / than our fathers – no father but a humble / brother')[3] is not really the boundary between death and life ('you are dead and we are likewise dead / with you, in this humid garden').[4] Nor is it the divergence between 'passion' and 'rigour', which nonetheless makes them different. It is time: an incompatible approach to temporality, a diverging poetics of history.

To put it simply, Pasolini dreamed of regression rather than revolution. Let us recall his 1963 film *La Ricotta*, in which Orson Welles plays the part of a(nother film's) director, and recites a page from a book of Pasolini's poems:

> I am a force of the Past.
> My love lies only in tradition.
> I come from the ruins, the churches,
> the altarpieces, the villages . . .[5]

3 Pier Paolo Pasolini, 'Gramsci's Ashes', in *The Selected Poetry of Pier Paolo Pasolini*, ed. and trans. Stephen Sartarelli (Chicago: University of Chicago Press, 2014), p. 169 ['meno sventato e impuramente sano / dei nostri padri – non padre, ma umile / fratello'].

4 Ibid.

5 Pier Paolo Pasolini, 'April 25, 1962', from 'Worldly Poems', in *The Selected Poetry of Pier Paolo Pasolini*, pp. 309–10.

These formed, in turn, the crux of Pasolini's peculiar modernism, the fruit of an 'arbitrary / birthright, from the outer edge / of some buried age'.

> And I, a fetus now grown, roam about
> more modern than any modern man,
> in search of brothers no longer alive.[6]

As a Marxist stubbornly (and admittedly) hostile to dialectics and suspicious of progress, Pasolini did not merely find in bygone ages some salvific model. The word 'tradition' in his poetic language has hardly anything to do with mores or calcified conventions. Its meaning must be extracted from the technical lexicon of philology and connoisseurship: necromantic disciplines able to animate vast tracts of time sedimented under the patina of documents and monuments – indeed, 'ruins' and 'altarpieces'. It was there that Pasolini's lyrical, counterintuitive Marxism of regret looked for its principal object of preoccupation: oppressed peoples. As he confessed to Gramsci's tomb, he was 'drawn to a proletarian life / from before your time', which he religiously adored for 'its joyousness, not its millennial / struggle – its nature, not its / consciousness'.[7]

Gramsci's Marxist lexical imperatives (*lotta, coscienza*) are abjured, in this tercet, in favour of a sensual vitalism, a primitivist *jouissance*. Rather than looking ahead to imagine and organize the end of the dominating class, Pasolini's communism longed for an age that pre-dated class itself. The prehistorical, antediluvian (sub) proletariat of his political and erotic utopia had to be protected from, not liberated by, progress – protected, in fact, from history. Like dusty marmoreal vestiges or spontaneous varieties of indigenous plants, immobile figures in an altarpiece or weeds growing over ruins, their pre-bourgeois, pre-enlightenment status – 'not

6 Ibid., pp. 312–13.
7 Pasolini, 'Gramsci's Ashes', p. 178.

life, but subsistence' – was not some subaltern condition in
Pasolini's poetry. It was a blessed, aspirational Eden, 'perhaps
happier than life': something that a bourgeois intellectual who
chose Marxism could merely envy from the outside, lust after.
Only the absolving, absolute space of poetry could accommodate
such confessions.

As the 'locus of the absolute'[8] in Pasolini's oeuvre, poetry forms
the aesthetic and existential axis around which its multiple fila-
ments are threaded. Throughout his entire career, after all, he iden-
tified simply as a *scrittore*; verse remained the one genre that he
practised nearly uninterruptedly. Yet the phenomenon of writing in
Pasolini's body of work proves stubbornly inextricable from *seeing*.
The book of poetry from which Orson Welles reads in his filmic
self-portrait as a *passéiste* intellectual is closed by a section titled
'The Book of Crosses', in which the lines' different typographic
lengths visually form the titular crosses on the page.[9] These resur-
rect Guillaume Apollinaire's avant-garde *calligrammes* – or, more in
line with Pasolini's interests, the medieval and early-modern tradi-
tion of *carmina figurata* which so fascinated Italian philologists.[10] A
visual encounter with Giacomo Manzù's neo-Hellenic *David*
(Figure 24), a 1938 bronze sculpture that Pasolini probably saw
only in photographs,[11] inspired a poem in his debut book of verse
– the first of many poetic visions of the visual arts (the most ambi-
tious of which are included in this book) suspended between
descriptive ekphrasis and prosodic criticism. But, unlike his politi-
cal fantasies, it is beyond poetry that Pasolini's hybridization of the
linguistic and the iconic assumed its most concrete shapes.

8 Fernando Bandini, 'Il "Sogno di una cosa" chiamata poesia', introduction
to Pier Paolo Pasolini, *Tutte le poesie*, vol. I, ed. Walter Siti (Milano: Garzanti,
1993), p. xv.

9 Pier Paolo Pasolini, *Poesia in forma di rosa* (Rome: Garzanti, 1964); partly
translated in *The Selected Poetry of Pier Paolo Pasolini*, pp. 306–62.

10 See Giovanni Pozzi, *La parola dipinta* (Milan: Adelphi, 1981).

11 Manzù's bronze *David* was exhibited at Rome's Quadriennale 1939
alongside the artist's *Seated Cardinal*.

Pasolini's notion of film as 'the written language of reality' understands the inscription of meaning as something more (or less) than verbal – something equally and intractably visual. If poetry remained the crux of Pasolini's world and worldview until his death, *language* had become for him fatally tainted in Italy by the late 1950s and 1960s, rendered aridly inexpressive by its ever more technocratic and mediatic applications.[12] In later years, his cinema would intermittently sideline the verbal in favour of pure physicality, in all its messy exuberance and unruliness. What increasingly mattered for Pasolini were the spaces between and alongside words – spaces that the critic Gianfranco Contini, interpreting the phono-symbolism of onomatopoeias in Giovanni Pascoli's poetry, had called the realm of the 'pre-grammatical'[13] (and which Pasolini himself had identified as the expressions of an 'interjectional pathos', describing the affective dimension of sounds in the work of a younger poet, Giorgio Caproni).[14] On the screen, that pathos took the form of bodily inflections and eruptions, paralinguistic gestures, all of which fell felicitously *short* of oral articulation. To that end, Pasolini drew upon another, more fitful, locus of his life: painting.

He traced his earliest childhood memory, in fact, to painting, specifically to a framed Madonna whose eyes appeared to flicker

12 To wit, McKenzie Wark's analysis of Pasolini's film theory as a 'weird-realist semiotics that can function both descriptively and critically in a neo-capitalist world that has downgraded the word'. Wark's essay offers a brilliant synthesis of Pasolini's fusion of cinematic and semiotic theory in the texts published collectively as *Heretical Empiricism*. McKenzie Wark, 'Pasolini: Sexting the World', *Public Seminar*, 15 July 2015, at publicseminar.org.

13 See Gianfranco Contini, 'Il linguaggio di Pascoli', in *Varianti e altra linguistica* (Turin: Einaudi, 1970), p. 234. The first issue of the journal *Officina* came out the same year in which Contini gave this essay as a lecture in San Mauro di Romagna (1955), and it was a monograph on Pascoli. Pasolini's introduction insisted on Contini's intuitions; see Pasolini, 'Pascoli', in *Saggi sulla letteratura e sull'arte*, vol. 2 (Milan: Mondadori, 1999), pp. 997–1006.

14 See Pasolini, 'Caproni', in *Saggi sulla letteratura e sull'arte*, pp. 1165–9 ('una antica figura di "pathos" implicita nel caldo impeto interiettivo').

and to follow his infant self around the room.[15] *In-fans*: without
language. To be sure, it was in literature that the young Pasolini
made his mark. He penned his first poems at the age of seven,
burying himself in Baudelaire, Rimbaud, Novalis. The modernist
canon – particularly the strain leading from Symbolism and
Mallarmé to the Surrealists and the Italian Hermetics – shaped
his budding sensibilities along with the late-Romantic and deca-
dent sophistications of the poets in the national school programs:
from Foscolo and Leopardi to Pascoli himself, on whom he
would end up writing as a university student. Yet for his own
maturing verse he adopted the dialect of his mother's native
Friuli, where he would go on to found a makeshift 'academy' for
local students and teach a range of Romance philologies against
the grain of official (that is, Fascist) Italian. 'In a village of Friuli,
his soul was born / confused with a damp wall / and a patch of
grass black with water'. Thus reads his 1949 poem titled 'L'Italia',
its imagery echoing in the *Suite furlana* from the same years: 'my
life / was alive as grass on a black bank'.[16] In the wake of Italy's
consumerist boom of the late 1950s, even the verbal vehicle of
such memories would appear to Pasolini corrupted by linguistic
instrumentalization. Only in the pre- or post-discursive lay for
him the means of escaping bourgeois language and the soulless
'communicability' to which it condemned Italy's citizens. It was
in the periodically speechless realm of cinema that his poetics
would take refuge, just as it would later seek out spaces and
bodies ostensibly unspoiled by the inexorable spread of Western
industry. The grass and leaf-strewn ground on which his camera
lingers in *Notes for a Film on India* (1968); the humble imple-
ments which it homes in on in *Notes towards an African Orestes*
(1970) – these form the latter-day, far-flung transpositions of
that vanished patch of Friulian grass.

15 On Pasolini's 'animist mysticism', see Sartarelli, introduction, *The Selected
Poetry of Pier Paolo Pasolini*, p. 15.
16 *The Selected Poetry of Pier Paolo Pasolini*, pp. 21, 451.

Pasolini's abiding love for the flat hinterland to the west of the Tagliamento river – a world of peasants and day labourers threaded by creeks and brooks – manifested itself first and foremost in the seemingly infinite gradations of its Rhaeto-Romance tongue. Summer trips to his mother's hometown of Casarsa nourished this interest. The family's more permanent installation there in the early 1940s sealed Pasolini's elective identification. He pridefully noted, years later, that he was the first to put the sounds of one particular strain of *furlan* to the page as poetry, to commit its workaday aurality to the more exalted inscription of literature. Precisely in its smallness, this 'little language',[17] this 'dialect of a small world',[18] swelled to contain a whole new (old) world. In these efforts lie the germ of a lifelong preoccupation with the language of the marginalized, and with the margins of (bourgeois and petit bourgeois) language itself. Yet Pasolini's concern for the dialectal and the vernacular tellingly, and simultaneously, took visual form.

To these same years date his earliest paintings and drawings in green ink or ochre oil, some done on coarse sackcloth, others on cellophane (a notable prolepsis of his eventual directorial pursuits) (Figures 5, 27, and 31). These home in on mulberry groves, river-banks, copses of birch, farmhouses, and their humble, anonymous denizens. Unnamed maids and farmhands pose frontally, or else appear absorbed in some task or toil. The majority of likenesses are male. Forming the embryo of his later heretical confession to Gramsci's ghost, Pasolini's love for this Friulian arcadia figured into an erotics as much as an aesthetics; desire sprang not from the familiar but from this world's wonderfully crude divergence from his own petit bourgeois upbringing. He matched his fixation with verbal dialect with a concomitant theory of 'dialectal *painting*' – a theory explored in several of the texts presented here.[19] Well before

17 Quoted in Giacomo Jori, *Pasolini* (Turin: Einaudi, 2001), p. 12.

18 From Pasolini, 'Poeta delle ceneri', *Tutte le poesie*, vol. II, pp. 1261–88.

19 'Poetry written in dialect', Pasolini writes, 'is a phenomenon of the petite bourgeoisie, not of the people'. 'Dialectal poetry 'represents the popular world through the facile and hypocritical technique of pure chromaticism.' Pasolini,

penning the 1954 essay by that title, he exercised its principles in his own painting and intermittent art criticism. The curled and matted pate of a young boy convalescing in bed; a clutch of motley, lopsided wildflowers lolling out of a vase; a naked youth performing his ablutions with a bucket at his feet and a washbowl set on a simple cane chair. The mix of coarseness and grace in such bodies echoes the language spoken in these spaces, their redoubtable 'smallness'.

The prideful miniaturization of Pasolini's nascent theory of the provinces was not isolated from wider Italian and European landscapes. 'The work of painters from Friuli', he writes in a 1947 exhibition review, 'is so elevated that it can undoubtedly be translated into the lexicon of a national pictorial language'. A few lines later, he connects the 'Byzantine spectres' of Giuseppe Zigaina's vernacular portraits to Picasso's new 'scandalous' style.[20] In a work like *Figures* (Figure 32), we see Pasolini himself experimenting with Picasso's imagery of the late 1920s and early '30s (underscoring even more pointedly the eventual disenchantment of his 1953 poem on the Spanish master [pp. 69–78]).[21] Also completed in Friuli, Pasolini's *Narcissus* (Figure 3) and two striking self-portraits (Figures 22 and 23) reveal an abiding attention to the modernist strategies and wounded narcissism of artists near (De Pisis) and far (Cocteau). After all, Pasolini's own early dialectal work in painting and poetry, while nourished by a direct experience of (and erotic longing for) the margins, found its audience and interlocutors beyond the Tri-Veneto region, in the most ancient and culturally active centre of northern Italy. *Poesie a Casarsa*, his first

'Dialectal Painting', in this volume, pp. 79–80. Writing on the relationship of dialect to a 'poetics of regression' in Pasolini's work, his biographer Enzo Siciliano notes that its impetus 'is transferred to stylistic experimentalism *tout court*'. See Enzo Siciliano, *Pasolini: A Biography*, trans. John Shepley (New York: Random House, 1982), p. 190.

20 Pier Paolo Pasolini, 'Il ritratto a Udine', *Il Mattino del Popolo*, 12 October 1947, reprinted in *Saggi sulla letteratura e sull'arte*, vol. I, pp. 237–43.

21 All page references given in the text are to the present volume.

book, was printed at Mario Landi's Libreria Antiquaria in Bologna, in 1942. In the same year and in the same city, two of his paintings (a Friulian landscape and a portrait of a fellow Friulian artist) were included in an exhibition of young painters organized by the local Fascist association of university students.[22] Neither the book nor the paintings went unnoticed. The poems caught the attention of Italy's most prominent philologist and literary critic of the twentieth century, Gianfranco Contini,[23] who was then teaching Romance philology in Switzerland to escape racial persecution, and became a revered *auctoritas* for Pasolini after the war;[24] and the paintings were selected by a jury that included the modernist master Giorgio Morandi. In both cases, the crux of Pasolini's aesthetics lay in the human phonetics and the sparsely inhabited landscapes around Casarsa.

Pasolini called this imagery 'primordial' – just as he would deem the cinema in turn.[25] His extraordinary painting *Native American* (1947; Figure 5) both borrows from and projects upon quite a different aboriginal culture, particularly in underscoring the proud, fragile vernacular of Friuli's tongues and customs. A

22 The exhibition opened on 24 January at the Sala del Dopolavoro 'Professionisti e Artisti' and included the work of young Italian artists such as Gastone Breddo, Nemesio Orsatti, and Biancarosa Arcangeli. See Domenico Trento, 'Pasolini, Longhi e Francesco Arcangeli tra la primavera 1941 e l'estate 1943. *I fatti di Masolino e di Masaccio*', in *Pasolini e Bologna*, ed. Davide Ferrari and Gianni Scalia (Bologna: Pendragon, 1998), pp. 56–7.

23 He positively reviewed the book in Gianfranco Contini, 'Al limite della poesia dialettale', *Corriere del Ticino*, 24 April 1943.

24 Pasolini famously called Contini 'lo mio duca', adopting a formula used by Dante to talk about Virgil in the *Divine Comedy*. See Francesco Galluzzi, *Pasolini e la pittura* (Rome: Bulzoni, 1994), p. 16. Pasolini had used the same term, in his youth, to talk about the romantic poet Ugo Foscolo; see for example *Saggi sulla letteratura e sull'arte*, vol. 2, p. lix. We will return below to this Dantesque conception of the rapport between a *maestro* and *allievo*.

25 Cited in Jori, *Pasolini*, p. 24. 'No matter how infinite and continuous reality is, an ideal camera will always be able to reproduce it in its infinity and continuity. As a primordial and archetypal concept, cinema is therefore a continuous and infinite sequence shot.' Pasolini, 'Quips on the Cinema' (1966–1967), in *Heretical Empiricism*, p. 225.

sense of origins extends from the perceived ingenuousness of Casarsa's peasant world to Pasolini's own erotic awakening at the time: 'unsullied in my sex . . . the boy who flies in dialect / over his unworldly, virgin heart'.[26] Writing to his friend Franco Farolfi in the spring of 1941, Pasolini professes to having 'seen – and I saw myself in the same way – young men talking about Cézanne and it seemed as if they were talking about one of their love affairs, with a shining and troubled look'.[27] The formal transgressions of modernism stand in here for more private vexations. But who in Friuli would have been discussing Cézanne's painting with such vehemence? Or discussing it at all? It was less likely on the banks of the Tagliamento than along Bologna's via Zamboni that one would have overheard such talk, or glimpsed such tellingly troubled looks.

Trans-Historical Art Histories

'The greatest artist of the modern era'. Thus Roberto Longhi – with whom Pasolini had begun his studies at the Università di Bologna in 1939 – describes Cézanne at the end of his *Breve ma veridica storia della pittura italiana*.[28] Longhi notably links the 'classic repose' of Cézanne's forms to those of Piero della Francesca, who would become one of the legendary touchstones for Pasolini's cinema, particularly his *Gospel According to St. Matthew* (1964). Longhi was concerned less with iconography than with style. He sought to disrupt the canon as much as to perpetuate it, and his

26 This 1947 poem likens the induction into adulthood to the entrance into a museum; see Pasolini, 'Language', in *The Selected Poetry of Pier Paolo Pasolini*, pp. 98–103.

27 Pasolini, Letter to Franco Farolfi, sent from Bologna, spring 1941, in Nico Naldini, ed., *The Letters of Pier Paolo Pasolini, Volume I: 1940–1954*, trans. Stuart Hood (London: Quartet, 1992), p. 122.

28 Roberto Longhi, *Breve ma veridica storia della pittura italiana* (Milan: Rizzoli, 2001 [1914]), p. 162.

approach to art history renders Pasolini's heretical Marxist regret for the past and the marginal rather more legible. Alongside his formative rediscovery of Caravaggio, for instance (see Figures 1 and 2), Longhi helped resurrect the legacies of various provincial painters – an attention to minoritarian cultures which would echo in the work of his shy but reverent student. 'Our rapport', Pasolini writes,

> was ontological and absolutely impervious to any practical specification. This might be one of the reasons why *all this* belongs to another world. Only later did I try to summon up this time and place. However, my shyness may have endured enough to prevent me from recollecting with practical effectiveness, or with any real ability to break the idealistic veil that separated me from my teacher. One could say that, after that time in Bologna, we became friends, even if our interactions remained scarce. One could even say that Longhi became my real teacher only after that time. Back then, in that wartime winter of Bologna, he was simply the Revelation. (p. 167)

Nearly religious revelations came in the form of Longhi's slide comparisons. Pasolini recalls the juxtapositions as a para-cinematic phenomenon, unfurling in the lecture hall's pregnant darkness in a lyrical stylization of filmic montage.

An almost operatic experience of slide projections persists not solely in Pasolini's enchanted recollections (and films, so deeply inspired by Longhi's method, as we will see), but also in Longhi's own experiments with the cinematic medium. At the Venice film festival of 1947, he presented a short film on Carpaccio produced by filmmaker Umberto Barbaro: a sequence of black and white reproductions of paintings, details, and visual pairings accompanied by Longhi's own voiceover. Mixing erudition and anachronic audacity, the film concludes with a quick jump between three astonishingly rhyming details across epochs: a little dog that appears almost identical in famous canvases of Carpaccio, Titian,

and Manet.[29] This is the kind of bold visual epiphany that shocked and excited Pasolini during his university years, leaving a durable trace in his imagination (and one would swear that the same dog, traced by Longhi from the Venetian Renaissance to Parisian Impressionism, appears in the arms of a cantankerous Laura Betti in the decidedly iconophilic *La Ricotta*).

Forming the basis of what would become his volume *Fatti di Masolino e Masaccio*, Longhi's courses of the early 1940s also addressed the Italian *Duecento* and *Trecento*, Caravaggio and his imitators, and, of course, Piero, on whom the art historian was preparing a second tome. It was here that Pasolini received what he called his 'figurative epiphany', so consequential to his cinematic compositions and their rapport with a painterly sense of framing and spacing.[30] Though interrupted by his conscription during the last throes of the Second World War, Pasolini began honing that figurative sensibility under Longhi's direct supervision. In the essays about Longhi included in this book (pp. 154–5,

29 Longhi and Barbaro also produced shorts on Caravaggio (1948) and Carrà (1952), respectively, though the latter is lost. On Longhi's films, see Alessandro Uccelli, 'Due film, la filologia e un cane. Sui documentari di Umberto Barbaro e Roberto Longhi', *Prospettiva* 129 (January 2008), pp. 2–40.

30 Pier Paolo Pasolini, dedication of *Mamma Roma* (Bologna: Edizione Cineteca di Bologna, 2019). Pasolini and his fellow editors Roberto Roversi and Francesco Leonetti would even name their Bologna-based journal *Officina*, in allusion to Longhi's 1934 volume *Officina ferrarese*. Siciliano, *Pasolini: A Biography*, p. 186. In Francesco Galluzzi's elegant terms, Longhi 'taught Pasolini how to see, and how to account for having seen'. Galluzzi, unpublished manuscript, p. 23. On Pasolini's art historical training, and relationship to painting more broadly (and specifically), see Francesco Galluzzi, *Pasolini e la pittura* (Rome: Bulzoni, 1994); Alberto Marchesini, *Citazioni pittoriche nel cinema di Pasolini da Accattone al Decameron* (Florence: La Nuova Italia, 1994); Patrick Rumble, *Allegories of Contamination: Pier Paolo Pasolini's Trilogy of Life* (Toronto: University of Toronto Press, 1996); Matthias Balbi, *Pasolini, Sade e la pittura* (Alessandria: Falsopiano, 2012), rejoined more recently by Ara H. Merjian, *Against the Avant-Garde: Pier Paolo Pasolini, Contemporary Art, and Neocapitalism* (Chicago: University of Chicago Press, 2020) and Ara H. Merjian, ed., *A Force of the Past . . . More Modern than Any Modern: Pier Paolo Pasolini for Art History and Practice* (Manchester: University of Manchester Press, forthcoming).

167–72), we translate the epithet that Pasolini used to talk about his first thesis advisor with the word 'teacher'. In the Italian, however, Pasolini invariably uses '*maestro*', which was (and remains) a loaded word in Italy's exceedingly formal academic discourse – one of the oldest institutions in the country (far older than the country itself, in fact). Still used internationally in fields where Italian tradition is invoked as the aesthetic benchmark (classical music, academic art, gastronomy), *maestro* in Italian denotes the leader of a school of thought, the initiator of a method. The traditionally homosocial, masculine, and 'ontological' rapport between a *maestro* and an *allievo* is seen culturally as a sort of intellectual filiation: among various professors and mentors at one's *alma mater*, the *maestro* is the one elected as a model, a *magister vitæ*.[31] The fact that Pasolini chose an art historian as his *maestro* is significant, especially considering that he ended up with a *laurea* in literature after starting a thesis with Longhi.

Before its drafts would be lost during Pasolini's desertion from the Nazi-Fascist army (and thwarted by Longhi's suspension for refusing to swear allegiance to Mussolini's Repubblica Sociale Italiana), that thesis focused upon 'contemporary Italian painting'. The chief subjects of the study – Giorgio Morandi, Carlo Carrà, and Filippo De Pisis – had long since established themselves as three of the country's most eminent artists. Conspicuously absent from the constellation of former 'Metaphysical' painters was the originator of Metaphysical aesthetics himself. Acclaimed in Paris by Apollinaire and others before the first World War, Giorgio de

31 A possible literary root of this idea lies in the relationship between Dante and his mentor Brunetto Latini in *Inferno*, or, more aptly, between Dante and Virgil, who is repeatedly called 'maestro' in both the *Inferno* and *Purgatorio*. The *Divine Comedy* is directly mentioned in Pasolini's text about Longhi as a *maestro* (see pp. 154–5 of this volume). Alessandro Giammei would like to thank Gary Cestaro for the idea of Dantesque 'queer filiation' that he shared with the programs in Italian Studies and Medieval Studies at Princeton University in his 2017 lecture 'Queer Filiation from Virgil to Dante'.

Chirico faced less forgiving criticism upon his debut in Italy. It was the pen of Longhi himself, in fact, that had dealt the fatal blow: a withering 1919 review titled 'To the Orthopedic God', which anticipated some of de Chirico's subsequent critical (mis)fortunes.[32] Sparing no scornful metaphor or sneering analogy, Longhi dismissed de Chirico's imagery as a 'miscegenation' of epochs, styles, and pictorial idioms.[33] Ironically or not, the 'juxtaposition of antipodal civilizations' which Longhi decried in de Chirico's Metaphysical imagery would form one of the defining tropes of Pasolini's work: its pursuit of cultural 'contamination', 'anachronistic pairings', and a fundamentally analogical approach to narrative.[34]

Indeed Longhi's influence upon his former student exceeds explicit iconographic citations. It surfaces as much in method and language as in any particular imagery. Pasolini himself describes the art historian's rhetorical style as effecting 'an immobility . . . which blocked the flow of time'.[35] Publicly venting about the visual illiteracy and cultural mediocrity on full display in the

32 Roberto Longhi, 'To the Orthopedic God', *Il Tempo*, 22 February 1919. It was the flippant hybridity of the Metaphysical images that stirred Longhi's contempt: 'Sesostri[s] sits atop the Eiffel Tower, while Buddha's fleshless fingers roll up a *Manoli* cigarette . . . factory smokestacks ally themselves with medieval fortresses, while Pirelli [the tire manufacturer] and Borso d'Este [the first duke of Ferrara] understand each other from the first mutual wink of their lone artificial eyes . . . One often finds the juxtaposition of antipodal civilizations, so horrid that only the miscegenation of Baroque art with that of Japan during the time of the Borghese Pope's missions could rival them in offensiveness.' See Ara H. Merjian, 'Enduring Aspersions: A Century of Roberto Longhi's "To the Orthopedic God" (1919)', in *Giorgio de Chirico: Il Volto della Metafisica*, Genoa, Palazzo Ducale, 29 March–7 July 2019, pp. 28–39.

33 For his part, Pasolini mentions de Chirico's name only in passing, in an early review of the work of the Ischian 'naïf' painter, Luigi de Angelis.

34 Laura Cecchini writes that 'anachronistic pairings' distinguished Longhi's own methodology from contemporary, Crocean aesthetics. Laura Cecchini, 'Baroque Futurism: Roberto Longhi, the Seventeenth Century, and the Avant-Garde', *The Art Bulletin* 101:2 (2019), p. 31.

35 Pier Paolo Pasolini, 'Anna Banti, La camicia bruciata', in *Descrizioni di descrizioni*, ed. Graziella Chiarcossi (Turin: Einaudi, 1979), pp. 86–7.

reviews of his second film, *Mamma Roma* (1962), Pasolini
directly invoked Longhi's authority in his defence (still address-
ing the *maestro*, almost twenty years after graduation, with the
reverential '*lei*' of formal interactions with professors).[36] No film
critic in Italy had the 'eyes' to recognize the anachronistic pairing
of Quattrocento and Caravaggian iconographies in the stunning
image of the young protagonist's deathbed, which everyone
superficially linked to Mantegna's famous *Lamentation over the
Dead Christ* (Figure 17). By composing that image in black and
white, Pasolini was practising Longhi's trans-historical,
mnemonic and intuitive, genealogical approach to forms and
their dialogues across time (and, in a sense, across slides). The
film's dedication to him is no coincidence.

Longhi's influence on his most unorthodox pupil went beyond
aesthetics, impacting Pasolini's contributions to the cultural poli-
tics of his time. Just a year after *Mamma Roma* came out, Italy's
leftist intellectuals of different generations began drawing the
battle lines of the 1960s cultural Marxism in Italy, staked upon
diverging approaches to realism and experimentalism. Generating
a cascade of binary oppositions (figurative vs. abstract painting,
linear vs. visual poetry, bourgeois vs. *nouveau roman* fiction, and
so on), such dualisms complicated the established ideological
dichotomy between the Socialist Realism from the USSR on the
one hand, and abstract and informalist painting (particularly from
America) on the other. One of the most illuminating of Pasolini's
militant contributions to the debate took the form of a public 'sotto
voce' confession addressed to his friend and fellow communist
writer Alberto Moravia. In the pages of *L'Espresso*, where Moravia
had written an op-ed about the contiguity and contemporaneity of
realism and experimentalism, Pasolini rebutted that such contem-
poraneity was 'merely chronological, not historical'. To prove his
point, he resorted to the quintessentially Longhian example of
Masolino and Masaccio, who worked 'together, in the same hours,

36 See p. 121 of this volume.

with the same light', and yet painted two different historical ages, two different ideas of the world.[37]

In addition to his method and philosophy of history, Longhi's prose, as well as his public and performative approach to his job beyond the ivory tower of the (then still young) academic discipline of art history, were essential ingredients in Pasolini's brand of intellectualism. Longhi is the only art historian whose entire opus appears collected in Italy's most prestigious literary series of recognized classics, Mondadori's monumental 'I Meridiani' series (inspired by the French Bibliothèque de la Pléiade, and the publisher of several Pasolini anthologies). Contini himself edited the 1973 Longhi volume, deciding to open it with an anthology of critical essays about the art historian as a writer: that is, Longhi's style, his language, his narrative and rhetorical strategies. The book sealed Longhi's canonization as one of the gold standards for Italian prose of his era: a neo-Baroque model in the vein of D'Annunzio, Baudelaire, and Ruskin,[38] an exquisite raconteur comparable to the greatest Italian novelist of his times, Carlo Emilio Gadda.[39] Longhi's stylistic influence on Pasolini in the practice (at once erudite and militant) of art criticism – particularly as a performative conjuring of images – inflects all of the writings collected in the following pages, as facets of Pasolini's radical interventions into postwar Western culture. As Francesco Galluzzi has rightly noted, the methodological and ideological anti-fascist constellation at the root of those interventions

37 Pier Paolo Pasolini, 'Sottovoce a Moravia', in *Saggi sulla letteratura e sull'arte*, vol. II, pp. 2773–4.

38 See in particular Pier Vincenzo Mengaldo, 'Note sul linguaggio critico di Roberto Longhi', in Roberto Longhi, *Da Cimabue a Morandi*, ed. Gianfranco Contini (Milan: Mondadori, 1973), pp. lxiii–lxxix.

39 On the stylistic and hermeneutic contiguity among Contini, Longhi, and Gadda, see Manuela Marchesini, *Scrittori in funzione d'altro. Longhi, Contini, Gadda* (Modena: Mucchi, 2005). For a study of how Pasolini's style and ideology was influenced by this writerly milieu, see Francesco Ferri, *Linguaggio, passione e ideologia: Pier Paolo Pasolini tra Gramsci, Gadda e Contini* (Roma: Progetti Mussali Editore, 1996).

– traditionally reduced to the dyad of Gramsci–Contini (that is, Marxism and philology, language and politics) – must be expanded to include Longhi and art history.[40]

Untimely Writing

As an (avowedly dilettante) historian of art and (intermittent) critic of painting Pasolini was no mere epigone. He would later evoke the writing of Bernard Berenson, Longhi's lifelong associate and rival, when discussing his own *Gospel*, indebted though that film is to Longhi's own revival of Piero as a figurative model.[41] For all of Longhi's consequence for Pasolini's mature practice, the latter refused to confine the genealogy of painting to the redoubt of formal and stylistic development. Lecturing on the painting of Romanino (c.1485–c.1566, see Figure 4) (whose legacy Longhi himself had helped to revive), Pasolini underscores the social and historical matrix out of which the Lombard artist's work emerged. Redressing his Longhian lessons with a close reading of Lucien Goldmann's Marxist sociology, Pasolini insists upon 'the visual consequence of a more profound cultural experience' (p. 134). And by exporting Longhi's lesson into realms traditionally perceived as creative, such as cinema and poetry, Pasolini opened an alternative route, evading the specificity of any of the formats to which he lent his inexhaustible pen: newspapers and literary magazines, exhibition catalogues and film scripts, canvases, and academic publications, the contingent and the untimely.

It should be noted that Longhi himself had begun his career not only as an art historian but also as a critic of contemporary painting

40 Galluzzi, *Pasolini e la pittura*, pp. 16–17.

41 In the same vein, whereas Arcangeli oriented himself against the circle around the Roman journal *Corrente*, Pasolini was unafraid to express his conflicting sympathies. See Trento, 'Pasolini, Longhi e Francesco Arcangeli', p. 62, and Machtelt Brüggen Israëls, *Piero della Francesca and the Invention of the Artist* (London: Reaktion, 2020).

and sculpture, including the Italian Futurists. That versatility further
shaped Pasolini's university years, to which date his first efforts in
criticism in a publication centred in great part upon the visual arts.
With his close friend Fabio Mauri, a young artist who would become
a leading figure in Italy's postwar neo-avant-garde, Pasolini founded
Il Setaccio (The sieve) – a Bologna-based clearing house for every-
thing from contemporary painting and poetry to radio and political
debate (see Figures 11 and 12). Its masthead dated with the Roman
numerals of the Fascist calendar ('XXI' for 1943, marking twenty-
one years since the March on Rome, and incidentally, Pasolini's
birth), the journal still paid lip service to the regime with articles on
'Fascism as a Spirituality', polemics against the Comintern, and
regular excerpts from the Duce himself on the pride of nationalist
syndicalism. In and among these texts appear articles and images by
Mauri and Pasolini. In one instance, the latter's verse in Friulian (a
risky deviation from linguistic orthodoxy) flanks a sculpture by
Giovanni Micconi, who had sculpted a monument to Fascist youth
(*Guardia del Littorio*) in the city of Udine. Such was the strange
cocktail of culture under late Fascism, dispensing carrots and sticks
in turn, as incompetent in its indulgences as it was earnest in offi-
ciousness. In the cracks through which a number of cultural
phenomena slipped unopposed, Pasolini and Mauri carved out a
humble space for more ambitious strivings.

For all their occasional pedantry, Pasolini's early texts are not
written from the sidelines of painting. They come from a critic with
skin in the proverbial game. Recall that his own works appeared
during these years in exhibitions juried by authorities no less distin-
guished than Morandi. In later years, Pasolini would maintain a
kind of wilful ignorance of aesthetic 'evolution' except in its surviv-
ing – and often expressly retardataire – painterly guises. Following
some passing references to the Venice Biennale of 1943, he would
not be drawn to contemporary topics except sporadically over the
next three decades, usually when called upon to write a catalogue
essay, or else spurred – as with his review of Gino De Dominicis'
work at the 1972 Biennale (Figure 29) – by far larger cultural

controversies. The present anthology thus reveals an erratic oscilla-
tion among para-academic contributions, careful studies of (and
paternalistic admonishments to) some rather obscure painters, and
a few grandiose takes on some of the more visible events in the art
world.

Because they appear inorganic (both in a Gramscian sense and
in terms of overall editorial consistency) and often extraneous to
what distinguished Pasolini internationally, these texts have only
partly filtered into Anglo-American letters, and, even then, in
often fragmentary form. This is especially the case when they bear
upon the cinema – the aforementioned and widely cited 'Venting
about *Mamma Roma*' forms a case in point, often cited without its
larger context. It is, however, precisely in the diversity of their
scope, discipline, and subject – from portraiture by minor
communist Italian artists to 'Caravaggio's light' – that these pages
betray the relevance of artistic discourse in late-modern and post-
modern Italy, at all levels of the cultural industry: from occupied
universities to provincial state-sponsored exhibition spaces; from
the managed leisure of *dopolavoro* (recreational activities) admin-
istered by labour unions to the glossy pages of popular periodi-
cals. They also, more subtly, reveal the philological and political
tenacity of the 'tradition' with which we began: an uninterrupted
dialogue from Giotto to the present, whose constants speak
directly to proletarian and peasant life – the only place, in fact,
where such a life might be fully contemplated and preserved or
restored.

Though peppered with self-effacing confessions of dilettantism,
Pasolini's later texts – like his first – reveal a familiarity with the
stylistic, historical, and historiographic development of European
painting, from the early modern (and occasionally the
Romanesque) to the contemporary. As his 'Notes on George
Besson's "French Painting 1900–1940"' demonstrates, this
included a healthy circumspection regarding the often parochial
defensiveness of Italian criticism vis-à-vis Paris. Such circumspec-
tion is countered by a degree of (perhaps politically expedient)

pride: 'We Italians can certainly say that we are not late', he writes, in a seeming echo of some interwar screed from the pages of *Valori Plastici* or *La Ronda*. He was, after all, still writing under Fascist rule. Yet Pasolini also ironizes with keen insight this 'abeyance of certainty and pride with regard to the last forty years of painting' in Italy (p. 49). Some of his subsequent essays, like his review of a Carlo Levi retrospective or his lecture on Romanino, open onto wider horizons even as they remain grounded in Italy. These offer substantial lexical, stylistic, and methodological insight into Pasolini's art historical formation. Other texts are impressionistic in the literal sense. Take for instance his observations on the work of his friend Fabio Mauri, or the short gloss on the paintings of the Syrian-Italian artist Nabil Reda Mahaini, penned decades later, not long before his own death. Even in their brevity they submit glancing impressions to Pasolini's characteristically involuted, almost helicoidal prose. A prose that – like the poetic, pictorial, and cinematic oeuvre of which it is an extension and reflection – replenishes itself by wilfully 'contaminating' its intellectual tributaries: flowing out from formal and technical reflections, dipping now into semiotics and structuralism, swelling into lyrical excursus, settling into thinly veiled autobiographical allusion.

The latter forms perhaps the most salient leitmotif in its own right – an epiphenomenon of Pasolini's entire body of art criticism. Whether implicitly or explicitly, subtly or unabashedly, all of his writings on painting prove self-referential to one degree or another.[42] We read about Mauri's violent and sensual 'contamination' of styles, for example, and Rouault's 'plebeian lyricism'. It is, Pasolini writes, 'pastiche' which affords Lorenzo Tornabuoni

42 Francesco Galluzzi has noted the same tendency, citing Guido Santato and remarking: 'Non è una novità che il lavoro critico di Pasolini assumesse anche il valore di "una forma di indiretta autobiografia, riflessa nello stile degli autori esaminati, nella loro imagine".' [This is not the first instance in which Pasolini's critical writing took on the quality of 'a form of indirect autobiography, evincing the very style and imagery of the authors under examination'.] Galluzzi, *Pasolini e la pittura*, p. 39.

(Figure 34) a ' "figural integration" that synthesizes an entire cultural universe', while Renzo Vespignani's painting (Figure 35) reveals 'an inner contradiction, a kind of wound' culminating in 'stylistic contamination' (pp. 96–7). The same tendency extends to Pasolini's poetry. The chromatic fields of Friulian colour by the painter Federico De Rocco (1918–1962) – who guided Pasolini's own first efforts with a brush – spread to the 'margins of a mute and ardent province / . . . where / language is by now dialect, and dialect / falls silent among alder trees and ruins' (p. 103). Even Pasolini's occasional, commissioned art historical interventions – such as his lecture on Romanino – pull no punches in this vein; the 'tormented' Lombardian painter, Pasolini insists, 'existed outside of his own age', refusing the social and aesthetic 'homologation' slavishly abided by the rest of his contemporaries (p. 136). Pasolini's confrères could hardly have mistaken the upshot – however unintended – in the allusion to Romanino as 'a clairvoyant . . . working in a time of moralistic and ideological repression', or in the reference to his possession of a 'sensitivity [bearing] a pathological, morbid facet' (p. 132).

These insinuations occasionally reach a higher mathematics of self-reference. 'The *Narcissus* that Carlo Levi painted is not himself, but rather a Narcissus who, by discovering the image of himself, discovers himself objectively and discovers the objectivity of reality . . . in a curious and ambiguous way, dramatic and fascinating in equal measure' (p. 174). Pasolini's own Friulian poems on the Narcissus myth, and his early rendering of a Baroque Narcissus (the Barberini canvas long believed to be a Caravaggio, see Figures 1 and 2) cannot have been far from his mind. His subject ostensibly remains the 'social' and 'mysterious' reality of Levi's painting (rather clumsily articulated in his text). Yet Pasolini gives up the proverbial ghost by the essay's end, remarking, somewhat improbably, that Levi manages to 'smash the boundaries that separate painting and literature, literature and cinema, cinema and something else. It is a triumphal, explosive, vital demonstration that painting is not an

artistic genre but something else: a formal universe with its own internal laws' (p. 177).

In a more tangible sense, Pasolini's writings reflect the range of his intertextual (and simply interpersonal) experiments. He helped present Guttuso's work at Rome's Galleria La Nuova Pesa, for instance, just before the pair set about collaborating on Pasolini's meta-documentary, *La Rabbia* (1963).[43] Lapsing intermittently into ekphrastic verse, Pasolini's presentation of Guttuso's drawings fleshes out the images' skeletal 'prose', which, he insists, already evince a certain poetry in their workaday expressivity. As usual, we find barely concealed allusions to Pasolini's own aesthetic and ideological penchants, whether in 'a lyrical prose alongside your compulsive poetry', or an 'overcoming [of] realism (details, psychology, regional and national styles) [which] stiffens into a wrinkled iconicity outside of history' (p. 115). The writing is conspiratorial, conversational. 'This is where you become a brother to me: in the desperate commitment always to be doing poetry.'[44] Guttuso would soon lend his voice for the punchy, 'prose' dialogue of *La Rabbia*'s double commentary (re-joined by the author Giorgio Bassani, who reads the film's lines of poetry in a comparatively mournful and elegiac tone). Montaged from extant newsreels into sequences by turns mordant and lyrical, the film treats that which Pasolini also identifies as the engine of Guttuso's painting, namely 'our century's irrationality'. Guttuso's work itself punctuates *La Rabbia* toward the film's end. One of the few images reproduced in colour, his *Crucifixion* (1941) exemplifies a way forward out of what Pasolini identifies as a contemporary aesthetic impasse, between the stale formulations of Socialist Realism and the bankruptcy of abstraction. Epitomizing the latter are the film's recurring, anaphoric invocations of Jean Fautrier's paintings (Figure 6): signs of a cultural and

43 With regard to the left's ongoing culture wars at the time, it is interesting to note that the exhibition's guest book bears the signatures of both Togliatti and Michelangelo Antonioni.

44 See p. 106 of this volume.

spiritual impoverishment propped up by a fulsome neocapitalism.[45] For Pasolini, the only acceptable mode of expressivity was one which – as he writes of Guttuso (and thus of himself) – retains 'a faith in reality, and therefore in figuration' (p. 112).

That figurative faith manifests in the heterodox dogma of Pasolini's aesthetics, forged throughout the 1950s in dissent from avant-garde tendencies as much as from communist creed. Cementing his prominence in Italian letters, the *terza rima* verse collected in *The Ashes of Gramsci* (1957) announces, as we have seen, what Pasolini calls 'the scandal of self-contradiction'. This formulation entailed a simultaneous embrace and abjuration of Gramsci's strain of communism. Yet it also comprised dissatisfaction with the strictures of realism on the one hand, and the contemporary imperatives of experimentalism on the other. The book's canticle 'Picasso' already brings this dissatisfaction to a simmer. Occasioned by the Spaniard's retrospective at Rome's National Gallery of Modern Art in the spring and summer of 1953, the poem's opening stanzas strike a series of discordant notes. The Valle Giulia sits in the Villa Borghese both 'heated' and 'silent', in an Italy 'innocent' yet 'impure', redolent of a 'death as sweet as air'. At the outset, Picasso's work offers an earthy respite from the capital's bourgeois and bureaucratic philistinism:

> The first canvas, with its eroded and intense
> crust, in an almost artisanal, gem-encrusted
> arabesque, is painted with earth
>
> and furtive fire: the old
> pre-war spirit, still fresh,
> mixes them with scandal and festival (p. 71)

45 As various scholars have noted, Fautrier's mid-century paintings – particularly his *Hôtage* series – respond to the horrors of Nazi violence. See Merjian, *Against the Avant-Garde*, Chapter 1.

In Picasso's (pre-war) eye for 'scandal and festival' Pasolini recognizes his own, along with a shared investment in what he calls, elsewhere, pure 'magma' (a term used by the traditional Hermetic poet Mario Luzi in defiance of the nascent neo-avant-garde)[46] – a magma of lyrical passion, tempered by an 'artisanal' touch:

> The expression surfacing on the skin
> of the canvas, as if emerging from its visceral recesses,
> infected with burning disaffection . . .
> . . . here is the Expression,
> gluing itself to eyes and hearts (p. 72)

From this ideal, expressive viscerality, however, the Spanish *maestro* is said to stray. From 'reverberating figurations' Picasso lapses, Pasolini writes, into something else. His 'error' lies less in what the paintings provide than in what they fail to accommodate over the decades, namely 'the people's sentiment', 'communal song'.

That year's retrospective in Rome was Picasso's largest exhibition to date. It only included works from 1920 to 1953, however, bypassing entirely the artist's Blue and Pink periods – as well as a significant portion of his early Cubism, by then classical in its own right. It was an immensely popular event, one intended for 'the masses'. It formed an opportunity for the Italian Communist Party (PCI) to demonstrate its counter-hegemonic power for purposes both educational and propagandistic. Guttuso sat on the curatorial committee alongside eminent art historians. Holding such a flagship event at the National Gallery of Modern Art was a victory for its chief curator, Palma Bucarelli (Figure 13), one of the most visible and consequential champions of the avant-garde in Italy; the list of her major Roman retrospectives after Picasso's reads like a

46 Mario Luzi's *Nel Magma* (which came out with Pasolini's main publisher Garzanti in 1966) was one of the few contemporary works presenting a poetic resistance to the new instances of experimentalism incarnated by younger neo-avant-garde poets connected with the student movement and leftist extremism.

syllabus on abstraction: Mondrian (1956), Pollock (1958), Rothko (1962). Though belonging, in theory, to the same side of the political spectrum as Pasolini, Bucarelli pursued an idea of modern art – along with that of other contemporary art historians from Rome's university, such as Giulio Carlo Argan and Maurizio Calvesi – fundamentally at odds with his own. In a sense, Pasolini's poem bears more upon the 1953 exhibition itself than the actual works it presented to a diverse audience: 'Absent / here is the people . . . in these canvases, in these galleries' (p. 75). With *The Ashes of Gramsci*, Pasolini himself could lay claim to the mantle of 'civic' poet – a title which others would posthumously bestow upon him. Indeed, the book's first edition sold out in fifteen days, and most of its components, including 'Picasso', were printed in newspapers and magazines circulating widely across Italy.

But what of the 'people's sentiment' in Pasolini's own work? Does it entail, as one philosopher would have it, an 'aestheticizing and decadent populism'?[47] T. J. Clark has obliquely set into relief the problem that dogs Pasolini's 'peasant ontology'. 'The figure "peasant"', Clark writes, 'is approximate, of course – not to say duplicitous. It lumps together far too much: it ignores or travesties class struggle.'[48] A risk of travesty persists in Pasolini's exclusion of the peasant from historical time. He sought, in a wider sense, to de-urbanize the postwar proletariat, whether in Rome's *borgate* or later in Harlem and the Bronx, where, in the mid-1960s, he claimed to find members of an (ostensibly monolithic) 'African-American subproletariat' numbering in the millions.[49] The fruits of his

47 Rocco Ronchi, 'L'ideologia italiana: "Pasolini" a quarant'anni dalla morte', *r/project anticapitalista*, November 2015, at rproject.it. Ronchi's deconstruction of Pasolini's 'iconicity' is a tad overwrought in its turn, suggesting that any criticism of 'Pasolinismo' today necessarily results in social (or at least intellectual) stigma on both right and left. If Pasolini (as individual and vector of disparate ideologies) indeed offers things to both reactionaries and progressives, those things are not – as Ronchi claims – a matter of 'generalized consensus'.

48 See Daniel Marcus and Daniel Spaulding, 'Interview with T. J. Clark', *Selva: A Journal of the History of Art*, April 2019, at selvajournal.org.

49 See Ara H. Merjian, 'Pasolini's African America: Race, Class, and the

disenchantment with orthodox communism (despite his conces-
sions to it in his Roman novels) hardly rescue Pasolini's work from
a frequently specious populism – intermittently raided today by
reactionary Italian political groups claiming an inveterate connec-
tion to the 'land'. This dimension of his work never endeared him,
at any rate, to most other 'heretical' leftists. Already in 1960, the
critic Angelo Guglielmi declared Pasolini's Marxism 'suspect' and
'culturally imprecise' – a verdict renewed after his reaction to
Rome's student protests (and to 1968 in general), and revisited by a
range of figures on the Italian left ever since.[50] On the other hand,
the ongoing and intensifying hagiography of Pasolini and his work
undermines his legacy, ignoring its nuance and occasional nasti-
ness. The 'sacred icon' made of 'Pasolinism' is not one we aim here
to venerate. The question remains, rather, whether something
redemptive (redemptively secular) might be found in iconicity
itself. Or else found in the painterly imagination that gave (and
gives?) it shape.

Vanguard of the Rear Guard

Pasolini's antagonism toward avant-garde strategies – in theory, if
not always in practice – only increased exponentially. Just weeks
after his text for Guttuso's exhibition appeared in print, he took to
the pages of *Vie Nuove* for an even more exasperated screed.

> Typical and glorious product of neocapitalism, abstraction repre-
> sents the latter in every respect, obeying its injunction against any
> intervention on behalf of the artist. 'Artist, concern yourself with
> your inner-most questions! Let your art trace the contours of

Limits of the Analogical Imagination', *SubStance: A Review of Theory and Literary
Criticism* #153, 49:3 (2020), pp. 71–100; Franco 'Bifo' Berardi, 'Pasolini in
Tottenham', *e- flux* 43 (March 2013).
 50 Berardi calls Pasolini 'a bad poet and an old-fashioned ideologue whose
knowledge of Marxist philosophy was quite poor' (ibid.).

your inner life, even the deepest and most unconscious!' Thus capital demands of the artist. And the abstract painter triumphally carries out his orders, and, lost in the deliciously anguished meanderings of his interior life, even enjoys the privilege of clinging to his pride; enjoys the illusion of obeying nothing but some secret inspiration, one less . . . bourgeois.[51]

This denunciation of abstraction cannot be reduced to an orthodox adhesion to the Communist Party's line on the politics of art. While Pasolini's aesthetic regressivism resonated with Marxist officialdom in its appreciation of Guttuso's expressive realism (Figure 19), for instance, or Carlo Levi's figuration (Figure 33), it diverged with regard to other modern masters. In addition to Picasso, there is the case of Morandi, whose tonal solipsism and inhuman subjects (see Figure 10) invited, in postwar leftist circles, the same humanist and anti-capitalist screeds that Pasolini reserved for abstract painting. The leader of the PCI himself, Palmiro Togliatti, had equated the avant-garde's soulless geometries with the glassware filling the canvases of Morandi and his imitators, averring that even the hackneyed academism of 'pompier' genre scenes proved more pertinent to the people than Morandi's 'full bottles, empty bottles, and ghosts of bottles'.[52] Pasolini's camera indulges similar bottles in at least two scenes from *Accattone* (1961), his debut feature film, invoking a painter he had been studying since adolescence (and before whom his own painting had appeared in competition). The image of Stella washing and sorting old bottles retrieved from the garbage was, Pasolini noted, a 'private homage to Morandi', just as he would later ascribe even his reprising of certain actors to the 'recurrence of bottles in Morandi's work'.[53] (Even the briefest glance

51 Pasolini, *Vie Nuove*, no. 47, 22 November 1962.

52 'Bottiglie piene, bottiglie vuote, spettri di bottiglie'. Signed under the pseudonym 'Roderigo di Castiglia' for his column 'A ciascuno il suo', Togliatti's venting on modern art came out in the tenth issue of *Rinascita*, 1 January 1953, p. 8.

53 He confessed this to Jean Duflot in a famous interview, see *Entretiens avec Pier Paolo Pasolini* (Paris: Éditions Pierre Belfond, 1970), p. 326.

at Pasolini's mixed media drawing *Lamps from the Safon* [1969; Figure 9] suffices to register the persistence of his affinity for Morandi's still lifes.)

La Rabbia (Figure 37) perhaps constitutes Pasolini's clearest self-positioning in the culture wars of Italy's Cold War. In it, Fautrier's images become the epitome of the anguished abstraction which he denounced in *Vie Nuove*. With gossamer pastel strokes juxtaposed onscreen with the hydroelectric froth of Umbria's Marmore Falls, they are marshalled to illustrate 'the powerful world of capital [which] has, as its arrogant emblem, an abstract canvas'.[54] Fautrier's work also perhaps stands in for a more personal agenda *à clé*. Newly arrived in Rome in the early 1950s following his scandalous exile from Friuli, Pasolini had found some respite in the friendship of Toti Scialoja, a fellow poet and painter. Pasolini's 1955 essay on Scialoja acknowledges the latter's path from a para-Cubist expressionism toward less objective representations; yet it also insists upon Scialoja's commitment to 'social premises rather than ontologically artistic ones' (p. 91). This changed by the decade's end. Following a few years' residency in New York City, Scialoja had turned to abstraction, with some of his recent works now rhyming with Fautrier's impastoed compositions (Figure 6). Scialoja's perceived renunciation of 'social premises' surely informed Pasolini's more private 'rage' – or at least a vague sense of betrayal – alongside *La Rabbia*'s more pointed fulminations against racism, colonialism, consumerism, and neocapitalism. According to critics who knew them both, like Enzo Siciliano and Biancamaria Frabotta, the friendship between Pasolini and Scialoja did not survive this aesthetic argument (though Pasolini's own intermittent affinity for pushing figuration to the brink of abstraction, ironically, survived well into the 1970s in his films and 'plastic' works alike [Figure 28]).

54 Pasolini, 'Trattamento', in Pier Paolo Pasolini, *La Rabbia*, ed. Roberto Chiesi (Bologna: Edizioni Cineteca di Bologna, 2009), p. 14; originally published in *Vie Nuove*, no. 38, 20 September 1962.

For Pasolini, Scialoja's case represented one symptom of a larger cultural and political disease, which visual art set into relief as in a Dantesque allegory. It was, arguably, some germ of informal painting that Pasolini spied (and abhorred) even in Picasso's postwar work at the 1953 retrospective: a justification of what was happening in Northern Europe and in New York, a sanitized 'idyl of white orangutans' utterly alien (incomprehensible, even hostile) to 'the people's sentiment'. Contemplating Picasso's canvases in the context of Bucarelli's hanging, and the relatively narrow chronological span of the retrospective, Pasolini detected a symptomatic 'excess of expression' even in the details of early figurative works. He deploys the same terms in his essay on Scialoja to describe his friend's errant arc from expressionist figuration to over-expressive post-figuration: a passage that he considered politically and ethically offensive.[55] Always at ease in the role of Cassandra, Pasolini had perhaps noticed in the halls of Picasso's retrospective the metallic sheen of *The Red Armchair* of 1931 – captured in one photograph being sized up by Italy's President of the Republic during the show's opening. In paintings such as this, Picasso had pioneered the use of industrial Ripolin enamel, which in turn became the signature material of Rome's youngest generation of painters throughout the 1950s. Mario Schifano, who had Picasso's same brand of enamel shipped from Paris, followed a path that might have earned Pasolini's approval: from abstraction to figuration, the opposite of Scialoja's trajectory. Yet his shiny enamels of the late 1950s and '60s, championed by Bucarelli and the Communist Party and even sold to finance extraparliamentary leftist groups such as Lotta Continua and Potere Operaio, did not represent the human and natural figures that Pasolini longed for. Championed by Moravia, Schifano is absent from Pasolini's critical purview, and the painting of his contemporaries appears only *à clé*, in various guises of disdain and disparagement.

55 Alessandro Giammei, *Nell'officina del nonsense di Toti Scialoja: Topi, toponimi, tropi, cronotopi* (Milan: edizioni del verri, 2014), pp. 69–79.

In his writing on Guttuso, Pasolini sneers in passing at 'newspaper ads, which have become . . . the specialty of neocapitalism' (p. 107). Particularly as mass-produced foils to individual expressivity, advertisements had likewise become raw material for Italian neo-avant-garde painters and poets, as they had for pioneers of American Pop across the Atlantic. Along with those of his peers around the Piazza del Popolo, Schifano's images were inspired by billboards, advertisements, and the mass media at large unfurling with new vigour across the capital. And while this strain of leftist 'Italian Pop' deployed Picasso's Ripolin in new forms of figuration – without simply resorting to pre-war schemas – their literary counterparts resurrected Dada and Surrealist practices of detached and automatic writing, aiming to mobilize neocapitalist language against the ruling class itself. In appropriating and ironizing imagery and new formats, these groups sought to come to terms with the ubiquity of the mass media and the attendant flattening of vernacular culture. Even Guttuso professed his (qualified) approval for Pop painting, particularly to the extent that it interrupted the avant-garde's relentless presentism. At the very least, it returned aesthetics to basic acts of mimesis. Yet, despite their generally Marxist, anti-conformist, and anti-establishment orientation – despite, in short, their status as fellow travellers – Rome's neo-avant-garde fell wholly afoul of Pasolini's sensibilities.

La Rabbia's release coincided, in fact, with the emergence of the Gruppo '63 – a cluster of poets, novelists, musicians, and artists named for the year of its formation. Seeking to appropriate the language of consumerism in order to ironize and subvert it, the Gruppo '63 directly opposed older anti-fascist protagonists in the cultural scene who enjoyed Pasolini's support, such as Moravia, Guttuso, and Bassani. Their goal was to assert a new experimentalist hegemony on the left. Their points of reference (from the French avant-garde to the *Tel Quel* group to the student movement) were alien to the older generations of Marxists they aimed to replace. Pasolini's poetry, cinema, and criticism represented to them precisely that which Pasolini himself detested about abstraction (and even in

Picasso's faltering 'expressivity'): a navel-gazing self-indulgence, unreconstructed subjectivity, a too-exquisite aestheticism. Calling him '*l'auleta esibizionista*' (an anticlassical and homophobic joke on Greek flutes and narcissism), the poet Corrado Costa derided Pasolini's idea of modernity in the pages of one of the group's fringe publications, *Malebolge* (1964–1967). Offering a close reading of his poems, Costa argued that Pasolini's work echoed nothing of Rimbaud's imperative to be '*absolument modern*'; instead, it simply extended Gabriele D'Annunzio's para-fascist and egomaniacal Decadentism. As proof, he adduced Pasolini's 'pictorial-coloristic vision' and 'symbolic-coloristic apparatus': traits of an apolitical subjectivism masquerading as civic poetry.[56]

Pasolini brought these grudges to bear on painting only obliquely. He dismissed poetry by *neoavanguardia* poets like Edoardo Sanguineti and Nanni Balestrini, for example, as failing to accommodate 'even a faint shadow, nor chiaroscuro, and therefore [it] never has any ambiguity'.[57] The obscurity and recession afforded by metaphor, by contrast, offered Pasolini the only respite from a world now wholly 'frontal and flat . . . without shadow and depth', as on the relentlessly planar surfaces of Schifano's enamels. Such terms apply equally to contemporary painting by Roman artists like Renato Mambor and Giosetta Fioroni, which borrow the squashed frontality of television and advertising imagery.[58] Pasolini's resistance to this appropriationist approach to representation echoes in his overwrought homage to the 'neo-academic' painting of Lorenzo Tornabuoni (Figure 34), which he describes as a 'transfiguration' of Soviet Socialist Realist posters of the 1920s (p. 164). The contemporary irrelevance of Tornabuoni's art mattered little, or not at all, to Pasolini. What mattered was the attempted reprise of a 'figural integration' in the teeth of a high culture which

56 Corrado Costa, 'L'auleta esibizionista', *Malebolge* 1.1 (1964), pp. 45–8. The text was reprinted in *il verri* 52 (June 2013), pp. 20–6.

57 Pasolini, 'The End of the Avant-Garde', in *Heretical Empiricism*, p. 129.

58 See Merjian, *Against the Avant-Garde*, Chapter 2.

had consigned such efforts to oblivion. In attempting to sabotage
the codes of neocapitalism by adopting and exacerbating them,
the neo-avant-garde's experimentation resembled for Pasolini
'someone condemned to death who takes his life before being
executed'.[59] Rather than a cure for Italy's ailments, the neo-avant-
garde itself embodied for Pasolini 'the cultural sickness of the
generation of consumer prosperity'.[60] Bourgeois culture, he
announced in every possible forum, was an illness with which all
of Italy had been fatally infected.

Diagnoses of its effects mounted in Pasolini's work with apoca-
lyptic frequency and intensity as the decade progressed – a rhetor-
ical brinkmanship responding not merely to particular tormen-
tors, but to the wider socio-economic contagion of which they
were both victim and servant, host and henchman. History,
Pasolini claimed, was now coterminous with bourgeois history;
there was no longer any escape from its dimensions. The film
Teorema (1968) allegorizes that immanence in a bourgeois estate
on the outskirts of Milan, its members succumbing to afflictions
either mental or physical. Following their intimate brush with the
divine – in the form of a mysterious visitor played by Terence
Stamp – the father, mother, daughter, and son all fall ill in turn,
shattered by a dawning self-knowledge of their fundamentally
hollow existence. The son, Piero, lives out his particular pathology
as an abstract-expressionist painter (Figure 14). Laying down
looping skeins on transparent panes of Perspex, he paints like
Jackson Pollock as captured in Hans Namuth's legendary film
Jackson Pollock 51, which screened at the American painter's retro-
spective at Rome's National Gallery – an event attacked in parlia-
ment by Communist deputies; Pasolini's friend, the art critic and

59 Pasolini, 'Comments on Free Indirect Discourse', in *Heretical Empiricism*, p. 92.

60 The phrasing is that of Umberto Eco, whose campaign to appropriate
elements of consumerist culture for neo-avant-garde strategies amounted for
Pasolini to a suicidal act. Umberto Eco, 'The Death of the Gruppo 63', in *The Open
Work*, trans. Anna Cancogni (Cambridge, MA: Harvard University Press, 1989), p.
237; Pasolini, 'Cultura dopo l'"impegno"', *Vie Nuove*, n. 34, 26 August 1965, p. 445.

politician, Antonello Trombadori, denounced the show in the museum's guest book.

Pasolini hardly toed the Party line. Yet abstract painting repeatedly surfaces in his work as both sign and symptom of a specious autonomy – a pathetic gesture of revolt masking a (by now) inexorable conformism. Aside from sharing a first name (and a youthful penchant for painting), the character of Piero evokes Pasolini in other ways as well. For, despite (or because of) his hostility to abstraction, Pasolini sporadically practised it in painting over the decades, whether in early exercises from Friuli or later iterations which evoke the very Informalist experiments he railed against. The crypto-Catholic, quasi-religious pieties of his aesthetic method – as in *Teorema* itself – set Pasolini further at odds with a leftist neo-avant-garde seemingly resigned to the fundamental disenchantment of late bourgeois modernity (and aiming to assimilate that disenchantment to critiques of the culture industry). Despite his own exasperation and resignation at the victory of bourgeois culture, Pasolini could not help but rattle its cultural cage with the angry (and outmoded) clang of lyrical and confessional expression, whether in poetry or – as he drifted away from literature to film – the 'cinema of "poetry"'.

Cinemas of Poetry, Cinemas of Painting

It was, in fact, Pasolini's skirmishes with the literary avant-garde which pushed him toward the cinema throughout the 1960s, including attempts at its theorization in a series of ambitious essays. As a 'trans-national and trans-classist' phenomenon, film raised the stakes of any possible resistance to the 'passive revolution' of neocapitalist culture and the 'humanistic languages of the elites'.[61]

61 McKenzie Wark glosses Pasolini's film theory: 'Cinema, or rather *audiovisual language*, is the terrain of struggle in neo-capitalism analogous to the struggle over literary language in the immediate postwar years. The difference being that it is not a language that descends from the superstructures of state, school, church and literature. It emerges within the infrastructures of production

Like the language out of which it was made, literature appeared for Pasolini increasingly evacuated of subjective potential. Film, by contrast, offered a laboratory of new signifying codes and, thus, their potential, lyrical, transgression. In a brilliant synthesis of this film theory, McKenzie Wark writes that Pasolini 'found in cinema a technical language, part of the infrastructure of neo-capitalism, which could light the embers of something archaic, because of the very nature of the cinematic sign itself . . . and hence [could] potentially reproduce a reality beyond neocapitalism'.[62] Pasolini controversially likened the audiovisual nature of reality to 'cinema' at large (as opposed to the more limited example of an individual film): 'The first and foremost of the human languages can be considered to be action itself.' 'Reality', Pasolini writes, 'is nothing more than cinema in nature'.[63]

In positing the world as a series of uninterrupted human actions comparable to cinema, Pasolini invokes the phenomenon of the 'happening' – a rare convergence of his theoretical constellations with contemporary avant-garde experimentation. Various scholars have picked up on this reference as a means through which to grasp Pasolini's film theory, particularly in its temporal dimensions. Indeed, film's 'analogy with painting' remained limited to the visual for Pasolini. It obtained chiefly as a set of stylistic decisions, respective inscriptions of *written* language, to which cinema necessarily adds sonic facets.[64] Yet in its spatial dimensions, the 'minimum units of the language of cinema' remain fundamentally pictorial in Pasolini's theory and practice alike – a 'system of *visual* signs'.[65]

He was the first to admit this, remarking in 1962 that his 'cinematic taste does not derive from a cinematographic origin but rather

itself'. Wark, 'Pasolini: Sexting the World'.

 62 Ibid.

 63 Pasolini, 'The Written Language of Reality', in *Heretical Empiricism*, p. 205.

 64 Unlike a theorist like Rudolf Arnheim, whose investment in silent film entails his insistence upon the 'partial illusion' of painting, Pasolini claimed to 'reject the notion that the true cinema is silent cinema' (ibid.).

 65 Ibid.

from a figurative [plastic] one'. Rejecting both neorealism and the more recent extemporaneity of *nouvelle vague*, Pasolini professed to 'hate naturalness . . . I am after the plasticity of the image'. He understood the viewer, too, to be just that: a spectator who *views*, first and foremost. 'The intended audience of the cinematographic product', Pasolini writes, 'is also accustomed to "read" reality *visually*'. At its heart, the cinema evokes a Continian 'pre-grammatical' – even 'pre-morphological' – world of dreams and memories through its 'pure and simple *optical* presence'. As with verbal language, however, the possibility of a cinematic poetics depends upon the encrusted proprieties of cinematic prose: conventions which may be lyrically disturbed through edits, cuts, superimpositions, and other techniques. In other words, in order to violate expressively the world's optical presence, a cinema of poetry must first establish familiar grammatical codes to be violated. In this sense, Pasolini's own cinema proves as resolutely prosaic as it is lyrical and expressive. Not by coincidence does Stephen Sartarelli remark of Pasolini's poetry that it regularly 'excelled at playing by the rules while simultaneously breaking them'[66] – a notion which holds for his cinematic work as well. From *Accattone* to *The Gospel* to the *Paper Flower Sequence* to *Teorema* he experimented with superimposed montages, intercuts, and the modernist ambiguity of the 'free indirect' camera – all examples of 'extreme stylistic articulations'.[67] For the most part, however, in place of demonstrably experimental strategies, we find in Pasolini's films rigidly stylized and symmetrical compositions. As he discusses in the text 'Technical Confessions' (1964) (pp. 125–8), these compositional strategies evacuate millennial, Christian iconographies of their theological pith to borrow an abidingly hieratic shell.

66 *The Selected Poetry of Pier Paolo Pasolini*, p. 6. 'Thus, despite its great novelty within the immediate cultural context, and despite his later penchant for radical formal experiment, Pasolini's poetry and his creative project in general were as recuperative as they were innovative and social . . . He had an uncanny ability to use existing institutions – public, private, literary, stylistic, and so on – to successful ends while undermining them from within and without.'

67 Pasolini, 'The "Cinema of Poetry"', in *Heretical Empiricism*, p. 178.

More often than not, that shell is the human body – that which the art historian Michael Baxandall calls the 'effective unit' of narrative in Quattrocento painting. Pasolini's film theory, in fact, obliquely anticipates aspects of Baxandall's landmark *Painting and Experience in Fifteenth-Century Italy*.[68] This is not the place to recapitulate the complex set of propositions comprising Pasolini's theory, informed by Saussurean linguistics and bearing its own specialized grammar and lexicon. Yet the resonances (and divergences) between some of its formulations and Baxandall's notion of a 'period eye' are instructive, and set into further relief the consequence of painting for Pasolini's work at large – a consequence which further underscores some of the contradictions at the heart of his film theory. The resonances do not play out merely in films explicitly engaged with Christological themes, like the *Gospel*'s uses of Piero, or in religious *tableaux vivants* like *La Ricotta*'s recreation of Pontormo's and Rosso Fiorentino's respective *Depositions*. Pasolini even remarked upon the felicitous resemblance of his *Gospel*'s protagonist – the young Catalan actor of Basque descent, Enrique Irazoqui – to the Christs painted by Georges Rouault.[69] Yet reality itself was for Pasolini always already divine in its secular expressiveness. 'Being' was for him not something natural, but stylized. 'My vision of the things of the world, of objects, is not a natural or secular one; I always see things as a bit miraculous.'[70]

68 Michael Baxandall, *Painting and Experience in Fifteenth-Century Italy* (Oxford: Clarendon Press, 1972).

69 'The same contrast between the styles of *Accattone* and *The Gospel* comes out in the references to painting: in *Accattone* there is only one figurative element – Masaccio, perhaps deep down Giotto and Romanesque sculpture as well ... whereas in *Gospel* there are numerous different sources – Piero della Francesca in the Pharisees' clothes, Byzantine painting (Christ's face like a Rouault) ... Recently [1968] I saw an exhibition of Rouault's work with some paintings of Christ where he had exactly the same face as my Christ.' Pasolini, cited in Barth David Schwartz, *Pasolini Requiem*, second edition (Chicago: University of Chicago Press, 2017 [1992]), p. 416.

70 Pier Paolo Pasolini, television interview with Enzo Biagi, 'III° B facciamo l'appello', RAI, 1971, 58 mins., and *Il sogno del centauro*, ed. Jean Duflot (Rome: Riuniti, 1983).

it is solely by way of technical processes and stylemes that we may grasp the real significance of that religiosity. Whoever, instead, speaks of it solely in terms of content (whether explicit or implicit) grasps it only approximately, superficially. In fact, the religiosity lies not in the need for personal salvation or development (from pimp to thief!), nor, externally, in the fatality which determines and concludes the entire story, and which is emblematized in the final scene's sign of the cross. It is found, rather, in the very mode of seeing the world, in the technical sacrality of seeing itself. (p. 126)

Pasolini's atheist-religious approach to the miracle of things allowed him to transform Longhi's connoisseurship into an epistemological approach to reality across the ages. Recurring physiognomies and conventions (even dogs and bottles) amount to reincarnations, spiritual phantasms in their own right, attesting to the presence of otherwise lost conditions and lives. Feeling chronologically, and not historically, contemporaneous with the neo-avant-garde – like Masolino and Masaccio in Padua five centuries before – Pasolini's visual, pre-grammatical intuitions provided him with a compass to navigate the disaster of neocapitalist sterility.

Baxandall reminds us that Leonardo, at one point, planned to codify in painting the full range of human physiognomic conventions, at least those most salient in his day. In the absence of any definitive set of rules to that end, Da Vinci encouraged painters to draw upon the gestures of 'orators and dumb [sic] men'. The symbolically laden gesticulations of preachers, too, meant that the Quattrocento viewer brought to painting a set of precepts about the body and its potential inflections. 'Developing a list like this in one's mind', Baxandall writes, 'revising and enlarging it from one's experience of the pictures, is a necessary part of looking at Renaissance pictures'.[71] Even still, he notes, 'There are no

71 Baxandall, *Painting and Experience in Fifteenth-Century Italy*, p. 65.

dictionaries to the Renaissance language of gestures.'[72] In a similar vein, Pasolini writes: 'There is no dictionary of [filmic] images.' And in a further, striking rhyme with Leonardo's taxonomic ambition, Pasolini invokes as an example of one established 'gestural' system the language of 'deaf-mute Neapolitans': 'It is on such a hypothetical system of visual signs that the language of the cinema founds its practical ability to exist, its right to be conceivable as the result of a series of naturally communicative archetypes.'[73] Published a few years after his death, the monumental volume *Corpi e luoghi* (1981) collects over two thousand stills from Pasolini's filmic corpus to constitute precisely a sort of dictionary: a set of gestures and faces, bodies and their interactions with landscapes, aiming to investigate retrospectively the structure of a systemic, cinematic idiolect.[74] This kind of philological taxonomy connects Pasolini's mature cinema back to the profound localism with which his work began, by way of an obstinate faith in the grammatical potential – and pre-grammatical allusions – of sight.

In developing his own 'patrimony of shared signs', Pasolini turned again and again to painting, consciously and unconsciously. In painting's expressive stylizations of the real lay, for Pasolini, its ineluctable lyricism, as evinced in his respective elegies to Guttuso and Scialoja: 'Lucky you! Every time you raise a pencil or a brush, you always write in verse. A painter is a poet who is never forced by circumstances to write in prose ... [he] subverts the logical nexuses of regular grammar through the use of another delirious and refined grammar, provided by that same consciousness' (pp. 105 and 90). In its muteness and fixity, painting – like poetry – makes the world over into something at once less and more, something locatable in language but also unbeholden to its totalizing grasp. Pasolini wanted it both ways: to establish a cinematic

72 Ibid.

73 Pasolini, 'The "Cinema of Poetry"', in *Heretical Empiricism*, p. 168.

74 Michele Mancini and Giusepe Perrella, eds., *Pier Paolo Pasolini: Corpi e luoghi* (Rome: Theoria, 1981), published in English as *Pasolini's Bodies and Places* (Zurich: Edition Patrick Frey, 2017).

grammar and to mine cinema's pre-grammatical recusancy and exuberance. We find a similar paradox (at times, contradiction) in his philosophy of painting: a cleaving to figuration, to its relationship to history and language, to the real; and a simultaneous obsession with the irrational and the oneiric, with what he called an 'un-amalgamated magma'. This surfaces (quite literally) not only in his own para-informalist experiments in painting, but also through the pictorial crust of his poetry, in a Rome where an 'informal, festive, bloodthirsty psychology takes visual shape: coagulating in its lyrical equivalents, in images'.[75]

The mid-1960s witnessed a wholesale reconfiguration of leftist politics. The touchstones of Marxist culture – proletarian labour chief among them – gave fitful ground to New Left concerns: for colonialism and environmentalism, for questions of identity and ethnicity, for all manner of alternatives to Stalinist technocracy. The same years saw painting – as an *institution*, rather than mere practice – emerge as the aesthetic *tête de Turque* for the European and American neo-avant-gardes. The abstract and informalist painting that Pasolini continued to disdain throughout the decade had already been consigned to the proverbial dustbin of art history. Yet Pasolini remained uninterested in – blithely ignorant of – contemporary debates over the fate of painting. If he responded to Pop art (productively and antagonistically), phenomena like Minimalism, Neo-Concrete Art, Fluxus, Arte Povera, Land Art, etc., never even registered on his horizon (even as the last two resonate in and with his work in various ways). Aesthetic transgressions, he writes in a polemic essay about the cinema of his time, 'do not take place on the barricades' but rather 'within a concentration camp where everything is transgression'.[76] His last film, *Salò, or the 120 Days of Sodom* (1975), allegorizes that

75 Pasolini, 'Notte sull'ES', in *Romanzi e racconti*, vol. II (Milan: Mondadori, 1998), p. 405 ('l'informe, festiva, sanguinaria psicologia prende forme visive: si coagula nei suoi equivalento poetici, nelle immagini').

76 Pasolini, 'Unpopular Cinema', in *Heretical Empiricism*, p. 270.

concentration camp as a sprawling bourgeois palace, inhabited by
Fascist aesthetes inflicting their desensitized appetites upon the
bodies of proletarian youths, in a macabre mix of torture and self-
satisfied refinement. Lining the walls of that infernal manor are the
most exquisite expressions of late Western experimentalism
(abstract, Dadaist, and Futurist canvases, copies of Duchamp,
Braque, Léger, Balla, Boccioni and others): witnesses to horror
from within the sidereal silence of their framed, inhuman beauty
(Figure 15). The obvious, didactic echo between the violent sexual
transgressions in the rooms and the supposedly revolutionary
aesthetic transgressions on their walls redoubles the parallel join-
ing the film's apologue to the 'new fascism' of late capitalism.

It is perhaps Pasolini's wilful (or unwitting) imperviousness to
the dialectics of postwar aesthetic progression – especially its
relentless challenges to painting as a practice and a worldview –
which ensures his peculiar significance for art history. For Pasolini,
the director – and the poet, the painter, the artist writ large – must
'forestall the modernist impulse towards permanent and system-
atic violations of the code and "go continuously backwards, to the
firing line".[77] Neither classical beauty nor mere transgression –
neither aesthetics nor heresy – will ever suffice to explain Pasolini's
poetics and politics of the visual: a stubborn return to the prover-
bial firing line, a privileging of origins over originality, a dream of
the new conjured up out of radical regressions fixed in pigment. A
lyrical poet, artist, filmmaker, a timely critic of painting and an
anachronic historian: the author of the texts that we present in the
following translations approached the visual arts from a vantage
point both irreverent and deeply conservative – at once 'more
modern than any modern' and an unabashed 'force of the past'.

77 Maurizio Viano, *A Certain Realism: Making Use of Pasolini's Film Theory
and Practice* (Berkeley: University of California Press, 1993), p. 266.

TEXTS

For Manzù's *David* (1942)

Your town, my friend, turns pale from fatigue;
you turn your head, still,
patient in your tempted flesh.

You are, David, like a bull who one day in April
walks sweetly toward his death,
led by a laughing boy.

In an edition of 300 numbered copies, the Libreria Antiquaria Mario Landi in Bologna published Pasolini's first book of verse, Poesie a Casarsa *(1942) when he was just twenty years old. In this volume appeared 'Per il "David" di Manzù', which has never been translated into English in this version, which invokes in its title the artist whose work it addresses. The poem takes as its inspiration the bronze sculpture* David *by the artist Giacomo Manzù (1908–1991), cast in 1938 and shown at the Roman Quadriennale of 1939 (Figure 24). Figuring a crouching boy who turns his head as if hearing someone or alerted to some presence, the sculpture is anecdotal, but also, in keeping with Manzù's ambition, potentially allegorical. Underscoring the 'anti-monumentality' of the boy's pose, the art historian Flavio Fergonzi*

has described the work as 'a sort of manifesto-piece for the new values of humanity and spirituality that could be recognized in it'. Though the poem's inspiration is generally assumed to be Manzù's 1938 casting, the artist made two similar sculptures bearing the same title, respectively dated 1936 and 1940.

Along with two subsequent collections of his Friulian-era poetry, Poesie a Casarsa was anthologized in 1954 in the volume La meglio gioventù (The Best of Youth), published under an imprint of the prominent journal Paragone, founded by Roberto Longhi, Pasolini's former teacher and Italy's most distinguished art historian. Under the working title Romancero, Pasolini worked intensely on this volume, developing the language of its original poems both in terms of literary style and dialectological precision. In its final version, simply titled 'David', the poem's first stanza changed significantly: 'Leaning on a well, poor boy, / you turn your kind head toward me / with coarse laughter in your eyes'. Pasolini kept refining his Friulian poems for decades, collecting them in a second comprehensive anthology titled La nuova gioventù (The New Youth) in 1975. Working from archival papers, the curators of the definitive edition of Pasolini's poems in the Meridiani series found four different variants of 'David'.

Notes on George Besson's 'French Painting 1900–1940' (1943)

Armed as usual with an extreme and almost exasperated avant-garde taste, Giovanni Battista Angioletti's essay 'From Impressionism to Total Art' (published in *Primato*) is driven (even dragged) by an eminently practised sensibility rather than by plausible critical reasoning. Angioletti sets about presenting the danger and decadence of a superlatively modern Italian painting which, vis-à-vis French Impressionism and various Post-Impressionist schools, we might define as 'total' (in a technical sense). The pretext for his argument is a French text, namely René Huyghe's *Les contemporains*, Angioletti's summary of which we rehearse here:

After Impressionism, which, as we have seen, signalled the end of the age-old contract between artist and society, the transition to the Fauve revolution already appears populist in origin. Pierre Bonnard's short-lived boldness is amplified in the pictorial expansiveness of Henry Matisse, itself translated into the violent, plebeian lyricism of Rouault and the sullen poetics of Vlaminck. This game of discoveries and outmanoeuvres continues unendingly: while Rouault rebels against the '*penchant traditionnel de la France*' (that is, against a sensitivity more

effusive and tender than passionate and pathetic), Derain brings Fauvism back to 'culture'.

Cubism then delivers the final, fatal blow against a realist vision. 'Here we are, then, ready to conquer the absolute', continues Angioletti's résumé:

> Our author, dogged partisan of the Latin spirit, recognizes in such a conquest the most potent attempt to realize the dream of Mediterranean art: *'organiser un art dont l'homme soit le seul creature et maître'* [to organize an art of which man is the sole creator and master]. We find, then, the expected names of Gris, Léger, Braque, Roger de la Fresnaye, and Picasso.
>
> After Cubism, Surrealism dives with all its force into an exploration of the unknown. Art thus assumes an absolute autonomy, from which the audience appears henceforth excluded. Such a miscommunication with the audience epitomizes the problem of young artists. Oscillating between the poles of Cubism and Surrealism, young artists couldn't find a point to rally around other than humanity: that is, the sole survivor of the destruction of painting and the imprisonment of matter. The more astute young artists understood that *this was not so much a time of rebellion against predecessors* as it was a time to act with shrewdness and discretion. With this in mind, we Italians certainly cannot say that we have arrived late. The Italian art of recent years, and not simply painting, was founded in fact *on a return to construction, to composition, to figures . . .* At the same time, movements that call themselves Metaphysical or evocative or Hermetic have left too profound an impression for a young artist not to even acknowledge them. In sum, today we tend toward a total art, forged from balance and serenity.

But herein lies the difference between the Italian critic and the French one. The former is possessed by a certain disquieted dissatisfaction, heralding the dangers and equivocations of the

'total' art; the latter seems to persist quietly, cordoned off in an abeyance of certainty and pride with regard to the last forty years of painting:

> On étonnerait le public en lui disant que dans les mouvements artistiques le plus outrancier de ce temps on il ne soit fumiste-ries idignes de son attention, *il y a sans doute l'accent le plus humain de toute l'époque* [One would shock the public by telling it that in the most outrageous artistic movements of these times we find not shameful offenses to its attention, but rather *the undoubtedly most human facet of an entire epoch*].

And this is clearly [George] Besson's position – a position of certainty, almost of vindication:

> La peinture française fut en XIX$^{\text{ème}}$ siècle un miracle de vitalité dans une Europe privée de maîtres. Même abondance en XX$^{\text{ème}}$, même frénésie de recherches, même rayonnement. [French painting in the nineteenth century formed a miracle of vitality in a Europe deprived of masters. We find in the twentieth century the same abundance, the same frenzy of research, the same radiance.]

Not that such self-satisfied assertions have been uncommon in Italian criticism of late, whether in the form of short polemics or broader considerations. Yet, here in Italy, such statements are always aimed at settling scores with typically ignorant critics; we are still far from actually believing that the most recent Italian painting (especially that of young painters) has attained something in which we could believe blindly, with no fear of collapse or crisis on the horizon. We can already witness this state of almost melancholic attentiveness in Angioletti, sparked by an ostensible, future 'total painting' still far from being realized in Italy today.

How might we speak of a total painting in the Italy of painters such as Scipione, Mafai, Guttuso, Birolli, etc., etc.? Better to take up the discourse initiated in a recent text by Virgilio Guzzi, titled

'Twenty Years of Painting'. Guzzi's conclusions on young artists are more up-to-date than Angioletti's, but perhaps no less partial: 'It is by now clear to anyone the importance of a polemic like that unleashed, at a certain point, by Scipione's and Mafai's work . . . *a polemic about the goodness and necessity of feelings.*' He continues: 'there are maybe four, five, or eight painters between Rome, Milan, and Turin. We could say that they tend – at least the most informed among them – toward an analysis of the prospective-spatial values of colour: *hence their attention to Van Gogh, Picasso, Cézanne.*' (I would echo the importance of Van Gogh, without forgetting the German Expressionists and Kokoschka.)

Along such lines thus proceed the two main strands of Italy's current criticism. On the one hand (Angioletti), there is the sense of having attained a keen wisdom, by means of which we might coordinate the closest and most distance experiences without betraying them: a painting that is cathartic and serene (it remains unclear how much this pictorial taste is influenced by the parallel aesthetics of Hermeticism, which also comprises concepts such as 'catharsis' and 'distance'). This is a painting that ultimately returns to tradition without shedding the appearance of the most anti-traditional experiences. On the other hand (Guzzi), there is a desire not to miss out on this general return to tradition: a desire for order and organization, yes, but through a stronger apprecia-tion of affects, of passions, of *heart*. Such an appreciation aspires to reconcile men with painting, not by prostituting art, but rather by making it express affects and passions in the boldest and most immediate of ways.

In short, it is tempting to say that Italy is still far from the Olympian confidence and cheerful certainty emerging from some quarters of French criticism and art history – as well as from the present text by George Besson. Of most vital interest is not the comparison of Italian and French criticism, however, but rather the Italian and French pictorial texts of the last forty years. Let us ignore for a moment the most recent Italian experiences (still devel-oping); it would seem that Italy's contemporary painting is superior

to that of France. And significantly so. It would take too much time
to demonstrate how a series of paintings by Morandi, De Pisis, etc.
are indeed superior to the various French paintings reproduced by
Besson. But, in short, the works described in his text lack the poetic
air – expressed through purely and intentionally pictorial tools –
that has been achieved in so many instances by our painters such as
Carrà, Morandi, De Pisis, etc. In fact, the work of these somewhat
older Italian artists relates not only to the painting of Cézanne and
Renoir, but also that of Delacroix and Daumier. By this I mean that
their art is purely pictorial, even when the content or the poetry of
their subjects appears to subsume the painting. With regard to these
three or four major Italian masters there is no need to discuss Post-
Impressionism; while it is true that their experience synthesizes all
the main Post-Impressionistic tendencies, their best results evince a
true expressive freedom and originality. Such qualities are rooted in
a new discovery of painting, in contrast with the non-painting that,
with its theoretical and autobiographical limits, characterizes Post-
Impressionism. On the contrary, the French culture of 1900–1940
described by Besson remains fully immersed in Post-Impressionism.
France attained the extreme consequences of that pictorial world,
from which it appears now to have no escape route.

In Besson's text, we find all the non-pictorialism of that world,
all its moral penchant for confession, theorizing, venting. But we
do not find the newness, the violence, the freshness of the first
painters who had founded Post-Impressionism. Matisse's latest
work is weary. The painting *Lecture* (1941), which serves here to
represent these recent efforts, is frivolous, futile, gaudy, and sadly
would not look out of place in a fashion magazine. Jean Puy's
Market of Sanary (1942) is boastful, gleaming, heavy with matter.
Marcel Gromaire's *Storm over Wheatfields* (1938) is horrible. And
should we be ashamed to confess that even Dufy, Vlaminck, or
Van Dongen have never fully convinced us?

We find in them a great and passive exhaustion, a boredom that
would kill for a bit of distraction. These paintings do not suggest
anything other than morality; they resemble a violent and even

ironic confession. They are so far from the serenity, the pictorial (not theoretical) wisdom, of Carrà or Morandi. While both Italian and French painters have learned from the same masters, the language of those masters has been invigorated – and at the same time endowed with a new virginity – in Italy. In France it carries on mechanically, content with the task of 'shocking the bourgeoisie'. But what is important to remark here is that Italy's younger painters (Mafai, Guttuso, Birolli, etc.) had the idea of latching on to the early experience of the superlatively modern French artists presented by Besson. They duplicated these artists' path here in Italy, and some of the resulting analogies are striking: look at how certain technical passages of Edouard Vuillard's *Two Women Under a Lamp* (1892) are identical to those of our Birolli's *Nude with Black Veil* (1941); or how similar François Desnoyer's *Toilette* (1938) is to the work of Guttuso.

Italian painters, in any case, come out on top in the case of such direct comparisons. Reaching a dead end in France, the same path in Italy reveals an almost desperate sense of exploration untamed by the kind of cheerful and benevolent criticism on offer in France. Greeted in Italy by a harsh (though not evil) criticism – the kind found in Francesco Arcangeli's 'Harshness for the Young Painting', in the journal *Architrave*, or [Guttuso's] 'Fear of Painting' – painting seems well aware of its precarious condition.

Published in Il Setaccio *(1942–43, see Figures 11 and 12), an art and literary journal which Pasolini co-founded with Fabio Mauri in 1942, this review-essay glosses a recent text by the French critic George Besson, which appeared translated from French and was reproduced alongside Pasolini's. The inclusion of a translation from French risked a certain scandal in wartime Italy; consider that just a few pages earlier, the journal dutifully published various tenets from the Fascist Party's* Foglio di Disposizione: *'The Duce and the Revolution demand the ritual of oath and obeisance, "including the sacrifice of blood". Whoever is unwilling and unready to make the supreme sacrifice has no right to spiritual citizenship in the*

Party. If he remains within its ranks by means of hypocrisy and dissimulation, he is a traitor.' While Pasolini's essay by no means lionizes Italian painting and criticism unreservedly, its upshot – the superiority of contemporary Italian aesthetics to that of the French – surely attenuated whatever risks the comparison might have occasioned. Though mired in some of the more provincial polemics of Italian criticism, the essay reveals the young Pasolini's familiarity with contemporary painting both French and Italian, particularly those artists on whom he was focused at the time: Carlo Carrà, Filippo De Pisis, and Giorgio Morandi. These painters, whose names reappear several times in the following pages, formed the subject of his aborted thesis under Roberto Longhi, and would remain touchstones for years to come.

'Paura della pittura' ('Fear of painting') is the title of a text by the painter Renato Guttuso which had been published in 1942 in the journal Prospettive. Giovanni Battista Angioletti (1896–1961) was a writer and journalist, while Virgilio Guzzi (1902–1978) was a painter of the Scuola Romana as well as an art critic for Il Tempo. *A curator at the Louvre, René Huyghe (1906–1997) also wrote on the history, psychology and philosophy of art. By contrast, almost no trace remains of George Besson, nor of the historical or editorial context of his essay – nor, for that matter, of who translated the text for* Il Setaccio.

On Light and the Painters of Friuli (1947)

Let me start with a wisecrack, which will make many of you smile (or will it?): in Friuli, painting is the artistic genre which produces the most brilliant results. With this opening salvo I am now committed to employing a critical language that will live up to the boldness of my claim. Let me make it clear that I am referring to a *milieu* (in the naturalist sense, so to speak), and that I intend to bestow a collective compliment upon the painters of Friuli. In any event, please don't misunderstand me: it's obvious that here in Friuli we possess no autochthonous pictorial civilization, but rather nourish refractions of those produced in the capitals (Paris, Milan, Rome). My discussion is thus *de facto* relativist in nature.

This Friulian pictorial milieu might best be established within parameters represented by [Felice] Casorati, by [Giorgio] Morandi, and by the tonal painting of [Virgilio] Guidi, as well as some vaguely Expressionistic and neo-Romantic influences (i.e., Guttuso). Parameters established, in other words, by non-Friulian artists. The way I have phrased it certainly makes it sound like a compliment: a means of freeing our best painters from the suspicion of provinciality, of dialect – which is to say, of tardiness. For those at least vaguely familiar with contemporary painting, the

aforementioned names amount to an implicit description – a trace, an impression – of Friuli's young painters. This has been fully confirmed here in Tricesimo; I left the exhibition with a clear image of a collective operation. Were I content – like so many critics in little reviews who throw a generic bone to every single artist on display – I would be incapable of communicating any sense of a collective trend: a hierarchy, a set of values. And the thread uniting those values, on which I aim to dwell here technically and theoretically, is 'light'.

Anzil sees light inside things, not around them. Forms, for him, are stars, not planets. His objects, his bodies, narcissistically illuminate themselves in his paintings; they invent their own third dimension in the chaos following expression. Anzil's light is a mental light: it makes me think of Piero della Francesca's 'universal light', or else of a Renaissance already in the throes of Caravaggian influences. That is where one must look to identify this painter's classicism (which he has even theorized in a manifesto) in all its bounty but also its barrenness. In the three paintings exhibited here, the elements of fanciful aestheticism that are typical of any new form of classicism are obvious in the *Nude*. In the face of the *Figure*, on the other hand, they manifest as an acceptable preciousness that requires a small amount of pictorial matter. It requires, however, a lot of work, and frees itself of any residual intentionality in the artist's *Landscape*, frozen in the marmoreal balance of a light devoid of any accident. Turrin's 'light' is similar in its sentimental significance (its poetic and refined sense of detachment), but it diverges from Anzil's as it tries to stay apace with the enchantments of tonalism; in his two landscapes and in his still life there are no more than three or four tones, the interaction of which produces a melancholic, well punctuated music. How could we not admire, in Turrin's art, these timid premeditations of a necessary (and a little epidermic) eternity? We might speak of an intellectual and poetic light in the work of Toso, Tavagnacco, and their less mature companion Gentilini: such a light does not fall on the objects but is generated by them, and generates them in turn. It is

hard to say whether this operation proves immune to certain dangers, particularly of a scenographic or aestheticizing kind. Such dangers, in fact, always dog the work of Toso, who in this exhibition reveals no progress (or at least movement) from positions he had already staked out, except perhaps for one Modiglianiesque nude. Also in the cold, poisoned greens of Tavagnacco, which are equally static, the deployment of Casorati's intellectual light is not perverted or mordant enough to reach a poetics beyond the veil of naturalism, and lingers indulgently over inlays and calligraphic ornament. The same sense of light appears in De Cillia, but with stronger Baroque and Romantic accents, as well as a certain penchant for impasto. In the three paintings that he presents here, however, light relies too much upon such accents, and the impasto appears too tormented and self-satisfied. De Cillia risks slipping down the oily path to mere aestheticism. Canci and Ceschia also move within the realm of a poeticizing light which envelops things atop a pleasant and limpid plane (with a touch of the Metaphysical) but ends up simplifying them too much.

And here we arrive at the second notion of 'light', still hugging the coasts of a great Post-Impressionist sea. On the one hand, reactions to the latter assumed a certain sense of construction: a reinvention of reality through the technique of Cubism and the myths of Fauvism, of Picassism, and, more broadly, of Metaphysical painting (and it is along the path of the latter that art reached the unnatural light of tonal painting and various modes of neoclassicism). On the other hand, there was further progress made along the lines laid down by Impressionism. It is well known that the absurd psychological ambition of the Expressionists often based itself on the chromatic and graphic foundations of Impressionism. I would briefly add that Impressionism ended up spawning a whole subset of 'good painting' by the early twentieth century – a painting *en plein air*, a painting of chromatic vibrations, of non-realistic approaches to naturalism, etc. In such work, light remains active and dynamic: it falls on the object from a naturalistic source (the sun) and deforms it, enriching it or corroding it.

To return to our exhibition in Tricesimo, this kind of light is the one used by Brusini, for instance. Look at his *Portrait,* or the more tasteful *Sleep,* and notice how even his little statue of the lying man is scratched by the rude caress of light. I could say the same about Celiberti's *Lagoon.* However, in the latter's case, it is the chromatic mass that is filled with light rather than the objects themselves; the ambition tends toward Sironi's style. The same goes for Dri, a more experienced painter. He does not impress us with the opaque, bruised, and malleable matter – lacking any sense of refinement – of his *Landscape* and *Morning;* but he looks better (or at least liberated from a still hesitant naturalism) in the desolation of his *Schoolboy.* The fourth painter in this circle of artists influenced by Carrà (in his Sironi and Carena phase) and by a timid strain of Expressionism, is Giulio Piccini. He has painted a *Porta Cividale* that, in its coarseness, reveals a 'naive' energy expressed physically within things themselves. *Last Lights* by Toniutti and *Landscape* by Mitri evoke that good Post-Impressionist painting which I mentioned above (De Grada, Semeghini, a certain line of [Ardengo] Soffici's art, etc.), with a resulting freshness and lightness in the former's oblique, brittle brushstrokes and, in the latter, an idyl of pink and blues painted with abandonment. Though I should mention Pittino here, I would rather gloss over his somewhat thorny contributions. Though I have appreciated his work for some time now, I cannot accept this latest retreat into a simplicity and tidiness from which, at least in its current form, I must express my dissent.

Like his *Head,* [Giuseppe] Zigaina stands alone. I would be the last not to support him were he to sacrifice (as he tends to) painting for intelligence, taste, or even polemics. His byzantine Picassism is nourished by a rather overt violence in the text of his painting: none of his intentions remains undeclared, he declaims them all with the intentional mess of stylistic pastiche. However, one should not be blamed for expecting more courage even from his 'mistakes', a more fiercely formal rigour.

De Rocco is as solitary as Zigaina, but on a different level. It is said that he is influenced by Saetti. Yet such influence is of a

calligraphic rather than rhythmical nature; De Rocco in fact exchanged the illness of his teacher Saetti (an *enfant du siècle*) for the health of Antonio Bellunello! Such health is expressed in the solid compositional balance and the warm construction of colours of his *Saint Catherine Comforting Nicolò di Tuldo*, with its beautiful black and white scene of the two nuns, and the tonal variety of a decorative element so well engineered within the composition's volumes. In any event, in view of some lazier passages and a certain academic patina, I prefer *Landscape*. Here De Rocco synthesizes Guidi's lyrical disintegration and Saetti's chromatic refinement into a moment of utterly limpid pictorial bliss. Look at how humidity (a naturalistic element) is conjured up by the fantastic means of vertical purple strokes over a compact and unripe green base. This meadow seems to me the most beautiful passage of painting in the exhibition.

Sculptors are also well represented here. I already mentioned *The Airplanes* by Brusini, and I would like to add some warm praise for Max Piccini and for the details in his *Little Madonna* and *Portrait of Paolo*. The exhibition's black and white section is less impressive; Tramontin is a good artist, but his two etchings prove overwrought. Brusini's *Lunatics* are amusing; Ciussi's pen is pure as its traces Guttuso-like physiognomies; Toniutti's *Horse* is remarkable, and so is the body (but not the head!) of Tubaro's kneeling boy.

This is a review of an exhibition of Friulian painters (including De Rocco and Zigaina, to whom other texts in the present anthology are dedicated) which opened in Tricesimo, near the Friulian city of Udine. It appeared in the Messaggero veneto *on 21 September. The allusions to artists from Sironi to Modigliani evidence a keen familiarity with the leading lights of early twentieth-century Italian modernism; yet the careful attention (and gentle reproaches) to contemporary Friulian painters underscores Pasolini's by now inveterate affection for his adopted region, as well as a wilful provincialism against the grain of the 'capitals'. While not without its place in*

Pasolini's writing more broadly, the piece's convoluted prose bears witness both to the ambition of a budding critic and to the perceived prerequisite of any young Italian intellectual: a facility with subordinate, Latinate clauses. The cautionary allusion to Metaphysical painting (and its misinterpretation of Piero della Francesca's uses of light) reflects Pasolini's initiation into the writing of his teacher Roberto Longhi, infamously hostile to Giorgio de Chirico's Metaphysical style. The theme of light surfaces frequently in Pasolini's art criticism, culminating in the unpublished fragment on Caravaggio which appears toward the end of this anthology.

An Anthology of Zigaina's Paintings (1948)

A philological examination of Zigaina's painting reveals that some of his sources operate like elective affinities. Not that I set too much store by his self-avowed pretexts ('to paint according to a musical closure', 'to fix the narrative in a timeless stillness', etc.). But I may be inclined to lend credence to these oral premises (and it hardly matters whether they were said in retrospect or not) to the extent that they offer the key to defining Zigaina's work in strictly critical – rather than polemical or aesthetic – terms: the functionality of his tools and the structural nature of his expression.

Getting back to the notion of sources as elective affinities, we find Ensor, Rouault, and a kind of Expressionism already morphing into a compositional tonality that removes expressivity to a considerable degree. Consider how much this Expressionism fails to spoil Zigaina's work, in *Prostitute* for instance, where an abject look crossed with nobility and an almost mortuary indifference appears fixed in the yellow of the left eye, in the decay of the cheek and in those two superb curly locks falling on the shoulders: all clues to a tale untold.

The painter's sentimental education is thus quite Nordic, which is to say that it is rooted in complexities not unrelated to the

candour of the convalescent. Though his research, like that of pure poets or abstract artists, aspires *directly* to form, it never quite makes the theoretical leap; in order to achieve the 'form' of figures (since he does not paint still lives or landscapes), Zigaina wants to keep painting human figures. He consistently eliminates any anecdotal element from his canvases. We should thus take note of his manual efforts, to the extent that doing so allows us to retrace the origins of his pictorial disposition, the brute, organic substance of his inspiration.

But let us, first of all, divide his oeuvre into three categories: *portraiture, pastoral composition,* and *sacred composition.* Such categories ideally proceed in chronological order. In a sense, Zigaina was born with the series of *Big Heads*; first there was a green period, related to the landscape of Friulian valleys as an obsessive motif; then, before the formlessness of his preparatory phase, a series of macabre (indeed, Ensorian) apparitions representing the evil products of a sensibility that, in his life at large, have contributed to making Zigaina a 'good' man. In the *Big Heads* – of which *Prostitute* already forms a solid example – we still find a contradiction. The contradiction begins with technical elements (matter that is too crude, oily, and blurred for the architectural facets of a two-foot-long head) and extends to the irreconcilability between movement and immobility.

When I say 'pastoral' composition, I mean it not simply as a genre, but as an evocation of Virgil's *Georgics* and Beethoven alike. For, Zigaina's landscapes are not idyllic at all; nor are they animated by the aestheticizing, sensual *Sehnsucht* of landscape painting. In these pastoral compositions appears what I call Zigaina's 'objectivity': a physical equivalence with reality, a plastic reconstruction of the real, free of any realist or pictorial complacency. At most we find some sensual excess, the necessary by-product of the flaming encounter of matter with an obsessive motif. Here too, colours obey the necessity of equivalence with the real, rather than simply a reciprocal rapport. Strangely enough, this does not result in atonalism or some other discordance; on the contrary, everything

appears immersed in an atmosphere pregnant with corporeality. Just as in that most 'physical' of Virgilian lines from the *Georgics* quoted by Serra: 'liquitur et Zephyro putris se gleba resolvit' [the rotten soil loosens and is made liquid by the West Wind].

With this sacred composition we are getting to the point. Should I specify the dimensions of Zigaina's great *Crucifixion* (about 3 x 1.5 meters), or of his *Marriage*, or *Sleep*? They certainly inform my discussion here, but will I take the liberty of leaving them aside – and this might form the greatest compliment that I pay to this young painter. We find ourselves again in the presence of his objectivity, which is to say his ability to build a work of art that differs from and lives independently of its author (think of Valéry). What is remarkable about this is that Zigaina's large works on hardboard bear nothing of what we would call perfection, tranquillity, or detachment. On the contrary, the first impression is that of movement and imbalance; the violent black outlines and this throbbing iron grating drag the dry anatomical data and the dry draperies into an unrelenting vortex, in attitudes still dripping with creative emotion.

Yet, after a few moments, everything reassumes its former order, recomposed in a configuration of classical breadth and fullness. (In philological terms, I should comment here upon the artist's longstanding love for the Byzantines immersed in an expressionistic excitement marked by some Picassian cadences – the Picasso of *Guernica*. Yet all these contradictory citations remain extraneous.) In front of *Concert*, one gets a real feeling for Zigaina's project, observable in a few points: the pure functionality of colour, the pure functionality of contour, a compositional fantasy of the greatest calibre. *Concert* is a large canvas, nearly square in format (about 1.5 x 1.5 meters), painted with colours reminiscent of fresco painting in hue (pure Prussian blues, dusky tones, violet, earthy browns) but of altarpieces in their mystery and pigment. Five or six figures of musicians playing wind instruments are composed – behind a gnarled web of outlines – with classical tranquillity, marked by a wealth of details including, most notably, one musician (in the

background) with a white face and hands adumbrated with blue stains. No one could deny that we are looking at a concert of music by Bach!

From my brief remarks, we might reconstruct an aesthetic aegis for this painter, at least in reverse – that is, by exclusion. For, his work remains extraneous to any lingering polemics over Impressionism; it lacks the complacency of either sensual chromatism or linear melody. Zigaina resides, in short, in that ambit of Secessionist painting which offers inspiration to a new postwar generation.

In the hinterland of the Friulian province, on the geographic margins of Franco-Occidental painting, adjacent to Northern Europe by way of Trieste: here, Zigaina obeys, in solitude, the commands of his inner daemon. Stubborn and sensitive, he has yet to outgrow the gratuitousness of his juvenilia. And it is for this reason that we bet on the young Zigaina, if we still can, with all the feeble credit afforded by our criticism, at the very moment when his personal exhibition in Udine manages only to *épater les bourgeois* – the eternally belated bourgeoisie.

A figurative painter and communist from the region of Friuli, Giuseppe Zigaina (1924–2015) remained a close friend of Pasolini's until the latter's death (see Figures 25 and 26). Published in Il Mattino del Popolo, a paper from the neighbouring Veneto province, this article discusses a local retrospective of works by Zigaina, whom Pasolini had met two years prior. The young critic read his friend's pictorial works through literary categories: he proposed a 'philological examination', analysed the paintings in terms of genre and sources, mentioning Virgil and Paul Valèry along with Picasso, and in the titles used the editorial term 'Anthology' to refer to a retrospective centred upon day labourers, farmhands, and other rural subjects. Zigaina's provincial imagery rhymed strikingly with Pasolini's commitment to vernacular subjects and their relationship to 'dialect' both linguistic and metaphorical. Zigaina later served as a consultant on Pasolini's 1968 film Teorema *(even producing the*

ersatz Abstract Expressionist paintings on Perspex done by the char-
acter Piero, see Figure 15), and appeared as a character in The
Decameron *(1971). After Pasolini's murder in 1975, Zigaina would*
go on to author several volumes driven by a (rather dubious) theory:
that Pasolini's entire life and death proceed according to a performa-
tive poetics of lyrical action and self-immolation. The line by Virgil is
quoted from Georgics I, 44.

Paintings by Zigaina (1948)

Several of Zigaina's friends subscribe to the philosophy of Benedetto Croce and thus are all too happy to accept the artist's painting as a 'fact', and to speak about him as if he were a gift. One indeed feels inclined to thank Zigaina for his innocent and offhand manner (and I am alluding here to the sense of 'thankfulness' that Gianfranco Contini once invoked apropos of the young Giuseppe Ungaretti). It may seem an easy invitation to love Zigaina, and an elegant solution. But that would not be much help to his work. Indeed it prevents us from entering its inner mechanisms, from witnessing him work at the heart of his aesthetic object. In his last exhibition (Udine, 7–22 November, at the Circolo Artistico), Zigaina presented a number of touchstones for those eager, in fact, to witness him work: pictorial equivalents of that which an author would call 'variants' – textual residues which help bring the reader into the heart of the author's activity, both potential and actual. And in Zigaina's case we are most certainly dealing with variants – rather than repetitions – of a single subject (a dead horse and its rider, for instance).

 Perfection is attained only in two or three of the pieces here, while in the thematically unified series we see the erasures, the *pentimenti*, the sudden inventions which precede a definitive

version and help to tell its story. An individual like Zigaina is, after all, easily seized by obsessions: those mild neuroses whose only pathology lies in the scars of old wounds, testaments to a very sensitive nature, to introversion as the unwavering mode of being. It is in this constant return to an obsessive motif that one discerns Zigaina's outlines: his personal story, his unobjectivity (or, to use a different word, his exquisiteness). This all causes him suffering, which he would like to be free of – to walk toward reality, toward the world, to become extroverted.

Indeed, if one thinks about natural objectiveness and about the power of an equivalence with reality in Zigaina's painting (as pictorial matter), one can logically conclude that the artist will eventually overcome this all too human problem. 'If I want to make "social" painting, then I want to do it with all my heart', he says. 'If I fail, it is better that I serve society in a different way, by disrupting my own history as a painter.' We can manage to console him even if his fishermen don't come from Rivarotta, or his labourers from Torviscosa. As soon as he got back from Venice, where he had exhibited his works at the Cavallino, Zigaina found himself once again immersed in the familiar atmosphere of Friuli's valleys. Green and white, the environment lends itself to motifs repeated almost like a bad habit in his work (recall the reapers in his green period, or the series of the *Big Heads*).

Almost immediately, he set about painting *Dead Horse with Its Rider n. 1*, a vast, skeletal study, still dripping and generic, but quite strong in its squalor. The motif appears already fixed in its essential lines, with the back of the horse unrecognizable in a contorted death. Its outlines are repeated (like the reprise of a musical motif in a lower key) in the lines of mountains reduced to pure *flatus vocis*: plain geometrical figures evoking space through elementary tonal rhymes. The same topic is reprised in both of the pen *Drawings*, where it remains the same, except that whereas in the first great sketch Zigaina executed only the idea of the form, here he tries to maintain the tangle of signs as he fixes, *more solito*, the white of the paper background, the concrete (even corporeal) value of the light. This will constitute, in the two or three versions that one could

consider definitive, a fantastic construction in black and white. Light is turned into tone and outline, enlarged until they become a shadow.

We should keep in mind that, in the two drawings, the parallel themes of the horse's back and the mountains remain almost identical to those established in the sketch; the former almost rounded, the latter more agitated and broken. Only with his *Tempera*, interpreting with more creativity the opportunities afforded by a different technique – so dry and light in terms of matter – does Zigaina give us the first important 'variant'. A sort of refracted triangulation with the line of the mountains results in the bottom outline of the horse being broken and reformed in the centre, where its flanks are hit by invisible arrows: a hiatus, an oblique caesura. From this version on, the back of the horse will bear this double cadence, reduced to these two linear abstractions. Moreover, where there used to be legs (under the space once occupied by the belly), Zigaina will start to 'dream' (as he puts it) the rider, who was previously nothing but a ghost, barely distinguishable from a sketched annotation. We find here some other drawings, too, one of which is vivaciously coloured in oil with those thick, constructive outlines to which Zigaina is partial. But they are just hints, marginal exercises which amount to a sort of shabby exquisiteness, if I may use the expression.

And, here, we arrive at Zigaina's most complex and greatest achievements: the large *Dead Horse with its Rider* and *Dead Horse and Men with Lanterns*. With regard to these two sprawling works on hardboard, we might mention (and why not, since we are speaking here of 'variants'?) Braque and Picasso, respectively. Of course, these names echo quite faintly in a world so personal; they form little more than obvious sources of assimilation. However, to speak of a Braque 'type' means to identify a genre: in this instance, generous and violent outlines which subordinate even the deployment of light, which becomes almost ornamental (I am thinking, in particular, of the great *Crucifixion* from last year). Colours, too, appear purely instrumental, bowing to the compositional facts. Zigaina builds with more compactness and less vastness, more rapture and less abandonment; he turns to fields of colour where light becomes,

as I said, tone, and tonal harmonies become precious because they are intrinsically content. The composition is a large and invented apparatus; it becomes an 'object', almost *à la* [Henry] Moore, but with such an intensity of hormones and naive vitality!

After these versions come *Men Killing Horses* ns. 1 and 2. The second is especially resolved in a strangely Metaphysical atmosphere, with wonderful harmonies in grey, violet, and light blue, where a gory, linear violence dissolves in the wake of Zigaina's gouging, Fauvist thrusts. And then there are the exquisite sketches of horses and crucifixions, the beautiful *Crucifixion* composed, so to speak, as a 'rhombus' in the vertical patch of a rectangle: maybe the single most mature thing in the exhibition along with last year's *Flautist*. And then we have the great compositions of *Fishermen* and the drawings of *Workers* ... But, in these, we find only the adumbration of Zigaina's newest thesis. We await its development.

In this second review of Zigaina's painting, Pasolini applies some of the methodological tools he gleaned from the contemporary literary critic Gianfranco Contini (1912–1990), whose work formed a touchstone for Pasolini's burgeoning prose and who came to serve as a key mentor. Contini had set about revising Italian literary studies by rejecting the idealism of Benedetto Croce, proposing in its place a more philological approach to textuality. In the 1930s, Contini applied his method – known as critica delle varianti *('criticism of variations') – to the 'variants' of Ludovico Ariosto's manuscript for the epic poem* Orlando furioso *(1516–1532). He did so at the same time that Roberto Longhi (another of Pasolini's mentors) was establishing an art history school with his seminal essay 'Officina ferrarese' (1934), devoted to an exhibition of fifteenth-century painters organized for the celebration of Ariosto's centennial anniversary in Ferrara. Pasolini approaches Zigaina's paintings in Udine in chronological sequence, as if they represented progressive versions of a pictorial text. Rivarotta is a small village in Friuli-Venezia Giulia; Torviscosa is a commune in the Province of Udine.*

Picasso (1953)

I

In the Sunday glimmer, gilded,
of Valle Giulia, the nation is heated,
silent: as innocent as it is

impure. It looks as if it's burning
with the people's joy, an irreligious
lethargy which, sunny, overflows

along the florid mouldings and fanlike
stairwells. This is but the act
in which an Italy of institutions

crumbles; an act of civility,
honest and anonymous . . . Some perform it
among the blazing flowerbeds and the fresh

shadows that, projected by the unbridled
pines of Villa Borghese, cross them; some
echo it in the festive

pomp of the Piazza di Spagna and are
blurred in a bustle that blanches
all around them, monotonous and stupendous: here

is ignited more brightly the sense of an Italy
striking an old note
of peace, in a death as sweet as air,

where the highest class rules, motionless.

II

And, down the stairway, the anonymous – a soul
without memory in a body made miserable
by centuries of humbly human dreams

of bourgeois experience – is now mythical
in this sunny Sunday
that sees him plainly in his plain suit.

How adorned of gentle passion
all of a sudden appear his life
and his mind (dominated

inside the heart of the Institution
by his hardened and servile dignity)
how he seems to burn, immune witness,

with his humble desire to understand . . .

III

The first canvas, with its eroded and intense
crust, in an almost artisanal, gem-encrusted
arabesque, is painted with earth

and furtive fire: the old
pre-war spirit, still fresh,
mixes them with scandal and festival,

with the immensity of thought and the purity
of technique; the blazing and smoky
surface interlaces its tones:

pasty petals on dried out clumps.
Insignia of the most supreme France,
when the sunset seemed like a scorching

dawn, and desperation like an expanded
pain of creation, and the fragments
of the century like his heraldic drawing.

IV

Yet, in clouds of white, in scintillating
outlines, with a lily's purity
and the carnality of a wild cub,

the foaming, raw children
already trace – even in the light of an idea
worthy of Velázquez, even in the lace –

the excess of expression that creates them.

V

The expression surfacing on the skin
of the canvas, as if emerging from its visceral recesses,
infected with burning disaffection,

shaking its scales with tonal
niceties: the expression that only resists, or even
stiffens, because of material,

intoxicating curdles. But here, among
the brush's scratching leaps, the zone
of an almost pastoral light, the splendour

of contrasts; here is the Expression,
gluing itself to eyes and hearts:
a gratuitous, pure, blind passion,

a blind dexterity, an indecent swelling
of the senses and, of the senses, a terse apathy.
To nothing but this godless frenzy

could Goya, in a decaying France,
surrender his violence. Here are expressed
pure anguish and pure joy.

VI

In the orderly procession,
a horde of feeling and doing –
not of believing – landscapes, people

are skeletons whose lost
objecthood appears corporeal:
expressing them means expressing their evil.

The patrician owl with a greedy green
on her chest, or a purple that has no
purpose but to inflame itself,

or a deranged, cunning scrawl in the eye,
there to betray; the flowers that turn into flesh
for a foetus or a chair and an enamel

of tones that covers them in wax, in the composite
gears; the beaches where the joy
of a ghoulish August gloats,

where invention wields a cretinous,
monumental freedom, free of charge,
a brutal freedom that the world

transfigures because of the obscure force
of vice, because of the pleasure
of exhibition: everything leads

to a calm frenzy of clarity.

VII

So much joy in this frenzy for understanding!
In this expressing that surrenders
to the light our confusion

as a heavenly matter, that lays out
our clouded affections in chaste
surfaces! The clarity that illuminates

their internal forms turns them into new objects,
true objects, and it does not matter – in fact
it is courageous, though delirious – that in them

is mirrored the shame of man who gives right
to Man, the shame of the most recent
man, this one here, who with wise

warmth looks at the figure of himself
ascending, highlighted, in the dreadful
slabs, his mistake, his

history. He looks at the exalting repressions
of the Church reduced to the dark rage
of sex, and at the clarity of liberal

wisdom stripped down to the pure clarity
of art; he looks at the decadence
of the enervated bourgeoisie

still greedy in its myopic regrets
and cynicism, sees them celebrated
in reverberating figurations . . .

But what a quiet and profound bliss
in understanding even evil; what an endless
exultation, what a decorous celebration,

in the heartfelt thirst for clarity,
in the intelligence that, complete, attests to
our own history in our own impurity.

VIII

So here it is then, full on, Picasso's error:
displayed in the vast surfaces
that unfurl across whole walls, his base,

friable idea, his pure fancy,
so agile for such a fat and forbidding
expressivity. He – the cruellest

among the enemies of the class that he mirrors
as long as he remained within its history
– an enemy by the frenzy and the Babel

of anarchy, a necessary infection – he comes out
among the people and gives, in a time that does not exist:
feigned through the tools of his own old

fantasy. Ah, this merciless Peace
of his, this idyl of white orangutans, is absent
from the people's sentiment. Absent

here is the people: the people whose murmur
keeps quiet in these canvases, in these galleries, just
as it explodes outside, joyful in the placid

festive streets, in communal song
that swells the neighbourhoods and the skies, towns and valleys,
all over Italy, up to the Alps, spreading

through mowed slopes and yellow
wheatfields – to the countries of a bewildered
Europe – where it reprises the ancient

dances and choruses in the ancient
Sunday air . . . And his error is here,
in this absence. The exit to

eternity lies not in this desired
and premature love. Salvation
is to be sought by staying

in hell, with a marmoreal
will to understand it. A society
fated to lose its way is always

bound to lose it: a person, never.

IX

Such unlucky decades . . . so lively
that they cannot be lived
except with an angst that leaves

them devoid of any knowledge, with the useless
pain of witnessing their loss
in an excess of proximity . . . Speechless

decades in a century still green,
burnt by the rage of actions
that leads nowhere but to scattering

the glimmer of Passion in their flames.
The last galleries are filled with pure
fear, expressed in crystalline zones

of senile, infantile cynicism: dark
and dazzled, Europe projects there
her interior landscapes. The light

of the tempest, mirrored with greater transparency,
is mature here: the rotting flesh
of Buchenwald, the festering peripheries

of strafed cities, the dismal tanks
of fascist barracks, the white
balconies along the coasts: in the hands

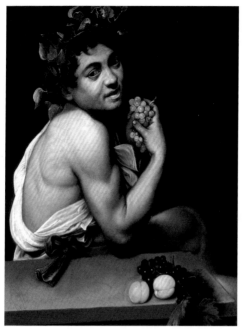

1. Caravaggio (Michelangelo Merisi), *Sick Bacchus*, c. 1593, oil on canvas, 67 × 53 cm, Galleria Borghese, Rome. Image in the public domain, courtesy of user: Oursana / Wikimedia Commons.

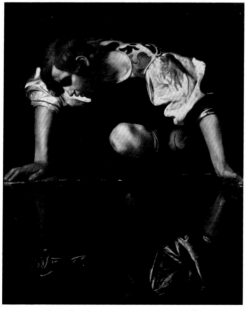

2. Caravaggio (attr.), *Narcissus*, 1597–99, oil on canvas, 110 × 92 cm, Galleria Nazionale d'Arte, Antica, Rome.

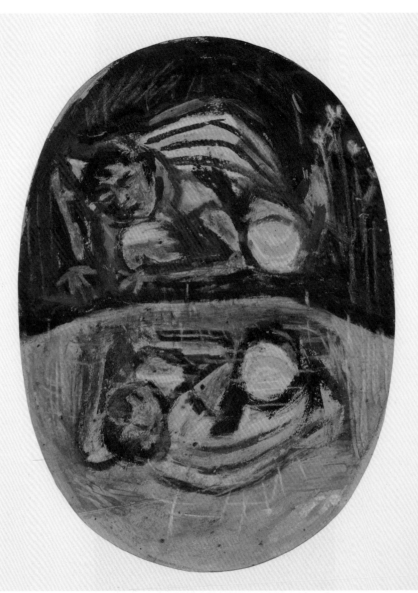

3. Pier Paolo Pasolini, *Narcissus,* 1947, tempera and pastel on brown paper, 27 × 37cm. Gabinetto Scientifico Letterario G.P. Vieusseux, Florence.

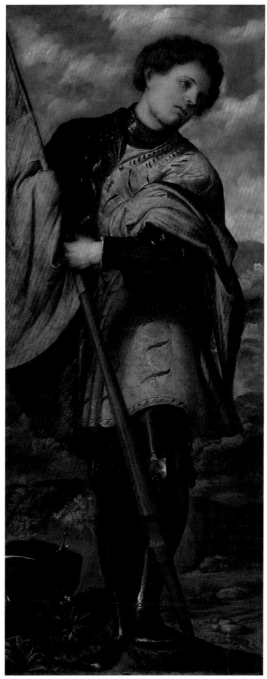

4. Romanino (Girolamo Romani), *Saint Alexander*, c. 1524, oil on wood, 159.5 × 64.2 cm, National Gallery, London. Image in the public domain, courtesy of user: DcoetzeeBot / Wikimedia Commons.

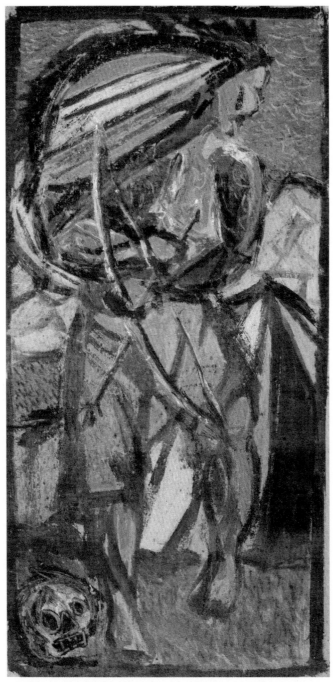

5. Pier Paolo Pasolini, *Nativo Americano*, 1947, 58.2 × 29.5 cm, tempera and pastels on thin brown cardboard, Gabinetto Scientifico Letterario G. P. Vieusseux, Florence. © 2023 Artists Rights Society (ARS), New York / SIAE, Rome.

6. Jean Fautrier, *Untitled*, c. 1954, mixed media, 38 × 61 cm, private collection, © 2023 Artists Rights Society (ARS), New York / SIAE, Rome.

7. Toti Scialoja, *Impronta bianca su sabbia*, 1959, mixed media on canvas, 114 × 167 cm, Solomon R. Guggenheim Foundation, New York. Gift, Fondazione Toti Scialoja. © 2023 Artists Rights Society (ARS), New York / SIAE, Rome.

8. Renato Guttuso, *Natura morta (omaggio a Morandi)*, 1965, tempera on paper, 82 × 82 cm, Private collection, Rome, Photo: Walter Mori, Mondadori Portfolio / Art Resource, NY © 2023 Artists Rights Society (ARS), New York / SIAE, Rome.

9. Pier Paolo Pasolini, *Lamps from the Safon*, 1969, mixed media, 41 x 31 cm.

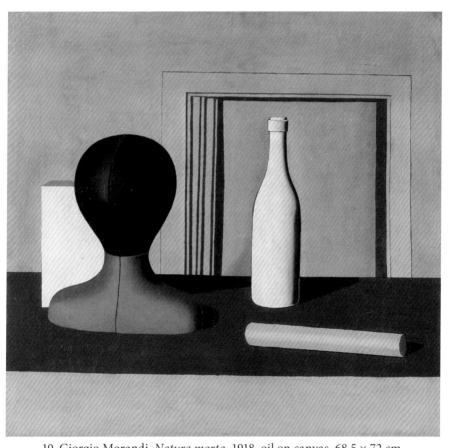

10. Giorgio Morandi, *Natura morta*, 1918, oil on canvas, 68.5 × 72 cm, Pinacoteca di Brera, Milan. Photo: © Pinacoteca di Brera, Milano, © 2023 Artists Rights Society (ARS), New York/SIAE, Rome.

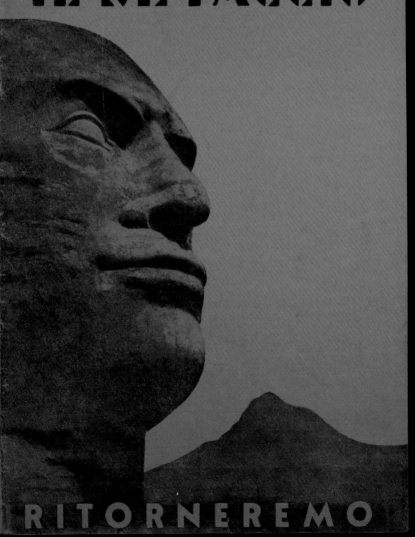

11. Cover of *Il Setaccio*, n. 6/7, May–April 1943.

Poesie friulane

Febbraio

Senza fuéis a era l'aria,
boscàs, vidis, moràrs;
di là da li ciampagnis,
sot i clars mons, paesùs.
Strac di zuià, tai l'erba
in tai dis di ferràr,
co i mi sentavi, frut,
a respirà la sera.
I soi tornàt li Estàs.
E drenti lis ciampagnis,
oh misteri di fuéis.
Quànciu ans son passàs!
Adess, eco Ferràr,
boscùs, vidis, moràrs;
ca, i soi sentàt ta l'erba,
i ans son passàs par nìia.

Senza foglie era l'aria, boschetti, viti, gel-
seti; di là dalle campagne, sotto i chiari
monti, paesetti.
Stanco di giocare, sull'erba — nei giorni di
febbraio — qui io mi sedevo, ragazzo, a re-
spirare la sera.
Sono tornato nelle Estati. E, dentro le cam-
pagne, oh mistero di foglie. Quanti anni sono
passati!
Adesso, ecco Febbraio, boschetti, viti, gel-
seti; qui sono seduto sull'erba, gli anni
sono passati per nulla.

Pier Paolo Pasolini

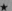

Ti si pogàvis liséra
liséra
cu na spala tal balcòn,
e cu na timpla ti provàvis
a sinti il freid dai veris.
Adess al è tant pòlvar
ulì, tal chel balcòn.
Ma a voltis
i vai dòngia cu la front
e di scundiòn
i provi a sinti
su chei veris il freid
dal me dolòur.

Ti appoggiavi leggera, leggera, con una spal-
la, alla finestra, e con una tempia provavi
a sentire il freddo dei vetri.
Ora c'è tanta polvere, lì su quella finestra.
Ma, qualche volta, vado vicino con la fronte,
e, di nascosto, provo a sentire, su quei vetri,
il freddo del mio dolore.

Riccardo Castellani

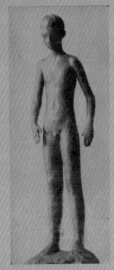

Giovanni Micconi - Piccolo nuotatore

Giorno dei santi

Ta l'aria scura e grisa
a pàssin nùlis tentis, muartis;
a sunìn lune a glons a glons
li ciampànis, sensa fin....
Ma tu, o zòvin, no mai pénsitu
ai siprés che scurs a vuàrdin,
cun che aria di mestizia,
tanta zent che va e no torna?
Pensa un puc a la natura,
a li fuéis che son cualàdis
ai mùtàs che van pai séil,
su chel vial plen di lamens.
Plovisina ta la strada,
un lumin s'impia lontàn;
dùcin insiemit, gràine e pìssui,
préia intòr dai fogolar.

Nell'aria scura e grigia passano nuvole len-
te, morte; suonano lungamente a rintocchi
le campane, senza fine.
Ma tu, o giovane, non pensi mai ai cipressi
che guardano oscuri, con quell'aria di tri-
stezza, tanta gente che va e non torna?
Pensa un poco alla natura, alle foglie che
sono cadute, alle nuvole che vanno pel cielo,
su quel viale pieno di lamenti.
Pioviggina nella strada, un lumino s'accende
lontano; tutti insieme, grandi e piccoli, pre-
gano intorno al focolare.

Cesare Bortotto

12. Interior of *Il Setaccio*, n. 6/7, May–April 1943, p. 19. Pier
Paolo Pasolini, Poesie Friulani, "Febbraio" (February); Giovanni
Micconi, *Piccolo nuotatore* (Young swimmer).

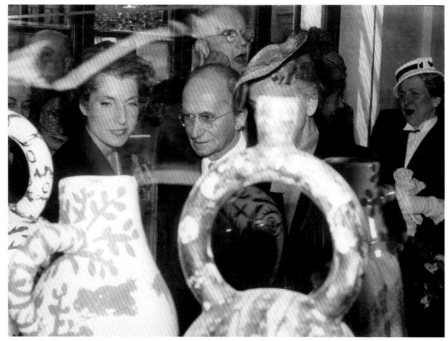

13. Palma Bucarelli and President of the Republic Luigi Einaudi at the inauguration of the Picasso retrospective at Galleria Nazionale d'Arte Moderna in Rome, 1953, photograph, courtesy of the Archivio Bioiconografico at the Galleria Nazionale d'Arte Moderna.

14. Still from *Teorema*, dir. Pier Paolo Pasolini, 1968. Courtesy of Aetos Produzioni Cinematografiche.

15. Still from *Salò*, dir. Pier Paolo Pasolini, 1975; courtesy of
Les Productions Artistes Associés/United Artists.

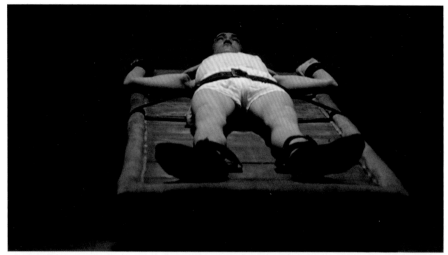

16. Still from *Mamma Roma*, dir. Pier Paolo Pasolini, 1962. Courtesy of Arco Film.

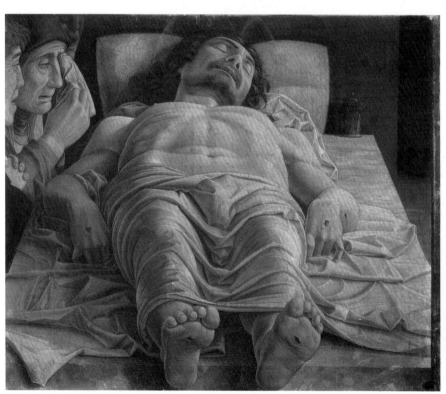

17. Andrea Mantegna, *The Lamentation over the Dead Christ*, 1490. Tempera on canvas. Pinacoteca di Brera, Milan. Image in the public domain.

18. Piero della Francesca, *Constantine's Dream* (detail from the 'la leggenda della Vera Croce' cycle), 1452–66, fresco, 329 × 190 cm, Basilica di San Francesco, Arezzo. Image in the Public Domain.

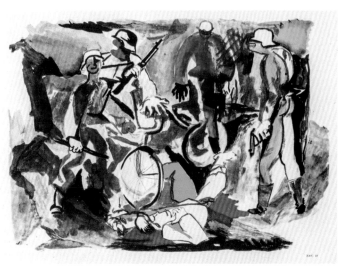

19. Renato Guttuso, plate 18 from *Gott mit uns*, 1945, published in Rome by La Margherita, 1945, from edition n. 599 from a limited edition of 715, © 2023 Artists Rights Society (ARS), New York / SIAE, Rome.

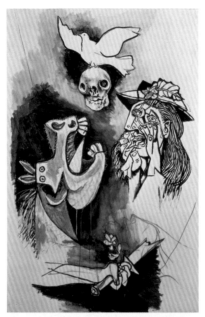

20. Renato Guttuso, *Lamento per Pablo Picasso*, 1973, mixed technique on paper on canvas, 176 × 115 cm, Galleria Nazionale d'Arte Moderna, Rome. © Alinari Archives / Art Resource, NY © 2023 Artists Rights Society (ARS), New York / SIAE, Rome.

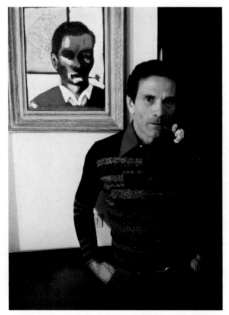

21. Massimo Listri, photograph of Pier Paolo Pasolini before his *Autoritratto col fiore in bocca* (1946–47), Rome, 1973. Courtesy of the artist.

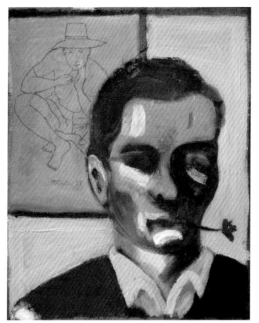

22. Pier Paolo Pasolini, *Autoritratto col fiore in bocca*, 1947, oil on hardboard, 42.5 × 34.5 cm, Gabinetto Scientifico-Letterario G. P. Vieusseux, Florence. © 2023 Artists Rights Society (ARS), New York / SIAE, Rome.

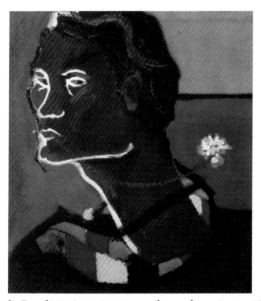

23. Pier Paolo Pasolini, *Autoritratto con la vecchia sciarpa*, 1946, oil on hardboard, 42.8 × 38 cm, Gabinetto Scientifico-Letterario G. P. Vieusseux, Florence. © 2023 Artists Rights Society (ARS), New York / SIAE, Rome.

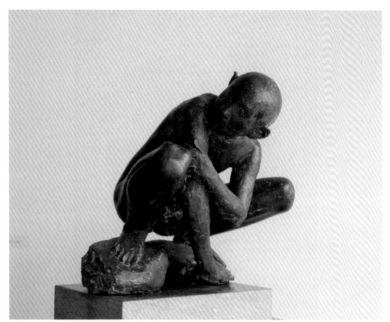

24. Giacomo Manzù, *David*, 1938, bronze sculpture, 48 cm, Tasende Gallery, La Jolla, California. © 2023 Artists Rights Society (ARS), New York / SIAE, Rome.

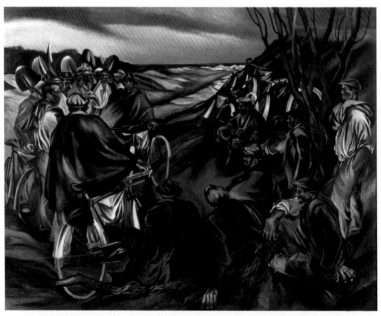

25. Giuseppe Zigaina, *Assemblea di braccianti sul Cormôr*, 1950–52, oil on canvas, 250 × 316 cm, Galleria d'Arte Moderna, Udine. Courtesy Museo di Arte Moderna e Contemporanea di Udine.

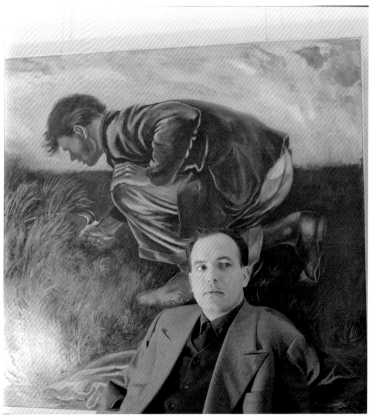

26. Paolo Monti, photograph of Giuseppe Zigaina before his painting, 1982, Fondo Paolo Monti, Civico Archivio Fotografico, Milan.

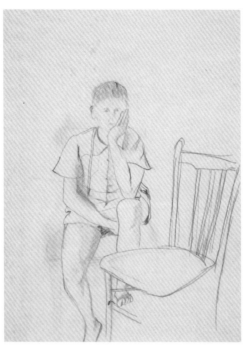

27. Pier Paolo Pasolini, *Boy with a Chair*, 8.18 × 11.61 inches, pencil on paper.

28. Pier Paolo Pasolini, *Sandbanks beneath a Gray Sky*, 1969
or 1970, mixed media, 50 × 70 cm, private collection.

PUNTI DI VISTA

Il mongoloide alla Biennale è il prodotto della sottocultura italiana

di Pier Paolo Pasolini

● I termini della vicenda e dello scandalo sono noti. Gino De Dominicis, un artista anconetano di 25 anni, perennemente vestito di nero, baffi spioventi, fino a ieri anonimo frequentatore dei bar di piazza del Popolo a Roma, espone un mongoloide alla 36ª Biennale. È l'8 giugno e il mongoloide (nella foto, Paolo Rosa, 27 anni) rimane soltanto per pochi minuti nel padiglione italiano, alla mostra "Opera o comportamento". I fotografi, però, hanno in tempo a riprenderlo più volte: con un cartello al collo e senza, vicino al suo "illustratore" e da solo. Poi entrano nella sala alcuni critici e artisti, urlano « Nazista! ». « È una operazione scandalosa che nulla ha a che fare con l'arte », « Bassa sottocultura », « In nessun caso si può usare l'uomo come oggetto ». De Dominicis si affretta a rimandare a casa la sua "opera". Si scatenano polemiche, denunce, lettere. Ancora una volta l'arte moderna viene messa

sotto accusa ed etichettata con ogni sorta di aggettivi; c'è chi vorrebbe darla in blocco alle fiamme. Siccome non si può dare alle fiamme l'opera di De Dominicis, non resta che cercare di capire come si è potuto arrivare all'esposizione di un uomo malato, incapace di intendere e di volere. È proprio su questa domanda che abbiamo voluto richiedere il parere di Pier Paolo Pasolini. Ci pare inutile presentare Pasolini, narratore, poeta, saggista, regista, attore, uomo di idee. I lettori di "Tempo" lo conoscono bene perché sul nostro giornale tenne dal 1969 al 1970 una rubrica di successo che s'intitolava "Il caos".

Roma, giugno

Una dozzina d'anni fa si è avuto nell'Italia letteraria il movimento della neoavanguardia. Era un movimento che reagiva all'"impegno" che era stato di moda durante il decennio precedente: vi reagiva in nome di un nuovo tipo di vita e di rapporto con la società. La miseria non c'era più, ma c'era il benessere; di padrone non c'era più, ma c'era il tecnico, eccetera, eccetera. L'integrazione era fatale, e quindi tanto valeva attuarla con cinismo ed eleganza. La neoavanguardia accettava i valori nuovi, non ancora definiti, del neocapitalismo: ed era a servizio del neocapitalismo che distruggeva — in campo linguistico e letterario — i valori classici del capitalismo classico.

La grande rivoluzione "interna" del capitalismo, iniziata nei primi anni Sessanta — in cui la civiltà borghese si rinnovava, progettando una specie di palingenesi — aveva trovato i suoi servi — al solito sciocchi e teppisti — nei letterati della neoavanguardia. La prima preoccupazione di questi letterati fu quella di destituire di valore — fino al completo discredito — i letterati della generazione precedente, ancora legati sia alla tradizione classica che alla tradizione eterna, o che adempivano ancora, ingenuamente, alla loro funzione di "buffoni di corte" (sia del

potere borghese che dell'opposizione).

Poi venne il '68: la rivolta studentesca travolse e distrusse questa neoavanguardia (anche se essa, col suo cinismo, aderì e si confuse col movimento studentesco). La nuova sinistra, che parve per un momento nascere durante quella rivolta, in campo letterario si presentò come strettamente contenutistica e utilitaristica, ossia contestò senza neanche prenderlo in considerazione o metterlo in discussione — tanto le appariva marginale e frivolo — il "disimpegno" della neoavanguardia: e parve tornare all'idea letteraria precedente dell'"impegno", ma con un radicalismo e i suoi servi — nei letterati della nuova — pari alla grossolanità: tanto da risultare addirittura neo-zdanovistica.

È da questo punto di vista massimalistico, con gli studenti contestarono anche l'"impegno" storico degli anni Cinquanta, come ambiguo, debole, e compromesso sia con il potere che con l'opposizione tradizionalista al potere. Anche per gli studenti del '68, la prima preoccupazione fu quella di destituire di ogni valore, di screditare i rappresentanti della cultura stabilizzata, al di fuori dei valori particolari, personali o specifici. La cultura tradizionalistica (sia di tradizione classica che recente) — fu così, nel breve giro esponenti — fu così, nel breve giro

di una decina d'anni, per ben due volte destituita di valore e screditata. I punti di vista da cui essa veniva criticata "globalmente", fino alla sua sconsacrazione totale, erano diametralmente opposti, ma il risultato era lo stesso.

La neoavanguardia, compiendo una rivoluzione puramente verbale, faceva, come abbiamo detto, il gioco della nuova borghesia, che voleva disfarsi del vecchio ciarpame classicistico, comprese le sue forme nuove (oltretutto "impegnate"). Ma anche gli studenti, senza volerlo, hanno fatto lo stesso gioco: essi cioè non hanno fatto altro che screditare e destituire di valore quello che il potere usa chiamare "culturame".

Ma non è questo il solo punto che accomuna la rivoluzione fatua, puramente letteraria della neoavanguardia e la rivoluzione neomarxista del '68. Ciò che accomuna queste due "rivoluzioni" è anche il linguaggio critico: preso ugualmente nel mondo neoborghese.

Questa identità del linguaggio ideologico ha consentito una specie di amalgama tra la neoavanguardia e il movimento studentesco: ha consentito cioè al neoavanguardia disimpegnati di passare disinvoltamente nelle file degli studenti al contrario così impegnati; e ha consentito agli studenti di usufruire di argomenti già pronti contro il "impegno" dei vecchi. Tale amalgama — del tutto assurdo — tra la neoavanguardia e il movimento studentesco è dovuto, da una parte, al cinismo dei neoavanguardisti (ormai più che nevrosi), e dall'altra all'ignoranza letteraria degli studenti.

Come ha reagito la sottocultura italiana a tutto questo? Ha reagito col solito conformismo e con la solita totale incapacità critica, tipica di ogni sottocultura: ha accettato cioè il ricatto dell'attualità e della cultura.

Dapprima ha quindi accettato la svalutazione della cultura italiana operata in campo puramente letterario dalla neoavanguardia (giustificandola tale svalutazione come un atto storico di revisione dei valori). Poi ha accettato la svalutazione della cultura italiana operata in campo ideologico e politico dal movimento studentesco (soccombendo al terrorismo dell'operazione).

Oggi, quindi, tutto si presenta come "svalutato". E vero che le ragioni della neoavanguardia sono frattanto passate di moda, non sono più attuali; ed è altrettanto vero che sono passate di moda e non sono più

attuali le ragioni del movimento studentesco. Ma la sottocultura italiana ha "cristallizzato la svalutazione", operata per ragioni così diverse dalla neoavanguardia e dal movimento studentesco: e l'ha fatto per ragioni tutte sue, che le sono storicamente pertinenti: ossia il qualunquismo. Ciò che la neoavanguardia prima e poi il movimento studentesco hanno ridotto a zero, si è fissato sullo zero nell'ambito della sottocultura piccolo-borghese italiana, felice di questo. Essa ha fatto suo il facile antitradizionalismo della neoavanguardia e, insieme, il pragmatismo e l'utilitarismo (che le sono così congeniali) del movimento studentesco.

Ogni momento culturale ha una sua idea — magari non descrivibile — dell'opera d'arte. Oggi che tutti i movimenti hanno ridotto a zero, qual è l'idea dell'opera d'arte che è nella testa e nell'escatologia critica della sottocultura italiana? Tale idea è una fusione tra l'idea della neoavanguardia dell'opera d'arte assoluto, letterario fino all'illeggibilità e all'inservibilità) e l'idea del movimento studentesco (di un po' leggibile e scrivibile dei contenutismi): una fusione semplicemente mostruosa.

Questa mostruosità incombe in ogni momento della vita italiana di questi anni. Infatti, anche fuori dalla letteratura tale mostruosità, come fusione — attualissima nella sottocultura — di due punti di vista culturali inconciliabili, si manifesta nella vita di ogni giorno. Si guardi il caso estremo del provocatore, figura inconcepibile fino a qualche anno fa, almeno in modo così numericamente impressionante. Tale figura è resa possibile dal fatto che c'è un punto in comune tra fascista e gauchista, tra qualunquista e marxista: per cui anche fisicamente il provocatore può essere accolto e accettato ovunque, essendo prodotto di una confusione che mescola mostruosamente posizioni diverse. Il caso di De Dominicis è di tipico prodotto di tale confusione mostruosa, assai può essere considerato una metafora. Egli innesta sulla provocazione della neoavanguardia (la "pop art" portata alle estreme conseguenze, eccetera — la provocazione neomarxista dei gruppuscoli, la denuncia velleitaria verbalistica portata ugualmente alle estreme conseguenze. Il ragazzo ai limiti normali che egli ha esposto è il simbolo vivente dell'idea dell'opera d'arte che è in questo momento determinata i giudizi del mondo culturale e politico-culturale) italiano.

PIER PAOLO PASOLINI

30. Pier Paolo Pasolini, *Roberto Longhi*, 1975, charcoal and chalk on paper, 48 × 36 cm, Gabinetto Scientifico-Letterario G. P. Vieusseux, Florence. © 2023 Artists Rights Society (ARS), New York / SIAE, Rome.

31. Pier Paolo Pasolini, untitled, undated (1940s). Oil paint on paper, 11.9 × 9.9 cm. Gabinetto Scientifico Letterario G. P. Vieusseux, Florence.

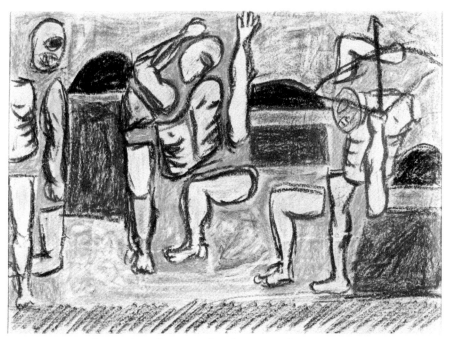

32. Pier Paolo Pasolini, *Figures*, colored wax pastels on paper, 9.84 × 13.77 inches. Gabinetto Scientifico Letterario G. P. Vieusseux, Florence.

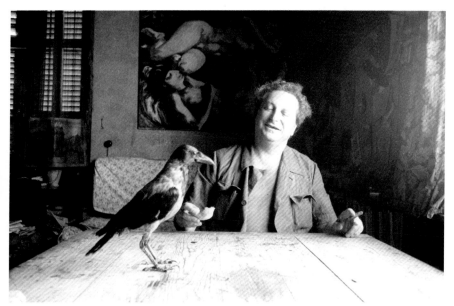

33. Sanford H. Roth, Carlo Levi in his studio, c. 1950, 35 mm photograph, Los Angeles County Museum of Art, Los Angeles. Digital Image © [2023] Museum Associates / LACMA. Licensed by Art Resource, NY.

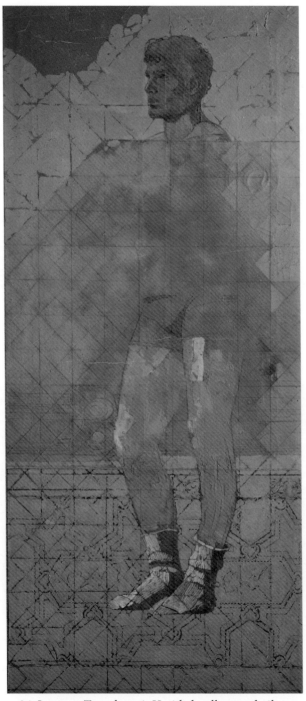

34. Lorenzo Tornabuoni, *Untitled*, collage and oil on canvas, 90 × 200 cm, private collection.

35. Renzo Vespignani, *Untitled ('Milano Metropolitana')*, 1970, ink on paper,
18 × 24 cm, Photograph by Paolo Monti, Fondo Paolo Monti, Civico Archivio
Fotografico, Milan. © 2023 Artists Rights Society (ARS), New York / SIAE, Rome.

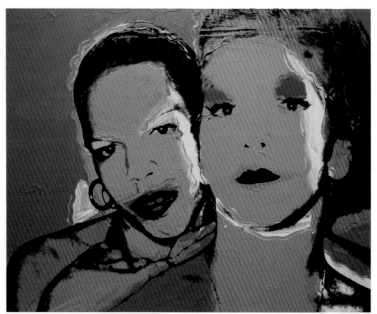

36. Andy Warhol, *Ladies & Gentlemen*, 1975. Synthetic polymer paint and silkscreen ink on canvas, 40 × 50 in. (101.6 × 127 cm). Courtesy of the Andy Warhol Foundation for the Visual Arts, Inc. © 2023 The Andy Warhol Foundation for the Visual Arts, Inc. Licensed by Artists Rights Society (ARS), New York.

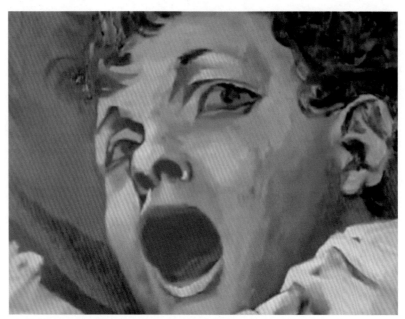

37. Still from *La Rabbia*, dir. Pier Paolo Pasolini, 1963. Courtesy of Istituto Luce, Minerva; still of Renato Guttuso, *Ragazzo che urla con bandiera rossa*, 1953, detail.

of this gypsy, they all become disgraceful
celebrations, angelic choruses of carrion:
proof that shame

can express the modesty
of our aching years, that it can pass down
their anguish, their joy: that one

must be deranged in order to be understood.

*Discussed at length in the introduction to this volume, 'Picasso' is
arguably Pasolini's most ambitious poem on the subject of painting.
It springs from, and centres upon, the large retrospective of the
Spanish master's work in 1953 at Rome's Galleria Nazionale di
Arte Moderna (5 May–5 July, and subsequently Milan's Palazzo
Reale, Figure 13). The retrospective included 200 works from
between 1920 and 1953. It thus excluded Picasso's Post-Impressionist
and early Cubist works (though Pasolini notably finds some glim-
mers of 'the old pre-war spirit'), but included a range of media
from sculpture to ceramics (such as the* Owl *to which Pasolini
alludes). The exhibition formed a crucial event in the attempted
construction of a communist cultural hegemony in postwar Italy,
and in fact came about as an express initiative of the PCI (the
Italian Communist Party). The Party's membership cards from
1953 bore on their cover Picasso's* Dove in Flight *(1950) embla-
zoned with the hammer and sickle. Polls for a general national
election opened on 7 June, just a month after the exhibition's
inauguration.*

*Characteristic in its dissent from party orthodoxy (and from an
'institutional Italy' more broadly), Pasolini's lyrical response belies
his subsequent, unwavering support for Picasso's greatest Italian
champion, the communist painter Renato Guttuso (see Figure 20).
'Picasso' was originally published in* Botteghe Oscure *(1948–60), an
international, multilingual journal edited by the novelist Giorgio
Bassani. It was subsequently included in* The Ashes of Gramsci

(1957) – perhaps Pasolini's most widely and successfully received volume of poems. It is composed, like most texts in that collection, in tercets derived from Dante's terza rima, *the quintessentially epic meter of the* Divine Comedy.

Dialectal Painting (1954)

In a general sense, poetry written in dialect is a phenomenon of the provinces. By 'provinces' I do not mean the strictly jurisdictional sense of the term, since one could apply it even to places such as Rome or Milan – cities which, in their non-traditional and non-dialectal environments, are, if anything, provinces of Europe as much as they are capitals in their own right. This means, in other words, that, in a general sense, poetry written in dialect is a phenomenon of the petite bourgeoisie. In underdeveloped areas – the South or the mountains – the people continue writing *their* poetry, popular poetry, or, to use Mr Menéndez Pidal's preferred term, traditional poetry. In industrial or urban areas, on the other hand, these subjects live entirely within the domain of bourgeois ideology. I am referring to that post-Risorgimento petite bourgeoisie that emerged with a glorious sense of future possibility at the turn of the century, but ended up nationalist or Catholic. Political stakeholders exercise the most diverse interpretations of this social class – from accusations of reactionary turpitude, to exaltations of its moral conformity and sense of frugality. Yet we find no better measure of its culture and moralism than its aesthetic products.

To understand, first of all, what poetry in 'bourgeois' dialect means in comparison with poetry in 'popular' dialect – and in turn what mentalities produced them – readers can turn to these works' respective texts, though many remain unavailable. We find a good enough example of the distinction in the region of the Marche, a representative collection of poetry (Antonio Gianandrea's *Canti popolare marchigiani* from 1875, to which one could add the *Canti popolari di Valdolmo di Sassoferrato*, 1940, edited by Giuseppe Vitaletti) and an equally serviceable collection of dialect poetry (Giovanni Crocioni, *La poesia dialettale marchigiana*, 1934). The latter reduces the popular world to a document of the editor's obsession with folklore, as well as his own conservative moralism. Moreover, it stylistically represents the popular world through the facile and hypocritical technique of pure chromaticism.

Applying this summary geographical model to painting, we may conclude that the Italian Macchiaioli form the exact counterparts of dialect poets. With regard to the pictorial language of that period (nothing other than the language of Impressionism) the Macchiaioli painters are purveyors of a pictorial dialect. Yet they were notably *Tuscan* dialect painters, and thus (at least in the best and most rigorous cases) they were not entirely de-centred from the pictorial language that they mastered belatedly and peripherally – that is, provincially. Indeed, if one were pressed to identify the pictorial equivalent of the Tuscan poetry of Renato Fucini and his imitators, no set of artists would rival the Macchiaioli. Neapolitan painting from the same period possesses its own regional roots; but even that painting emerged in relation to a centralized metropolitan 'language', which we could identify up to a certain moment as Verismo, and subsequently as part of D'Annunzio's Decadentism, with its sensual links to folklore (think of *Le novelle della Pescara* or *La figlia di Jorio*, which reproduces, almost literally, the verses of a popular *Passione* from the Abruzzi region). Comparing [the Neapolitan artist Vincenzo] Gemito with [the Neapolitan poet Ferdinando] Russo, one finds a stylistic convergence whereby Verismo merges with a descriptive

photographic precision – a precision that, precisely in its excess fidelity to objects (simultaneously oozing with local colour) surpasses its own sensorial and empirical limits.

This convergence continues – as is only natural – into the twentieth century. We find a remarkable number of artists, many not bad at all, working at the margins of the centralized painting of Milan–Florence–Rome. They indeed occupy a 'regional' space, meaning that they diverge from 'centralized' painters not simply by virtue of content, but also, to use Benedetto Croce's term, in their tone. Let us take as an example Pio Semeghini. Though extremely close to the 'centre' and undoubtedly 'contemporary', the Veneto region that Semeghini represents is a dialectal one: not solely for the objective content of its figures and landscapes, but also for the tone he uses to represent it (a tonalism drawn, we could say, from a crepuscular Post-Impressionism). Semeghini, in short, could form the pictorial equivalent of the dialect poet Virgilio Giotti from Trieste. Like Semeghini, Giotti received a 'centralized' training in and around the Florentine journal *Solaria*. Yet he remains peripheral precisely for his use of dialect, to the point of elaborating contemporary poetic motifs in a tone no longer contemporary to its own moment. My readers can in turn apply this model to their own chosen subjects, from the Rome of [the painter Franco] Gentilini and [the poet Mario] Dell'Arco, to the Milan of the Expressionists and [the poet Delio] Tessa. They will in the process grasp a phenomenon (the aesthetic value of which may always be queried – and we, as students of Roberto Longhi, indeed seek to query it) constituting one of the most important moments, objectively and quantitatively, of our culture.

Beginning with Pasolini's founding in 1946 of a homespun 'academy' of Friulian language, dialect formed for him as much a kind of cultural activism as a linguistic practice. Alongside his importation of dialect into the 'high' genre of lyric poetry, Pasolini authored numerous texts on dialect and its relationship to style, prosody, the novel, popular poetry, and the work of the Roman dialect poet

Giuseppe Belli. With this short essay, published in the prestigious La
Fiera letteraria *(1925–1977), he identifies a further, pictorial dimen-
sion to dialect, as well as its role in expression, identity, and resis-
tance to conformities social, sexual, regional, and national. Its inter-
disciplinary breadth is evident in the allusion to the Spanish
philologist Ramón Menéndez Pidal, and informed by Pasolini's own
previous translations from other 'minor' romance traditions such as
the Catalan. Especially striking – and telling – are the parallels he
draws between geographic/spatial marginalization and temporal/
historical displacement.*

*Pasolini's own fraught displacement to Rome in 1950 found him
summarily transposing the pastoral (and erotic) origins of his
Friulian interests to the capital's social margins and interstices. The
novels* Ragazzi di Vita *(1955) and* Una vita violenta *(1959) are filled
with Roman dialect, and in between their composition Pasolini
served as consultant on the language of the Roman demimonde for
Fellini's* Nights of Cabiria *(1957). In Italy, Tuscany is the region from
which the linguistic models for prose and poetry were chosen when
Italian language was standardized – a standardization rendered,
under Fascism, coercive and repressive. In the technocratic and
mediatic language of postwar Italy's 'economic miracle' (1958–1963)
and its aftermath, Pasolini would come to identify an even more
insidiously homogenizing use of national language – a 'homologa-
tion' which he countered with various interpretations of localized,
marginalized dialects and idiolects, linguistic and visual. As
discussed in this volume's introduction, his extension of dialect to the
practice of painting informed his own sporadic pictorial efforts, as
well as their numerous reverberations in his subsequent oeuvre.*

From 'My Longing for Wealth' (1955)

. . .

Lonesome to my bones, I too have dreams
that keep me anchored to this world
through which I pass as if I were nothing but an eye . . .
I dream of my home up on the Janiculum,
toward the Villa Pamphili, green up to the sea:
top floor, filled with the ancient
yet always cruelly new sun of Rome;
I would build, on the balcony, a glass window
with dark curtains of weightless cloth:
I would put there, in a corner, a table
custom made, light, with a thousand
drawers, one for each of my manuscripts,
so that I could abide by the ravenous
competing hierarchies of my inspiration . . .
Ah, a little tidiness, a little homeyness,
in my work, in my life . . .
All around I would put chairs and armchairs,
with an antique coffee table and some
old paintings by cruel Mannerists,

with gilded frames pinned against
the abstract beams of the windows . . .
In my bedroom (a simple little
bed, flowers embroidered on the blankets
woven by Calabrian or Sardinian women)
I would hang my collection
of paintings that I still love: next to
my Zigaina I would want a fine Morandi,
a Mafai from 1940, a De Pisis,
a small Rosai, a large Guttuso . . .

These lines are excerpted from the suite of poems, composed between 1955 and 1959, which opens Pasolini's polemical and politically frustrated volume, The Religion of My Time *(1961). Giuseppe Zigaina, Giorgio Morandi, and Renato Guttuso – all key painters for Pasolini (Figures 8, 10 and 25) – are discussed in various texts below. Marked by expressive deformations and an often hallucinatory use of colour, the work of Mario Mafai (1902–1965), a member of the interwar* Scuola Romana, *repeatedly defied the aesthetic imperatives of Mussolini's Fascism. Though the paintings of Ottone Rosai (1895–1957) remained anchored in a solid sense of geometry and commitment to the cultural health of Italy's rural life and landscapes, the scandal of his homosexuality caused him some problems with the regime. Rosai's reputation survived the war intact, and he was honoured in 1956 with a major retrospective at the Venice Biennale. More unabashed in his homosexuality and old-world eccentricity, the painter and poet Filippo De Pisis (1986–1956) remained a touchstone for Pasolini's aesthetics, both in the sentimentalism of his verse and the chromatic sensuality of his (often homoerotic) canvases. 'My Longing for Wealth' is contemporaneous with Pasolini's lyrical, confessional explorations of the Roman borgata and its subcultures, and the poem was subsequently included in his anthology* Poesie (Poems), *published by Garzanti in 1970.*

Zigaina's Painting (1955)

In another place and time (the long gone 1947, 1948), I tried to distil in critical terms the stylistic phenomenon of Zigaina's painting precisely at the moment it began to reveal its dimensions. I also (in *Officina*, July 1955) attempted to write its history in affective terms: a brief poem which, in testament to a shared fondness, bore the title 'I campi del Friuli' [The fields of Friuli]. Today, on the occasion of this exhibition, as a historian of my friend's work, I feel that it is perhaps possible to liberate myself from the restive and almost disquieting urgency of analysis, whether affective or stylistic. Not that his most recent canvases suggest a complete maturation and hence the conclusion of a decade-long cycle of work. Indeed, the passion, the violence, and the ingenuousness of the young Zigaina have remained intact. Yet it is precisely in light of these qualities that it is possible now to regard his painting not as some astonishing phenomenon but instead as an almost absolute morphology. The art historian could perhaps replace the critic by now. In establishing a normative trajectory of his painting, a 'law' of its progression, it is enough to juxtapose a canvas from 1947 with a more recent one: the ideological and thus formal evolution is immediately apparent, and it is not difficult to develop a critical

history. Even so, something in both paintings appears identical: as opposed to difference, this affinity – belonging to nature rather than to history – requires for its apperception a reserve of ineffability and a consequent, irrational act of sympathy.

Remaining within a terminology proper to the technical domain, we could say that Zigaina's language is of a kind habitually deemed 'detailist'. Midway between the influence of a decadent-expressionist tendency and the influence of a progressive-realist tendency, this language leaves its own forms of 'detailism' (conservative by definition) open to contaminations and innovations which have wreaked havoc on its purity. In fact, all of Zigaina's painting lives under the sign of contamination: a pastiche not ironic but in fact tremendously earnest. In no painting besides his own are such diverse and contrary elements so open to analysis, suggestions so unresolved, objectives so quixotic. The influence exerted on him by the two principal pictorial tendencies (along with the more implicit influence of certain historical periods, dormant except by way of deformed resurrections) simply and practically enrich his painting in terms of its magnitude, its lexical and morphological breadth. For the 'tone' of his detailism reabsorbs everything. This detailism presents itself essentially as a 'naturalist' strain of realism – a notably pre-ideological and ingenuous realism. If it has since determinedly adjusted – by means of a series of 'facultative differences' stemming from a heteronymous choice vis-à-vis painting – to an ideological (and in this case, political) realism, then so much the better. This naturalism is in any event just a component of Zigaina's style. For, in it, we find an implicit pastiche – the sumptuous, potent *contaminatio* of an exceptional twentieth-century Mannerist.

Yet here, outside of history and culture, placed before a 'natural' psychological phenomenon, before the irreducible *individuum* from whence Zigaina's 'tone' issues, we must declare our impotence if not our agnosticism. To speak in Longhi's terms, it is here that art criticism must transform itself into an artistic transcription, recreating the stupendous series of dawns and dusks, of

summers and winters through which Zigaina's Friulian world emerges, in an almost too stressed expressivity, full of trees, river banks, irrigation channels, and smooth valleys of reclaimed land devoured by the distant sea, populated by day labourers whose silence – thick as the sodden and clumpy countryside in the summer sun – resounds with the force of the loudest clamour.

But, to remain for a moment more before the exterior and schematic effects of Zigaina's inventiveness, we must conclude by describing its fate. The way that Zigaina relates to the viewer of his works belongs precisely to the irreducible acts of his prehistory: traced along a line of expansion, instinctual before it is moral. In his language, expressive elements always win out over instrumental, technical, and even artistic ones. Zigaina engages whoever looks at his canvas with the same expressive felicity with which he made it – makes the viewer party to its always jubilant and sensual inspiration. And thus, if an ingenuous impressionism remains implicit in his ingenuous realism – as a kind of violence, an intimate enthusiasm – it serves merely to demonstrate and communicate his love.

This is the last full extant text that Pasolini wrote about Zigaina's work (Figure 25). Related to a core of works exhibited in Milan, it most likely represents preparatory material for an unrealized catalogue essay. Rather than describing Zigaina's painting, Pasolini's poem 'I campi del Friuli' is a lyrical memory of the author's adolescence in Casarsa. Published in 1955 in the journal Officina, *it conjures up the natural and human landscape of the province with an elegiac tone. It was eventually collected in* The Ashes of Gramsci *along with 'Picasso'. The Latin contaminatio is used by modern literary scholars and classicists to describe the incorporation of elements of one play into another by the Roman playwrights Terence and Plautus. Pasolini used the word's modern iteration, 'contamination', to describe some of his most salient aesthetic tendencies: a penchant for pastiche; a leavening of modern content by disparate temporal, historical, and mythical allusions; in short, a relentless*

intertextuality, aimed in great part at opposing what he perceived as the homogenizing and levelling culture of neocapitalism. As is so often the case with Pasolini's art criticism, his description of Zigaina's work reflects most immediately on his own.

Toti Scialoja (1955)

Scialoja started painting around 1939. In Italy – still on the periphery of the grand European bourgeoisie's cultural production – the age was characterized by a fringe, anti-fascist avant-garde. There is no need to describe the figuration of this early Scialoja, remembered now as the most refined yet most turgid, the most cultivated yet endemic style of that period – in his case, a 'Roman' period. It is almost as if the expressionism that Scialoja adopted (not a 'historical' Expressionism, but rather a psychological and categorial one) needed to be both contrasted and completed by an exquisite tonalism. The result was an entangled and violent painting, whose sensuality was fiercely corrected by Scialoja's critical conscience. That conscience, in turn, was corrected by his psychological tendency to give and reveal himself, desperately – almost indecently.

Both these elements must still be taken into consideration in understanding Scialoja's new work: whether the critical and cultural component (expressed in a technical phenomenology that recalls Giorgio Morandi), or the ahistorical and pre-human one, animated by a pure and blind sensual violence.

After the war, Scialoja continued his research, which was clearly determined by the cultural world in which he was educated – a

world rich in opportunities, a Roman and Italian world that was also, however, a bit corrupted by cosmopolitanism, to use the term as Gramsci meant it. With some quite remarkable results under his belt, Scialoja has returned recently to the archetypes of that cultural world which he accepted and absorbed as a young man. He has done so by way of stringently artisanal means, stemming from a lucid need for renewal. The world to which he has returned, specifically, is a post-Cubist one, understood as a school – or, better yet, as a stylistic institution and contemporary tradition. With discipline and rigour he tamed his expressionist nature, in the process intensifying it rather than contradicting it. From this tension over the summer of 1954 arose the series of paintings which anchored the important exhibition held last fall at Milan's Galleria del Milione.

Scialoja applied post-Cubism to an expressive force that, by virtue of its excessive nature, tends to burn its content, or to deform and violate it, morphing into sheer energy and pure expressivity. Once he had reassimilated the most absolute and paradigmatic stylistic tropes of post-Cubism, the passage to abstraction became necessary and inevitable.

Yet what a unique and incomparable phenomenon is Scialoja's abstraction [Figure 7]! It is absolutely devoid of detachment and mathematical austerity (Mondrian's line); absolutely devoid of surrealistic and calligraphic grace (Klee's line); and absolutely free of the vulgar decorative geometries and colours that have, with a few exceptions, characterized Italy's abstract experiments these past ten years.

For Scialoja, pure pictorial form, the invention of space, is at its heart irrational. It is the expressive act crystallized, by consciousness, in an originary, informal stage. It subverts the logical nexuses of regular grammar through the use of another delirious and refined grammar, provided by that same consciousness. Think of Dylan Thomas, for instance (and it is not by chance that I invoke a poet as an example): his linguistic process is similar. In front of his canvas, Scialoja stands as if looking at a blank page on which he

has to capture some projection: an emanation (to use almost magical language) from his soul which, in that particular moment, proves the most expressible precisely because it is the darkest.

Situating historically the development I have roughly described here, one may conclude without a doubt that Scialoja's work currently figures at the very forefront of the stylistic institution of European painting. I am of course setting to one side the revolution which – stemming from philosophical and social premises rather than ontologically artistic ones – intends to dismantle that institution in its entirety. Scialoja's work exists beyond post-Cubism, Surrealism, or even abstraction, in a sort of no-man's land, where the artist – burdened by social and stylistic relations – finds himself completely alone, like an explorer filled with inebriation and anxiety.

Pasolini's fraught arrival in Rome in 1950 found him initially destitute, disoriented, and often disconsolate. The friendship of fellow poet and painter Toti Scialoja went some way in lessening that pain. Pasolini had attempted to review Scialoja's debut book of poetry, I segni della corda, *in 1953; his essay, however, was never published, and only appeared posthumously. In painting, meanwhile, Scialoja was in 1955 passing from a vaguely expressionist figuration to an informalist mode of painting. This introductory essay for his exhibition in Parma represents at once a friendly tribute and an ideological reproach by Pasolini. The latter had followed his friend's pictorial evolution through various previous exhibitions, including the one mentioned at Milan's Galleria del Milione – a prestigious venue where the Italian public encountered some of the first local exhibitions of artists like Kandinsky, Albers, and Léger between the world wars. Pasolini's text invites Scialoja to reject what Pasolini saw as an insidious aesthetic tendency: the abandonment of figuration (and its relationship to history) in favour of nonobjective tendencies influenced by American abstraction (and contemporary neocapitalist culture). The essay remains one of the most significant texts about the painting of Scialoja, who played a key role in the trajectory of*

Italian pictorial abstraction and nonsense poetry. As a teacher, Scialoja helped to train an entire generation of young artists in Rome, many of whom – like Jannis Kounellis and Pino Pascali – would go on to great success in their own right. The relationship between Scialoja and Pasolini, while initially warm and intimate, never recovered from their irreconcilable positions regarding abstraction.

Fabio Mauri (1955)

We find here a case which, though devoid still of stylistic history, may be defined entirely by its immediate violence. Indeed, for such psychological and expressive violence, the culture in which Mauri works at once co-opts him into its institutions and also rejects him. Mauri's stylistic tropes typically bear out the 'contamination' of Expressionist and Fauvist techniques, a contamination almost anterior to the artist's own intentions. We find on the one hand a 'turbid' and sensual violence, and on the other a 'pure', mental violence (to see it, one should look at the colours, applied *ad impasto*, in line with the Expressionist technique, and as pure form, according to the Fauvist). To this we add the further phenomenon of 'contamination': a formalism, in this case, of a chiefly chromatic kind, with figurative content that is satirical and surreal. But this stylistic average, so easily identifiable, is almost saturated with, if not transcended by, a quality that one might vaguely define as inspiration or talent, but which is actually something more complex and less graceful. Mauri's painting is in fact revolting in some ways. That stems from the insertion of his formal (one might say almost grammatical, but never merely aesthetisizing) research into an internal, torturous life which evolves as if on another plane

from the painting. And it is presented as more profound, more robust, than the kind of experimentalism we might expect from this painter. In fact, Mauri is not, by definition, an experimentalist; if he appears so here, it is by virtue of a kind of anticipation or, in any case, a diachrony, of potential expression, encapsulated and implicated in these singular works, yet already, for those who can feel it, overflowing.

A friend of Pasolini's since their student days in Bologna, Mauri co-founded with him the short-lived but significant art and literary journal Il Setaccio *(1942–43), to which both contributed essays and drawings alike. With this short text, Pasolini helped inaugurate Mauri's first solo exhibition at Rome's Galleria L'Aureliana, featuring stylistic experiments (expressivity, impasto, caricature) which the artist would soon abandon. Beginning with a series of proto-Pop assemblages and screen-like monochromes, Mauri quickly established himself as one of Italy's leading neo-avant-garde artists, going on to work in media from installations to performance. Though their aesthetic penchants diverged significantly, Mauri and Pasolini shared certain ideological sympathies and remained close. Not long before Pasolini's death, Mauri would involve him in his work literally and physically; staged at Bologna's modern art museum, Mauri's* Intellettuale *(1975) entailed the projection of Pasolini's film* The Gospel According to St. Matthew *onto the seated torso of its director.*

Renzo Vespignani (1956)

A series of paintings, each the same as the last yet never repeated; this is to say that an obsession presides over Vespignani's expressive process, and thus its evolution must be studied in its most infinitesimal changes and variations. The modern paradigm for such an undertaking is easily identified. Strange though the invocation of [Giorgio] Morandi's name may seem alongside that of Vespignani, he perhaps offers an illuminating comparison, helping to place the latter in his proper historical light. Vespignani is a painter who nourishes his artistic obsession on the historical (or as one says these days, the real) world [Figure 35]. Indeed, what made Morandi's work communicable was his almost maniacal (and therefore patient) transposition of the ineffable – by definition irrational – into communicable expression: still irrational in the mind's eye, but rational to the point of exquisiteness on the aesthetic level [Figure 10].

Something of this pattern applies to Vespignani's process. He too is haunted by a 'poetic' spectre which holds him in thrall. He thus tends to remain true to himself, unmoved even by the churn of an internal history. His creative act tends to translate this spectre into visual terms through a process of approximation, which up

to a point remains unchanged, until it gives way to variations at once minimal and significant.

This helps to define Vespignani's place – a representative one – in the history of contemporary Italian painting. His work relates not only to other exceptional young painters, like Zigaina, but also other young writers and poets. The phenomenon consists of two opposing yet concomitant approaches: one (mostly unconscious) based on a conformity to the latest traditions of decadence and exquisiteness, and the other (intentional) based on research, or, in this case, political engagement. This means that the aforementioned ineffable inner spectre takes the shape of an historical, material, or social phenomenon.

Vespignani's novelty lies in a desire to materialize the precise object of inspiration *before* a rationalizing aesthetic act takes hold. In Vespignani's case, the object is an intuited, unrelated, and obsessive vision of the city's peripheries. Before passing to the act of painting it, of reproducing it by way of some particular manifestation (a view of river docks, gasworks, a bus terminal in the *borgata*, a working-class housing estate), Vespignani attempts to interpret it historically, to distil into visual concretions a question of modern life, modern habits, sociological subjects. Vespignani's pictorial daemon thus coincides with his ideological passion. Yet, in light of his particular expressive medium, he cannot help but limit himself to the terms – however passionate and abidingly irrational – of condemnation.

The more plastically violent and precise Vespignani proves, then, the more he is a painter, and in turn a man of politics. All of this necessarily reveals an inner contradiction, a kind of wound. For a writer it would seem easier, at least outwardly, to reconcile the two strains of rationalization: stylistic and ideological. With the working class as his object, even an object of pure witnessing or indignant description, the writer will always have recourse to *mimesis* by which to revive his own life, to make the world speak through his language. The painter – Vespignani – holds this world before him in its exterior contours: the places where the

proletarian labours, suffers, clings to his desperate joys, his terrible squalor, his bottomless sorrows. To represent this world necessarily means to engage with stylistic contamination.

Though the innumerable details of working-class reality may find organization and unity in a clear ideological vision, organization, and unity – both technical and expressive, remain in debt to stylistic education, an education still in diachronic and contradictory relationship to that ideology.

This is not Vespignani's only dilemma. In these hostile circumstances, which tend to erode the artist's freedom to the point of reducing it to a bare minimum, it is clear that his research has to be taken to its extreme: to the point of an excavation, a violent passion that turns into a refined precision. This is what Vespignani does. The visitor to the exhibition can see for himself just how many times the painter attains the miracle of the perfect painting.

This catalogue essay helped inaugurate an exhibition of Renzo Vespignani's (1924–2001) work, held at the Galleria L'Obelisco in Rome. A child of the Roman borgata *of Portonaccio, Vespignani anchored his spindly drawings, prints, and paintings in the same kind of metropolitan margins to which Pasolini was drawn, in relentlessly figurative images of urban peripheries and working-class bodies. Beginning with his depictions of the Nazi occupation of Rome – and its liberation by partisan groups to which he contributed – Vespignani frequented circles affiliated with the neorealist movement in Rome, helping found a journal dedicated to social problems titled* Città Aperta *(in plain allusion to Roberto Rossellini's film by the same name). Like Pasolini, Vespignani resisted the aesthetic tendencies of many contemporaries, practising his strain of socially engaged neorealism well into his last decades. A key term which recurs in this and other texts by Pasolini is* 'popolare': *an adjective deriving from the same Latin root as* 'popolo' *and* 'people'. *Though the literal English translation of this word would be* 'popular', 'popolare' *is in fact quite the opposite of*

'popular' in Marxist and aesthetic terms. That is, it does not conjure up fame, notoriety, or diffusion; 'popolare' means here 'folkloric', typical of the working and peasant classes, related to the masses and to poverty; of 'the common people'.

'Piero's Frescoes in Arezzo' (1957)

He walks a few steps, raising his chin,
but almost as if a hand were pressing
down on his head. And in that ingenuous,
strenuous gesture, he remains still, welcomed
among these walls, into this light,
whose purity he fears he has spoiled
with an unworthy presence . . .
Under the crumbling base he turns,
with his minute skull, his shaven
worker's jaws. And toward the blazing
vaults, over the penumbra from which he is flushed
he casts suspicious glances
like a stirring animal: then for a moment, humiliated
in his audacity, he turns his warm eyes
our way, and then upward again . . . The sun,
so pure, burns along the vaults
from an invisible horizon . . .
Breaths of flame, from the West windowpane,
colour the wall that those eyes
dart over fearfully, among those

who own it, and do not kneel
inside the church, do not bow their heads: yet,
in the spurting light of day, it is so pious his admiration
for the figures breathed into the space
by another light.

Those demon arms, those dark
backs, that chaos of green soldiers
and violet horses, and that pure
light that covers everything
in the hue of fine dust: an onslaught,
a slaughter. The humbled gaze distinguishes
bridle from sash, mane from forelock;
the light blue arm that rises to
slit throats from the brown one that bends
to take cover, one horse stubbornly recoiling
from another that kicks on its back
into a mass of bodies bled dry.

But from there already the eye falls,
astray, elsewhere . . . Adrift, it stops
on the wall where, suspended
like two worlds, it discovers two bodies . . . one
in front of the other, in an oriental
penumbra . . . A dark-haired youth,
lanky in his massive clothes, and she,
she, the innocent mother, the unfledged matron,
Mary. Those humble eyes recognize her
immediately: but, docile in their meekness,
they do not brighten. And it is not the sunset
flaring up over the sleepy hills
of Arezzo that veils those eyes . . . It is a light
– oh, certainly no less gentle
than the other, but supreme – from a sun

sheltering in the spot where Man
used to be divine, shining over this humble hour of prayer.

Shining lower,
over the hour of the first sleep, of the
unripe and starless night that encircles Constantine,
emanating from the earth
whose warmth is a magical silence.
The wind pacified, but some
of its wafts drift lifeless,
among inert hazelnut bushes.
Perhaps, with a heartless vehemence,
gusts of insects' blessed wheezing
hiss over the open pavilion
among sleepless voices, perhaps, and some tentative
strums of guitar . . .
But here, inside the raised milky curtain,
at its apex, in an unadorned interior,
there is nothing but the darkened colour
of sleep: in his bunk, the emperor sleeps
like the white hump of a hill,
and the divine calm is terrified
by the calm shape of this dreamer.

. . .

*Like 'My Longing for Wealth', Pasolini's ekphrastic poem on Piero
della Francesca's frescoes in the Basilica di San Francesco of Arezzo
(Figure 18) forms part of the opening section of* The Religion of My
Time *(1961). Mixing free verse with carefully structured rhythm, the
poem centres upon a fifteenth-century cycle of paintings culminating
in the dream of the Roman emperor Constantine: the primal scene of
Western Christianity. The other scenes included in the Arezzo cycle
represent the so called 'stories of the True Cross': a series of events
and battles from the Biblical origins of humanity up to the seventh*

century CE. Though Piero worked on most of the frescos, they were initiated by a different, unidentified master. Pasolini's professor at the Università di Bologna, Roberto Longhi, played a key historiographical role in situating these frescoes among the most foundational works of the Italian Renaissance. In his seminal essays of the 1910s, Longhi also compared Piero's paintings to the work of modernists like Cézanne and Seurat.

Two Poems for Federico De Rocco

Your Colour (1959)
Your colour: the dream of a pure
and exquisite people, a pre-existent tone
which you spread to
the magical corners of your nature
the margins of a mute and ardent province

mutely and ardently you spread it – through stubborn choice
or modest honesty? – there, where
language is by now dialect, and dialect
falls silent among alder trees and ruins,

age-old canals and sun-drenched farmsteads.
Grace is surrender, labour is humility,
the absolute is an intense vibration of backcloths
behind the fresh images of an ancient life.

Clamour (1963)
'Rico, on the train,
during one of my trips,

in the iron clamour of a life
closed in a stupendous perpetuity, iron within iron
through tracks that hold up the world,

on the train,
in the iron structure of a meagre clamour,
you reappear to me, futureless,
and you are:
the wrought iron body of a dying figure
in the crazy incandescence of a square in San Vito.

Painting and youth!
Shared expanses of life in that past
of ours, rusty masses piling up
in the wonderful summers!

Alone, under the ferrous
fig trees, the hard tendrils of grapevine,
dying figures

in the mad sun of San Vito . . .
And now alone, I on this train,
you . . . Oh, painting and youth!
Nothing can restore you

but the great structure of life
which spreads all over the world, and especially
where you have been, in the shy clamour
of the workers' train from Udine to Venice,
striking
your iron: a filial stubbornness
to do good,
a wonderful obtuseness of love,
heart of a real man.

A local artist who participated in the foundation of Pasolini's academy of Friulian language in Casarsa, and also painted his portrait, De Rocco (1918–1962) met Pasolini during the Second World War. They remained close friends until the former's untimely death. Having completed a thesis at Venice's Accademia di Belle Arti on the Friulian Renaissance painter, Andrea Bellunello, De Rocco went on to lecture at the same institution, as well as to teach mural decoration for Venice's Istituto Statale d'Arte 'Carmini'. Though some of his compositions incorporate some modernist flourishes, De Rocco was a conservative painter and engraver of provincial landscapes and village scenes from his native Friuli – the kind of imagery to which Pasolini remained devoted despite his own experimental penchants in painting and other media. Pasolini wrote the first of these two poems for one of De Rocco's exhibitions, while 'Clamour' represents a eulogy penned soon after his passing.

Renato Guttuso: 20 Drawings (1962)

Dear Guttuso,

> after the wonderful digest
> for pure intellects
> that Moravia dictated (*non errare humanum est!*),
> after that wonderful contribution from the West,
> it is hard to reprise one from the East.

This is why I feel like writing to you through the verses of newspaper ads, which have become (maybe by the hand of your contemporary, [Leonardo] Sinisgalli) the specialty of neocapitalism.

Lucky you! Every time you raise a pencil or a brush, you always write in verse.

A painter is a poet who is never forced by circumstance to write in prose . . .

This is where you become a brother to me: in the desperate commitment always to be doing poetry, in every single discourse, even if you have to leave it unfinished, chaotic, inchoate – when prose, through its textual completeness, would serve to smooth everything out.

I look at your resting workers from 1945.

One of them, near the centre of the picture with his arms crossed, leans on his left knee with his left forearm. He has just finished his loaf of bread, stuffed with vegetables or eggs. He stays there, among the others, not even very sleepy or spent by his work, by his labour or his meagre wages. No, he spends an hour, maybe a day, oblivious in a rapport of pure habit with the things and the facts of his wretched life. His lips and nostrils are wide in that Sicilian way, and he is filled with sensuality and physical strength. He is not tormented by the drowsiness that comes after eating, especially under the midday sun. He's fine. But he doesn't even think of talking. Maybe the sip of bad wine he took goes to his head with a light bliss, fading into silence and into the quiet contemplation of his comrades nearby.

While the whole 'description' of this image, complete with psychological and vaguely sociological terminology, is prose, what makes it poetry is your compassion and love (or friendly irony, or brotherly sympathy) for a miserable fate, utter humility.

The face of this worker of yours has no left side: no eyelashes or eyebrows, no eyelid or eye, no cheek or cheekbone. Only an outline for the face, curling slightly into the hint of an ear under an old hat, pulled down on the forehead a bit.

Something terrible has erased the left side of this man's face, leaving it blank and white.

This is not the only example of monstrous incompleteness in the drawing. The right side of the body of the same worker (his whole flank, under the elbow) is also a swollen white area that was either erased or never even conceived.

White areas, contained by thin outlines, are arbitrarily scattered throughout the drawing. One nevertheless senses a certain diabolical symmetry: the back of the worker that reads *l'Unità* laying on his belly, in the foreground; the torso of the worker that, in an innocent but furious sleep, lies down on the short wall he has just built; the torso again, though covered by an almost finished arm, of the last worker on the left, also asleep.

And then there are other areas, almost white: the two legs of the
worker biting a loaf of bread with his skeleton's teeth, sitting almost
at the centre with his back against the wall. Those legs: where just
a trickle of ink draws the outlines and the folds of the fabric, almost
as if the frolicking of lines and folds (so furious, chaotic, and
inspired elsewhere in the drawing) were arbitrarily halted there.
As if a moment of regret made the tip of the pencil or pen caress
the paper with a whimsical, distracted lightness, instead of carving
into it and tearing it as in the rest of the drawing.

> The figures of ten workers
> emerge, white against white bricks:
> it is midday in Summer.
> But the chastened bodies
> cast a shadow: and the ruffled order
> of the white areas is faithfully followed
> by the black ones. It is a midday of peace.

But some of these black areas are clean: behind the ladder for
instance, or in the empty space of the internal staircase, or on the
cobbled alley. Others are dirty: under the legs of the last sleeping
worker on the right, on the wall behind the bucket, over the body
of the main sleeping figure. Some are generated by a dense and
orderly hatching, others by scribbles and clumsy stains.

> A few of the faces are human: where
> did you see them? The boy with the mess tin,
> wearing a headscarf,
> is of course the Beddamadre:
> a son of maternal Sicilians who,
> with ten more sons,
> crowd a slum in Casilino.
> The one next to him, the one
> with his big Algerian nose
> who tries, with his tightly crossed arms,

to force himself to sleep, is also a poor saint
recently emigrated and ready
to live a humble life as a citizen
with his band of comrades.

The figure of the worker who reads *l'Unità* is also a portrait, with
his pointy nose and tired cheeks under a tight flat cap. And so is
that of the worker who sleeps atop the brick wall, his arms tucked
under his head.

But . . . along with these figures from the Garden of
Gethsemane,
in accordance with the realistic iconography of humble sleep,
there are three ugly mugs
from Buchenwald.
It was nineteen forty-five: the skeletons were still alive.

People with skull-teeth
sticking out of fleshless gums,
holes in their lab-rat cheekbones,
walked among us. It was an experience
whose innocence is a lost seed,
the experience of heroic children:
I wonder how we managed
to remain so pure, to be so
brotherly . . . The hearts of poets were like
those of doctors unafraid of contagion
who go among the sick
with an almost happy presentiment of death.
Nothing was ever more full of dignity
than that shared horror.
And millions of those who were marked
by destiny, the sick who were supposed to stay there,
were still among us: their gaze,
filled with a strange light,

could not see beyond those years.
Here they are, now, in your drawing, three
of those predestined, who stayed
here, in the world that fell to us,
they stayed by mistake:
the mistake of compassion
which is the memory of heroic poets.

Even in chaos, a law of symmetry: it is in the name of that law that you have paid, these past fifteen or twenty years, your debt to the obligations of poetry. Your expressionism is just a tool to protect this absolute and stubborn expressive virginity of yours. Your expressionism is . . . using a pen that some schoolboy would use, or a pencil that streaks too grey, scrapes too much on the ugly and cheap yellowish paper; the kind of cheap pencil that frustrates unimaginative children doodling at school. Let's add to this the intentional heaviness and ineptitude of your hand, the raging violence of figures and portraits – which, in the newly discovered force of its immediate effects, and in the pre-cultural naiveté that it intends to convey, is almost offensive.

As you know, all of your drawings show the signs of a genuine and yet insincere contraction; a scream that is both authentic and out of tune.

It is with these apparently inadequate tools that you rebuild 'poetry', that cursed poetry to which we are destined, because of our century's irrationality, as in a sort of evasion – an evasion that might at least remain faithful to aesthetic sincerity . . .

Look back at the scratchy, greenish, and yellowy mush under the throat of the horse stretching its neck in the first study for Crucifixion, in 1940. And also:

1944: from one of the etchings of *Gott mit uns*, the figure shot in the back of the head (one can't tell whether he is facing backwards or forwards);

1948: the insolent clumsiness of the sophisticated neo-Cubist geometric decorations in your *Sewers*;

1950: in *Piazza Navona*, the coarseness of the two massive figures, especially the one with no coat in the foreground, sketched like a footless puppet with a couple of dirty brushstrokes;

1955: in *On the Lake at Lugano*, the dirty area (in the merely technical sense of the word, almost as if you accidentally smudged the blue and the sepia of the drawing with your finger) around the breasts of the girl on the boat;

1957: your painting *Political Discussion*, so refined in its colours, flawless, lacking any coarse or unfortunate sign, but filled with unfinished white areas that are perfectly, gratuitously left to the virginal state of the paper . . .

And that's enough; it would be too easy to continue this list.

That is the price you pay to the historical age you hate and condemn: this fury of yours against any logical completeness, this stubborn will to remain an inexperienced boy, always inspired, pre-cultural, pre-grammatical: the exclusively aesthetic utility of your language (even your elimination of anything that is not functional, like the areas you leave white, still amounts to an aesthetic act; you can't deny it!); this change of register between a caricatural essayism (*The Hundred Thousand Martyrs*) and lyrical prose (*The Prickly Pears*) alongside your compulsive poetry.

By definition, you are the object of a 'healthy' kind of love here. You might on the other hand become the obsession of a heartless philologist dedicated to compiling a history of your intentions, of the 'exchanges' between realism and aestheticism.

For instance, *The Prickly Pears*: an ingenious aesthetic solution because of the close-up from which the prickly pears are framed, isolating them from the context of the landscape and almost turning them into a simple arabesque, a formal abstraction. This cascade of prickly pears that, as if infinite, fills the entire painting, is executed with the same heavy, inelegant, functional, almost unpleasant wrist movements that are typical of a realistic sketch.

On the other hand, *Political Discussion*, which *is* a realistic sketch, is executed with an extreme sophistication of lines, typical of the best draughtsmen from De Pisis to Manzù. In addition,

since it is a coloured drawing, there are some coloristic flourishes executed with the nonchalant bravura of a skilled master, bathing in sensual delights.

Another series of textual comparisons within your stylistic history could revolve around 'voids'.

Take *The Figure* (1962): an intensely drawn face and, under it, a torso with two breasts barely traced by an uninterrupted line (the work of a great drawer). Yet, half of the face, barely defined by the usual outline, is a void.

Expressivity and expressionlessness sit side by side in this bourgeois woman's face. However, expressivity (which is to say a faith in reality, and therefore in figuration) is, as it often is, expressionistic here, and also slightly academic. Is this what you counterpose to the 'white' of the other half of the face, unexpressed in the totality of its abstraction: that absolute void that represents the aspiration and the (mystic) foundation of aestheticism?

Of course not. Deep inside, underneath this study of a *Figure*, beyond its historical stylistic features, there is the shadow, the spectre of an ineffable fact: your individual stylistic cipher. By choice and by nature, you are destined to be yourself.

I challenge anyone to demonstrate that this half-expressionist and half-unexpressed *Figure* is not yours. With the slight 'unpleasantness' that Moravia describes so well in his essay, this whole figure is proof of an unshakable faith: faith in the ultimate meaning that an expressive-unexpressive sign, in its criss-crossed webs, cannot suggest.

Any genuine suggestion of yours, any profound allusion, always bears upon reality.

Let's look again at *Resting Workers* (1945) in the light of this allusion. In the descriptions ventured so far, I have not considered that this drawing might be thought of as a coloured drawing. Among the outlines and the white areas that I mentioned, between the bodies in the light and their shadows, in the tormented black and white matter, we find some red.

The law of fantastic arbitrariness rules the disposition of these three or four red stains, which flow beneath the drawing and

occasionally surface with the typical disorder of natural phenomena. Red blazes in the shirt of the worker who:

> with his Algerian big nose
> who tries, with his tightly crossed arms,
> to force himself to sleep, is also a poor saint
> recently emigrated and ready
> to live a humble life as a citizen
> with his band of comrades.

It is one of those shirts one can buy for a thousand lire at the Upim department store or the flea market at Porta Portese. The red of youthful exuberance. It fits him with a careless grace as he pretends to steal a blissful nap, though he's too young and restless actually to sleep under the sun at that hour.

Then, that humble and thick red that homogeneously fills the whole shirt disappears into its mysterious subterranean current. It resurfaces in the scarf on the neck of the Buchenwald survivor, who grinds his teeth, and then, as if that little piece of cloth could radiate from the neck of the worker chosen to symbolize the barbarism of misery, it expands all around: to the shadow of the wall, and to the shadow on the side and lap of the worker next to it, eating the bread. Finally, it gets dirty, mingling into the ink of the black and white drawing.

Its last appearance – of course there is a third one; it must be symmetrical! – is in the hat of the last worker on the left of the observer, huddled up asleep.

In order to conclude its presence, and satisfy the unconscious aesthetic expectation for a 'round' of similar stains in the mechanism of the composition, red also appears in two more faded residues among the cobblestones, like two thin trickles of dripping blood.

Almost objectively, because of the content (that group of workers by the construction site that you drew), that red ends up becoming an allusion. In fact, it immediately appears so within our close linguistic 'circle'. It is the slightly ambiguous sign of a

meaning shared collectively. It is the proletarian red, the red of the sentiment of class struggle.

Its light, however, is not collective, in the obvious conventional meaning. If it were, it would become a rhetorical, rather than poetic, sign. In that red of yours, in the fact that you identify as a communist and sing communism, there is no immediate instrumentalization. On the contrary, there is so much mediation and implication that that red ends up expressing a completely private, exceptional sentiment: the sentiment of poetry. Like any great ideology, Socialist Realism directly asks the poet to be a poet; it has no need for his linguistic skills or his capacity for professional persuasion.

In this arbitrary, fragmentary red that is functional only to aesthetics, this fragmentary, interrupted, inspired, unpredictable red that is sophisticated to the point of being vulgar, lies your whole special strain of communism: your rapport with reality and with the working class.

You look with sympathy at a group of workers lying in the sun during their lunch break; you feel sincerely that they are your brothers, united in virility; almost no psychological or human element disrupts your connection to them. Then, when you describe them in your particular art, something inevitably calls to mind a pictorial tradition (compositions of sleeping figures, Gardens of Gethsemane) from which the workers are excluded. To reach them again you attempt to contradict this tradition with the brutality of your sign; but you cannot prevent the irreversibility of the movement that divides you from those humble comrades of yours, as you contemplate them.

You look with love at a bunch of workers lying in the sun; you understand, by virtue of charismatic experience (as a Sicilian, a son of the people, a man of the poor), the charge of their feelings and their physicality; you observe them, in their insignificant and epic actions alike, with the kind of complicit and ironic hilarity ensured only by a strong and reciprocal intimacy. When you represent them, you are no longer a brother: you have become almost a father, and move your eyes toward other allusions, other human relations

– cultural ones. You integrate workers into those cultural references with a fatherly hand, with the nervous, heavy, and dark signs of an impatient artist who, because of his culture, would otherwise be fated to follow the path of abstraction, the delight of pure form. Your stubborn fidelity to the figure is almost a form of neurosis.

You look, full of political consciousness, at a bunch of workers lying in the sun; you share their most insignificant concerns, the preoccupations of poor men; but you also share their historical problem as workers: you share their rage and hope, resignations, and revolts; in your pocket you carry the membership card of their Party. When you express them, you cross – almost unconsciously, fatally – the limits of expression, and you turn their protest into something that, by overcoming realism (details, psychology, regional and national styles), stiffens into a wrinkled iconicity outside of history.

The ambiguity of poetry. A poetry to which you are obliged by the school of your century, which permits only authentic intuitions; a poetry to which you are obliged by the sincerity of your faith, which you cannot betray with any rhetoric.

There is a colour as ancient as all the colours
of the world. Oh how we have loved it
almost incarnated in the wood of small miraculous
predellas, in Romanesque refectories,
in the dark choirs of the Apennines in summertime!
A red akin to leather, to the blood darkened
in the pores of wood by a midday
still alive in the thirteenth or fourteenth century – cherries
picked in the gardens of a Naples governed by peasant Kings,
raspberries that grew among the hum of buzzing wasps
confined by the centuries to
unrecognizable glades, and yet so familiar!
The red of History. Dust
and burnishings on the Thebaids of Lazio . . .
landscapes made Umbrian, Bolognese, or Venetian
by the slaughter of innocents, or the multiplication of loaves.

The blood of Italy lies in that red of the rich
where the everyday is always sublime,
and Mannerism rules over its realm . . .

Here it is now in our hands
No longer incarnated in canvases or panels of wood
in machines of sublime beauty required
by the apex of power.

A naive, awkward red, stuck
to paper or plywood
like a smudge or a scrawl, bound
to the casual and arbitrary freshness
of an expressive act that does not want to end.
Illegitimate, unfinished, raw,
never consecrated by the craft that
intimidates the humble observer . . .
Another sensuality, a different cognitive
confusion . . .

But it is fated that, on the other side of these years,
what is casual will become definitive,
the arbitrary absolute.
Meanings will become crystals:
and the red will reprise its history
like a river vanishing in the desert.
The red will be red, the red of the worker
and the red of the poet, a single red
that will mean the reality of a struggle,
hope, victory, and compassion.

*Italy's most prominent communist painter of the twentieth century,
Guttuso (Figures 8, 19 and 20) collaborated with Pasolini on several
occasions, including voicing the prose dialogue for the latter's meta-
documentary,* La Rabbia *[Rage] (1963), not long after this exhibition*

(Figure 37). Along with an essay by Alberto Moravia, this text introduced a catalogue of twenty drawings, displayed at Rome's Galleria La Nuova Pesa (1959–76). Founded by the anti-fascist partisan and entrepreneur Alvaro Marchini, the gallery championed figurative, realist and neorealist artists, against the prevailing grain of informalist painting at the time. Prominent among the gallery's (and Guttuso's) supporters was Pasolini's friend Antonello Trombadori (1917–1993), a member of the Italian Communist Party's central committee and contributor to the journals l'Unità and Rinascita (1944–1991). Pasolini's text includes a poem published in Rinascita, along with the reproduction of one of Guttuso's works; under the title 'Guttuso's Red', it subsequently appeared in a special pamphlet published by Nuovo Piccolo, a Parma-based monthly magazine of the PCI.

Conversational, conspiratorial, and dialogic, Pasolini's text unfurls in the second person. Its oscillation between prose and poetry underscores an approach to Guttuso's work through the prism of a Marxist, materialist lyricism. As with so many of Pasolini's texts on fellow artists (painters in particular), the essay is punctuated by thinly veiled projections of his own aesthetic tendencies ('Your stubborn fidelity to the figure is almost a form of neurosis'). Pasolini and Guttuso's shared devotion to the figure surfaces emphatically in La Rabbia, the montage of which presents Guttuso's painting as a kind of lyrical 'third way': between the dogma of Socialist Realism and the no less arid ambition of contemporary abstract painting. The text's allusion to the 'Algerian nose' of Guttuso's humble worker underscores an increasingly salient motif in Pasolini's work of the 1960s, namely the affective (and to a lesser degree ideological) affinity between workers of the global 'south'.

The mention of Leonardo Sinisgalli at the beginning is a cutting remark. An engineer, poet, artist, mathematician, and filmmaker, Sinisgalli was known as a prolific polymath: besides writing often for postwar Italy's proliferating newspapers, journals, and magazines, he founded and directed a number of publications and ran the advertisement office of Olivetti, one of the most successful and experimental industrial companies in the country.

Venting about *Mamma Roma* (1962)

Something unjust is definitely afoot. For whatever it's worth, I had predicted as much. Well before *Mamma Roma*'s release, I had written in *Vie Nuove* that 'this film's fate could be the same as my own'. In my case, after all, in my particular circumstances, in this society, it is forbidden to err. As usual, I was excessive in my passions, but also, alas, lucid. It is not only forbidden for me to err, but risky even to expose myself to the most simple criticisms. If one senses here a whiff of persecutory mania, it seems to me more than justified.

In reality, the 'fate' of my film (and of myself) no longer hangs in the balance. The film is doing quite well, in fact – as am I, already at work on a new African story.

But something unjust is afoot, as elusive and unfathomable as any other Kafkaesque situation.

Let us forget Colonel Fabbi's ridiculous screed [against *Mamma Roma*'s screening at the Venice Biennale]: an act, even in the most generous of assessments, of collective psychosis and personal ingenuousness, worthy more of pity than indignation. Besides, the injustice of Fabbi's outburst was more than offset by the magistrate's subsequent intervention, which set things right with a

clarity, courage, and intelligence that are frankly un-Italian, or at least all too uncommon in this country.

Let us also forget that fanatical pipsqueak who, at the top of the stairs of the Quattro Fontane cinema – during the silence right after Ettore's death onscreen – bellowed the kind of stentorian denunciation with which my readers are by now familiar ('Pasolini, in the name of this country's youth, I tell you that you suck!'). Even here, a certain pity (however ironic) seems a more fitting reaction than rage. In any case, I more than made up for the injustice of this errant hero's patriotic initiative with the uncivil slaps I dealt him, as soon as he thought he thought he'd gotten away with it and shut that pathetic mouth *minus habens strillante il nulla*. I should actually be ashamed of my back-alley reaction; 'I threw the first punch', 'I gave him one hell of a beating', as the toughs from the *borgate* would say. I really should be ashamed. And yet I must remark that, given the corners into which I am routinely pushed – having to reason with my fists – I feel a tried and true satisfaction: at last the enemy has shown me his true face, and I faced him in turn with a hail of punches, as is my sacrosanct right.

What seems to me unjust is the way in which *Mamma Roma* has been received by critics, first in Venice and then Rome.

Let me say straightaway I am the first person to feel dissatisfied with my work; and let me admit that I am perhaps more partial to *Accattone* than *Mamma Roma*. That said (and keeping in mind that my opinions of my own work possess their own objective value), I don't think *Mamma Roma* is the kind of film that comes along every day. As if a film's worth could be confined to its presentation at one festival or another. I consider myself objective enough to say that the film's opening banquet scene, the two long takes with [Anna] Magnani walking, the scenes of the love story between Ettore and Bruna among the ruins and along the canal, and the final sequence, all constitute cinematic passages that can't be dismissed in the name of generic discourses (however ideologically or morally sound), or else influenced by the film's public reception.

In short, what should count in a work of art is what is worthwhile, not what isn't. Instead, *Mamma Roma* has been judged exclusively in terms of the doubts it might elicit, almost as if the critic were talking nonsense to himself, in the grip of particular ideological interests (or something even worse): 'Sure, the film has some lovely things, many of them even. That's to be expected; so expected that I didn't even notice. Instead, I am, with exceptional perspicacity, latching on to those failed moments, whether in *Mamma Roma* itself or *Accattone*.'

Thus, the proverbial bee that has flown into the critics' bonnets; and thus the unjust circumstance in which I find myself.

That circumstance nevertheless bears out some explanation.

The explanation lies first and foremost in a large swathe of Italian film critics, whose cultural formation is pathetic. There is not a single one who does not feel at utter liberty to write about the cinema, and yet I remain unenlightened as to the criteria according to which respective journal editors commission these pieces. In the case of my own films, it so happens that such shoddy critical competence – whether specific or general – proves rather more transparent, to the extent that any appraisal of me as a director implies an appraisal, however directly, of me as a writer; or rather, it implies at the very least an allusion to a stylistic history comprising a series of literary works. It has thus happened on several occasions that I have had to read (how shall I put it?) literary criticism sublimated into a film review: literary appraisals filtered through journalistic vulgarizations of the most facile sort.

Take the whole Mantegna affair, for example. I had mentioned in an interview and then written at length in an article (published first in the magazine *Giorno* and then in the volume *Mamma Roma*) about how my figurative vision of reality derived from pictorial (rather than cinematographic) origins, and that this shed light on certain phenomena, particularly my mode of shooting. I explained, in short, that my films' pictorial references formed a stylistic penchant and not, blast it, mere re-creations of particular paintings!

But certain film critics, reading my comments with a cursoriness allergic to actual cultural engagement, drew conclusions almost moving in their complete and helpless ingenuousness, such that the body of Ettore foreshortened in the film's final scene led all of them, on cue and in chorus, to bring up Mantegna's *Dead Christ* [Figures 16 and 17].

Meanwhile, Mantegna had nothing to do with it. Nothing! At all! Dear Longhi, please say something! Explain how foreshortening a body and placing the soles of its feet toward the camera doesn't suffice to speak of Mantegna's influence! Are these critics blind? Do they not see that the black and white chiaroscuro rendered so starkly and forcefully by the cell holding Ettore (with his light tank top and dark face), strapped to a restraining bed, recalls artists who lived and painted several decades *before* Mantegna? Or that, if anything, we might speak of an unlikely and exquisite conflation of Masaccio and Caravaggio? We'll just let it go; as if such nuances might actually be grasped by individuals preoccupied with churning out their daily columns, concerned solely with not stumbling too egregiously, and thus attuned above all to 'public opinion' . . .

This incompetence, which wouldn't survive unless it were propped up by widespread conformism and cynicism, is at the root of a large swathe of Italian film criticism.

Now, for the average commercial production, such incompetence works just fine; it greases the gears operated by various interests, linking producers to consumers. It forms an ineluctable dimension of our world, a facet of our arid neocapitalism.

Yet ironically enough, from that inexorable cycle of production-consumerism, an auteurist cinema is being born in Italy – a cinema marked, like all poetry, by a strong sense of cultural necessity.

This is why the film critics at so many daily papers are no longer up to snuff. This seems to me a crucial problem in our culture.

One cannot expect rigour, integrity, love of truth, or honesty from careerists who – at the bottom of their petit-bourgeois hearts – hold culture in profound, ideological contempt. The fact that a

dozen or so good (honest and incisive) critics write for the papers means nothing; the sad situation remains as I have laid it out.

With regard to my work, then ... On the right wing, in the fascist and clerical papers, we find pure bad faith. A truly Kafkaesque situation. These individuals are capable of anything: denying the most crystal-clear truths, distorting the simplest facts. So just imagine what it takes for them to savage a film by sampling a *Rashomon*-like range of 'opinions'. And yet in the case of *Accattone*, despite their bitterness, their insults, their feigned indignation, they had been forced to accept the film's existence, to accept the phenomenon that it embodies. By contrast, they have succeeded in belittling *Mamma Roma*. How so? Because leftist (and ostensibly sympathetic) critics have expressed some doubts this time around.

And so, in short, this is what has happened. There is so much bad faith among those expected to carp that they have carped even about aspects that they might have praised, using the film's flaws as an alibi not to find anything good about it at all. As for the other, ostensibly sympathetic side, there is too much good faith to whole-heartedly praise a film bearing some faults, and too much good faith to defend it unconditionally.

Thus the right-wing abettors, understudies endowed with the cultural formation of failing eighth graders, took advantage of some honest ideological doubts on behalf of leftist critics in order idioti-cally to pan the film as a whole, to reject even its poetic significance (which they had been obliged to acknowledge in *Accattone*).

It is a pitiful situation (made all the more so by the fact that the doubts of some sincere leftist critics don't seem to me altogether sincere; I will never accept [Lino] Miccichés echolalias in the pages of *Avanti!*). This kind of discourse is inadequate to the level at which Italian filmmakers are working.

So much fuss and frustration over the various film festivals. And yet they are what they are: vanity fairs operated by producers who, with the prodigious cynicism of old time capitalists, know all too well how to exploit human weakness. And yet all of this weighs

very little in the country's actual cultural life. Film critics, by contrast, weigh a great deal. That is a problem which must be, if not discussed and dealt with (I won't ask too much), then at least recognized in all its pitiful and humiliating reality.

Published in his regular journalistic column for the communist paper Vie Nuove *[1946–78], Pasolini's editorial responds to the (by then predictable) polemics over his latest film,* Mamma Roma *(1962). To great scandal, his first feature-length film,* Accattone *(1961), had invoked Bach's St Matthew's Passion and early modern art historical citations in its cinematic consecration of the city's subproletariat. With* Mamma Roma *Pasolini redoubled these aesthetic 'contaminations'; Vivaldi's Basso concerto in D minor, Leonardo's Last Supper, and other hallowed pictorial allusions form part of the film's meticulously woven fabric, as tattered and abject in its subjects as it is exalted in their visual framing and hieraticization. Perhaps the greatest flashpoint – for Pasolini, at least – was sparked by the film's final scene, during which the camera pans over a prostrate and foreshortened Ettore, his lifeless body strapped to a table in police custody in unambiguous allusion to the dead Christ. The scene bears some of the most oft-cited lines with regard to Pasolini's pictorial citations (and his abiding relationship to Longhi), but they are best grasped in the larger context in which they unfurled: as Pasolini's reproaches not merely to an epidemic ignorance regarding art history (or its facile applications), but to a wider misprision of his wilful, stylistic 'contaminations'. As discussed further in 'Technical Confessions' (excerpted below), his use of early modern painting transcended any particular citation or 'content', searching instead after a 'sacred' way of seeing, framing, and isolating. Already adumbrated here, in the reference to an auteurist cinema flowering in the teeth of a baldly commercial industry, are themes he would explore in his 1965 essay, 'The "Cinema of Poetry"'.*

Pasolini's fixation with Rome's criminal and lumpenproletarian classes had stirred reactionary anger since the mid-1950s. The questions of martyrdom at play in both Accattone *and* Mamma Roma

seemed increasingly to bear upon his own physical experience; his columns in Vie Nuove *increasingly refer to both a metaphorical 'lynching' and a real threat of violence. As Pasolini discusses here,* Mamma Roma's *release exacerbated neo-fascist attacks on his person. The front page of the newspaper* Lo Specchio *published a photograph of Pasolini striking back at his attackers who, the headline declared, 'applauded the director on his face'. The Latin phrase 'minus habens strillante il nulla' roughly translates to an 'unintelligent individual yelling (into) the void'. A film critic for the socialist newspaper* Avanti! *(1896–), Lino Miccichè (1934–2004) went on to author some authoritative texts on Italian cinema and neorealism.* Rashomon *is a 1950 psychological thriller directed by Akira Kurosawa in which a series of characters relate their respective perspectives on the same crime, each contradicting the other. Before receiving an Academy Award in the United States, the film had won the Golden Lion at the Venice Film Festival, where it was screened thanks to Giuliana Stramigioli, an Italian scholar of Japanese Studies working in Tokyo.*

From 'Technical Confessions' (1964)

I remember doing an interview with *Paese Sera* a year or so ago, when production on *The Gospel According to St. Matthew* was in the news. I was quoted as saying that I wanted to record this new film 'in the street' with 'actors taken from the street', as the quasi-derogatory phrase would have it. I meant, in other words, that I wanted to film it like *Accattone*, with the same commitment to realism – much as an Impressionist painter might insist that he works '*en plein air*' as opposed to painting in a studio. That is, I wanted to use the same technico-linguistic methods, the same 'film-signs' which, as everyone knows, are relatively few in number: five or six lenses, four or five camera movements, a few lighting options (backlighting, flat light, lateral light, sun, dull light, tripod light, night). Naturally the nuances between different camera movements are as numerous as types of light. A tracking shot can be anywhere from twenty to thirty metres, to just a few feet – no comparison with linguistic, musical, or painterly signs in their variation. As a cinematic neophyte, I reduced the objective simplicity of *Accattone* to the barest of bones. And the result definitely seemed to me to achieve (at least in part) a certain sacrality: a *technical sacrality* which I conferred in the extreme upon both

landscape and characters. There is nothing more technically sacred than a slow panning shot. Particularly when it's discovered by a dilettante using it for the first time (I still feel the thrill of those panning shots across the crusty walls and desolate sunlight of Pigneto in Rome). Sacrality: frontality. And thus: religion.

Several individuals have written on *Accattone*'s intimate religious sense, its psychological fatality, etc. I kept the lenses strictly between 50 and 70mm – lenses which thicken matter, exalt three-dimensionality and chiaroscuro, lend weight and even the coarseness of worm-eaten wood or soft stone to bodies. Especially when used in 'dirty' light – backlighting (with Ferrania film!) which tends to carve around the eye sockets, to define the shadows under the nose and around the mouth, dilating and making the image grainy, almost like a photographic negative. With its figurative camera, the film as a whole gave birth to what the critic Pietro Citati called a 'sombre aesthetics of death'. It is with this in mind – this technical or stylistic process – that we may speak, as has often been done, of *Accattone*'s religiosity. For, it is solely by way of technical processes and stylemes that we may grasp the real significance of that religiosity. Whoever, instead, speaks of it solely in terms of content (whether explicit or implicit) grasps it only approximately, superficially. In fact, the religiosity lies not in the need for personal salvation or development (from pimp to thief!), nor, externally, in the fatality which determines and concludes the entire story, and which is emblematized in the final scene's sign of the cross. It is found, rather, in the very mode of seeing the world, in the technical sacrality of seeing itself.

In addition to the kind of rigorously simple technical selectivity afforded by 50 and 75mm cameras, with *La Ricotta* I added the 'Pan Cinor' lens for my basic panning shots and wobbly tracking shots – not so much for its zoom movements (still very limited), as for the grade of that lens, from 100 on up. This obtains effects even more dear to the eyes of an apprentice in Masaccio's studio: it further flattens images, making them warmer and coarser. You leaven them like loaves of bread, solid but (if I can invoke my

somewhat hackneyed process of sineciosis) light. As light as the paintbrush is light, even frothing, when it invents the most massive play of shadows in three dimensions, with Man at its centre and the Eternal Light as its source of illumination.

Contrary to what I presumptuously announced to that interviewer for *Paese Sera*, I ended up filming the *Gospel* in a completely different way than *Accattone*. I remember with terror the first few days on set. I had begun filming as I knew how at the time, with my usual tracking shots. But why didn't I figure it out even before starting? It was plain that the *technical sacrality*, the familiar simplicity which derailed from its habitual semantics the 'matter' of the Roman *borgate*, turned completely rhetorical and obvious when applied to the *actually* sacred subject matter I was narrating. A pimp from Pigneto rendered as a piece of Romanesque architecture or as a figure out of a Masaccio fresco was fine. But Christ himself? Christ posed frontally, shot with a 50 or 70mm camera, juxtaposed with brief and intense panorama shots? This became pure bombast, a kind of replica. I went on (erroneously) filming this way the entire scene in Gethsemane and Christ's arrest, which I could only then re-shoot in part, and which thus bears the indelible sign of my initial error. Whenever that scene comes on the screen, however seemingly attenuated and mediated by the montage, I feel intensely ashamed . . .

Bound up with each of Pasolini's films are various related texts including screenplays, interviews, and diaristic observations, penned either prior to filming or post-production (in some cases both). His approach to the cinema, in short, formed a multi-disciplinary and intertextual experiment never limited to the editing room or the screen. Indeed, as critical to Pasolini's cinematic corpus as his finished works are his wide-ranging notes 'for' or 'toward' other unrealized projects throughout the 1960s and '70s. Though he would gather his key writings on film theory in the 1972 anthology Heretical Empiricism, *Pasolini's other numerous texts on cinematic work (from questions of dubbing, to lighting, to script fragments) have*

since been collected in the large, posthumous volumes Per il cinema
1 and 2, *from which* 'Technical Confessions' *(appearing originally in
the newspaper* Paese Sera*) is drawn.*

*The essay combines technical and procedural details with a
synthesis of Pasolini's philosophy of cinema, and its rapport in turn
with the 'plastic' imperatives of figurative painting. He compares his
directorial and cinematographic strategies to both painting and
sculpture – but in their notably early modern iterations, comprising
Romanesque sculpture and Renaissance altarpieces. These films'
religiosity nevertheless obtains, he insists, not by virtue of content,
but through their technical 'language', staked upon hieraticism,
isolation, and an almost worshipful vision of reality as its own
miraculous consolation. The resulting 'sacrality' is brought to bear as
much upon the Rome's* borgata *as on more self-consciously religious
subjects, whether the Crucifixion scene of* La Ricotta, *or the Biblical
narrative of* The Gospel According to St. Matthew. *Pietro Citati
(1930–2022) was a writer and literary critic who responded enthusi-
astically to Pasolini's debut feature* Accattone *(1961). What Citati
referred to as the film's 'aesthetic of death' proves inextricable, in
turn, from a certain birth: Pasolini's inaugural venture as a director,
finding 'for the first time', as he writes here, an almost mystical tran-
scendence in the most abject of subjects. The term 'sineciosis' was
first applied to Pasolini's work by the critic Franco Fortini (1917–
1994): 'Antithesis is detectable at all levels of (Pasolini's) writings . . .
even in his preferred linguistic form, which is a subspecies of oxymo-
ron, called* sineciosi *in ancient rhetoric, and by which two opposing
attributes may be affirmed by the same subject.'*

The Art of Romanino and Our Time (1965)

PASOLINI – Don't ask me what I am doing here alongside professionals like [Renato] Guttuso and [Franco] Russoli, distinguished experts like [Guido] Piovene and Father [Ernesto] Balducci, not to mention [Gian Alberto] Dell'Acqua. In my youth, I actually had some ambitions be an art critic but, to be perfectly honest, I'm no longer up to snuff. I'm a bit like all of you who just visited this Romanino exhibition. I was scarcely familiar with his work before; I might have seen some reproductions of his paintings and read something that [Roberto] Longhi wrote about him twenty or so years ago. For me, therefore, this exhibition was a revelation. It left me amazed and surprised.

I would like to talk a little bit about my surprise looking at Romanino. I used to think of him simply as a minor master (one of those we call *petit maître*), which is to say that I thought his painting was a clearly delineated, perfect, typically provincial phenomenon. But I realized this is absolutely not the case. So, what am I doing here?

This morning I read in the paper that a woman was found dead in Paris with a samurai's sword stuck in her breast, her body bound: a Mannerist vision, so I am on topic here. The French police called

Georges Simenon to ask for his perspective on such a mysterious murder, and Simenon gave his opinion. I am basically playing the part of Simenon today, so please forgive me for leaning on the language of the detective story as I relate my somewhat technical and hermeneutical findings. I am going to try to include some elements of structuralist criticism in this study, and I believe this is the first time that someone has used structuralism to talk about painting.

What, then, is this proverbial murder scene to which I was called today, travelling all the way to the Val Camonica? I believe it can be synthesized in one of the words that Guttuso used earlier: personality. My body of evidence lies in the disparity, or inconsistency, or swift appearance and disappearance, of personality. As I walked through the exhibition, I kept asking the person next to me: 'Where is the Romanino? which one is a Romanino?' With every few paintings I was forced to revise my conception of the artist. At the end of this visit, and even today in Val Camonica, I still do not know who – or where – Romanino was. We have a preconceived (and erroneous) idea of what an artist should be; we look at [Lorenzo] Lotto's work, for instance, and we know exactly who Lotto was, even if, at times, he is not completely *Lottesque* himself. The same goes for Titian and others. But not for Romanino: we have no single image of him. We have no plastic (or even lyrical) idea of the true Romanino, of a Romanino who satisfies everyone and on whom we can all agree. This is the murder scene on which I have carried out my research.

I realized immediately that some of the leads I followed in the body of evidence were wrong from the start. Thinking of Romanino as an eclectic painter was the first misstep. He was not eclectic, at least not internally to his paintings. By saying this simply and superficially it perhaps sounds like there actually *is* some eclecticism in him. Yet the contents of a single painting – even the stylistic examination of those contents – reveals that we are not dealing at all with an eclectic painter. The qualities of eclecticism are nowhere to be found in Romanino, because eclecticism is never dramatic,

and Romanino is relentlessly dramatic. Eclecticism is never profoundly contradictory; Romanino evinces constant contradictions, and remains forever aware of the disparate stylistic motifs that he adopts and abandons. Eclecticism, moreover, always develops within a specific cultural setting (the reflection of what Barthes calls the various inscriptions of a cultural context); Romanino's eclecticism proves infinitely more complex than that. Rather than developing within a cultural setting, his work precedes or follows it. As Piovene and Guttuso have already noted, Romanino is either a precursor or a latecomer: the development of his eclecticism reaches back in time to some archaic Gothic moments, while predicting and prefiguring Caravaggio in the future.

Another wrong lead: thinking of Romanino as a master craftsman. He wasn't a master craftsman because his paintings lack the internal qualities intrinsic to master craftsmanship. Romanino is never just proficient, and this is proven by the fact that, along with some moments of extraordinary ability, one finds moments of clumsiness in his craft. This is not to say that he possessed no facility. I remember, for instance, the silver mantle of a Virgin that he painted with the anonymous perfection of a specialist in all the folds and shimmer of pictorial drapery. The clumsy details of Romanino's painting would have never escaped the brush of an expert craftsman, however. Guttuso could perhaps confirm this, but I believe that a master craftsman is never clumsy; he draws capably, elegantly, even when he paints quickly. When Romanino paints quickly, by contrast, his work verges on a certain ugliness. To be sure, he incorporates that ugliness as an expressionistic element, in his own way; yet it remains clumsy and unpleasant, almost repulsive. I suspect that many conservative viewers might have been scandalized by the hands of those crones representing the sibyls, and found them to be ugly. Those hands are horribly painted, and a master craftsman would have never done them like that.

Thinking of Romanino as a facile painter was my third wrong lead. None of his paintings inspires the elegance, grace, visual

pleasure that many minor painters (the so-called *petits maîtres*) do. One would never think to bring home one of Romanino's paintings, to keep it on display as some pleasant element of decor. Rather than inspiring delight, Romanino's work commands an absolute, even religious attention.

I do not particularly admire great craftsmanship per se, and I don't figure among those who would limit Romanino's greatest work to his Venetian phase, where indeed one detects a certain absolute grace. Looking at his work, I therefore do not experience the impressions that I usually get from the *petits maîtres*. The background in Romanino's paintings is always tormented. These backgrounds suggest a great severity, but not in the typical, formalistic sense that one finds in many Italian painters. Italian painters tend to be formalistically austere, which is to say classicizing, whereas Romanino never is; there is always a profound anguish at the heart of his paintings.

These constitute the preliminary findings of my investigation. Like any good detective, however, I would like to present some evidence. The first piece of evidence that I set forth is Romanino's stylistic awareness regarding his own stylistic experiments. An eclectic or facile painter does not possess that kind of awareness, and neither does a master craftsman. Romanino did: he abandoned some stylistic experiences for a while and then took them up again – unchanged – a few years later. Let me go back to the example of his work in the Cathedral of Asola. He painted (I don't remember which year) the choir there, and then repeated that same kind of painting ten years later. His tumultuous research as an austere and anguished artist led him during those ten years through a great number of other experiences. When a decade later he went back to the stylistic experience of Asola, he did so without missing a beat: he took up from the same exact point where he had left off, reprising wholesale his former stylistic strategies. In fact, he painted those same aforementioned ugly hands once again.

Another example of Romanino's extreme sensitivity, bearing a pathological, morbid facet, is his anguish [Figure 4]. What I have

been calling Romanino's anguish is the consequence of a repre-
sentative dimension, which I would like to place at the centre of
this talk. I am thinking of an altogether ugly painting: an altarpiece
in San Felice del Benaco, titled *The Holy Virgin with the Child and
a Saint*, painted around 1540, '41 or '42 (someone will perhaps
correct me if I am misremembering the dates). Now, that span of
years in Brescia coincided with a period of religious, moralistic,
and ideological repression. From what, then, did the painting's
ugliness spring? Romanino's art was farsighted; as those who spoke
before me have already demonstrated, it is filled with premoni-
tions of distant futures. The ugliness of that altarpiece in San Felice
del Benaco lies in its prefiguration of a seventeenth-century ugli-
ness – the non-Caravaggian seventeenth century, that is: an oily
seventeenth century in thrall to disingenuous altarpieces, which is
to say the age of the Counter-Reformation. A few years of curtailed
freedom and religious and ideological repression sufficed for our
Romanino to undergo a profound trauma, and even to fall prey to
the atrocious deficiencies that plagued certain painters of the
Settecento during the Counter-Reformation.

Romanino's art is thus not a light, elegant, and eclectic experi-
mentalism involving various visual idioms. It consists, rather, of a
bona fide series of experiments using discrete languages and
schools. To use a more current formulation, we could call it an
obsessive experimentalism, one that led the artist through succes-
sive experiences without connecting them in the coherent arc of an
evolution. When Piovene says that Romanino's Venetian period is
the most splendid but not his favourite, I don't think he means that
the influence of Venice's painters on Romanino's work ceased
abruptly – that it changed, as Longhi once wrote, from a Titianesque
splendour to an overripe and almost decadent aesthetic *à la*
Giorgione. The Venetian influence kept on tempting Romanino,
pulling him back, resurfacing in his later phases. His career is a
series of violent and anguished jumps of style from one language to
the next. Because of this strongly mimetic and anguished quality, it
is difficult to examine his painting from a structural angle. Some

consistently structural elements do appear in his work, however. I
am not really fluent in the terminology of painting, so forgive me if
I sound less than specific (I would be more precise if I were speak-
ing about literature). Two structural constants remain in Romanino's
painting throughout his varied and contradictory stylistic experi-
ences, and those who spoke before me have already named them.
On the one hand, there are Romanino's constant allusions to the
Gothic – the Gothic as a mentally or stylistically Nordic category,
arising from the Danube, not a generic Gothic return to the archaic
styles of the fifteenth or even fourteenth century. The other struc-
tural constant which appears in every single painting by Romanino
is his inventory of psycho-physical character portraits. The physi-
ognomy and the socio-psychological depiction of certain types
remains constant throughout all of Romanino's various periods,
from the Venetian to the Giorgionesque to the Ferrarese.

These are the two constant structures in Romanino's body of
work. Since they are more related to content and culture than to
form, they tend to elude a purely visual, formalist glance. I would
like to insist on the fact that these two constants are cultural
moments, and not formal structures, even if I am unable to proffer
convincing evidence. Romanino's references to the Gothic are
indeed formal, and they can most likely be explained through the
established narrative about sixteenth-century Italian artists having
access to famous German prints. Yet this is merely a symptom, the
visual consequence of a (more profound) cultural experience. The
pictorial models that reached Italy over the Alps from the Rhine
valley, those that Longhi wrote about, were not simply formal or
stylistic. They also entailed a different ideology, a different perspec-
tive on life, which is to say a different culture. Therefore, the
consistent re-emergence of Gothic motifs in Romanino's work
implies more a Nordic, German culture than an Italian one. The
same could be said about his sympathy for certain kinds of charac-
ters who belong, psycho-physically and sociologically, to the lower
classes. This, too, is not simply the fruit of Romanino's mood, some
random formalist phenomenon or kneejerk sympathy: it entails,

once again, a whole cultural phenomenon. It is almost as if Romanino's eyes were liberated from a blindfold which had impeded a realistic, immediate, and sympathetic vision of a poor world. I'm not referring here to the beggars painted by Ceruti that Piovene mentioned before; I mean the folk who live alongside the bourgeoisie. I mean the working class.

When Piovene was saying that the sibyls from the Asola choir reminded him of some realistically painted witches, I remembered that, upon looking at the same paintings, I thought those women were in fact the spinners from the mill where Renzo Tramaglino, the protagonist of Manzoni's novel *The Betrothed*, would go to work. So, painting synthesizes a vision of varied, contradictory, and dramatic stylistic experiments, but also reveals the concomitance of the two structural constants that I have been referring to. The coexistence of these two structural constants – which imply two cultural modes of perceiving reality – makes Romanino's stylistic experimentalism pre-textual and essential, not simply eclectic or restless. His study of diverse pictorial languages was pre-textual, in the sense that it allowed him to express himself despite the impossibility, as it were, of self-expression. If we look at all his stylistic experience, we find that it fundamentally lacks the two most typical kinds of discourse of his age: the Mannerist and the classical (while it would be more correct to speak here of classicism, I say 'classical' rather than 'classisizing' in the hope of avoiding a judgement of value). I don't mean to say that Romanino is never classical or Mannerist at all; there are, of course, classical and Mannerist elements in his paintings. One of his Virgins, for instance, bears a white sash whose hem falls parallel to the nose, recalling a similar composition by Pontormo; and one could trace many such parallels. There are numerous Mannerist elements and a lot of classical attitude, especially in Romanino's most poised and harmonious compositions. Yet he never plunges wholeheartedly into an absolutely classical or absolutely Mannerist stylistic experience. No painting by Romanino is wholly dominated by classicism or Mannerism.

Why? Because he didn't want to be classical, or a classicist; but nor did he want to be a Mannerist. I believe Professor Dell'Acqua said a few words about this earlier in passing. Romanino overcame classicism as an integral, total, and harmonious vision of the world; and he rejected Mannerism because it consciously dissolved, disintegrated, and degenerated this integral, total, and harmonious vision of the world. Mannerism was a form of heresy: Pontormo and Rosso Fiorentino may have painted the Crucifixion, but at their core they were plainly diabolical, they were heretics. Romanino was not, so he could not welcome the Mannerist criticism of classicism. He remained a believer, and this is demonstrated by the fact that his religious painting is always nonconformist. I may have some doubts about the faith of a pious painter like Moretto, who, as Piovene eloquently put it, remained a kind of classicist; but I have none about Romanino's faith, however dramatic and however perturbed by strange episodes, like that of the proto-seventeenth-century altarpiece that I mentioned before. Romanino was what his culture did not allow him to be; this is the crucial point. This is the crux of my talk, which I hope now swiftly to conclude.

In terms of time and history, Romanino existed outside of his age. His culture refused him the consciousness of what he was. His stylistic research was thus pre-textual in two senses: on the one hand it allowed him to avoid classicism and Mannerism, the two cultural moments which he rejected; on the other, it allowed him to escape himself – that self which he lacked the critical, cultural tools to express. So squarely anchored in the Renaissance and the sixteenth century, the great painters of Romanino's age bear out what [Lucien] Goldmann called the law of homology, according to which the structures of the social world are projected and reproduced through the stylistic structures of painters. Romanino, on the other hand, does not.

Titian's whole stylistic world is profoundly homologous to the Venetian society of his time, and therefore to a certain moment in Renaissance civilization. Even some painters working at the same

time as Romanino, like the other minor masters from Brescia (Moretto, Savoldo), are profoundly homologous to a certain Italian society of the Renaissance, and reproduce it in their style. Romanino does not. That is why his paintings prove so contradictory and complex. And so unrecognizable. Given his moral position in relation to the culture of his time, he could not directly reproduce the two fundamental cultural elements that I have been discussing, which were still quite immature in the Italy of his day. These two cultural moments consisted of a kind of Central-European-Danubian-German culture of the Reformation and its bourgeois tendency to look at the lower classes realistically – a tendency typical of the grand bourgeoisie, and at the root, in fact, of the Reformation's revolution in Central Europe. These elements eluded the structures of Romanino's society, conferring upon him a perpetual, insoluble crisis, an anguish he could not resolve. He was more modern than what Italian society and culture permitted him to be. Sometimes he escaped this historical cultural impasse by unsystematic means, prefiguring future pictorial types and structures that had yet to become convention. Take the extraordinary frescoes that he made in Pisogne, for instance, or his beautiful paintings in Breno on the story of Saint Daniel (one episode from this cycle is perhaps his masterpiece). I am going to say something provocative, so don't take it literally, but these works demonstrate that Romanino could have illustrated *Don Quixote*. There are, after all, in the history of art, some dice players who could have illustrated a book written a century after their birth.

Romanino's figures are not, as Guttuso claimed earlier and as is generally accepted, grotesque. They are simply made of the kind of realism conceivable to a sixteenth-century man: the so-called *stile comico*. It is a comedic realism set in opposition to a tragic style. We use the term grotesque to name it, but it was simply the mode of realism in that age. I'll say something else provocative now: Romanino painted some comedic and realistic moments (like Christ washing Peter's feet while wearing an apron, for instance) which seem even to announce Daumier's caricatures, if not

Impressionist painting. Caricature is a typically bourgeois, modern moment in art history, and I believe that Romanino is the only painter in the whole Renaissance who could have been a cartoonist, a painter of caricature, someone able to represent an entire social and realistic moment through the sign of caricature – in the serious, austere, and powerful sense of the term, of course, in the vein of Daumier. The cold grotesque style of the Gothic age is absent from Romanino's painting; his sibyls were thus never prefigured by, say, Civerchio's sibyls, or those painted by other Brescian artists before him. The Renaissance grotesque, purely metaphysical and absurd, is also absent in Romanino's painting.

To summarize, here is my conclusion: Romanino fought for his entire life on two fronts. One was against classicism as the expression of Italian civilization, which he had probably overcome through a non-classicist kind of Central-European-Nordic-Danubian-German-Protestant culture of the Reformation. The other was against Mannerism, a critical means of resolving classicism that Romanino could not embrace because he was a believer, an austere and rigorously moral individual: he could not abide by Mannerism even if he remained tempted by it. His extreme, vital violence continuously crumbled in a series of contradictions and clashes.

Guttuso said that Romanino was a typical man of the Renaissance, but I would say the opposite: he was a man absolutely extraneous to the Italian Renaissance . . .

GUTTUSO – I didn't say typical . . .

PASOLINI – A man of the Renaissance. Maybe Guttuso will rebut later, and this is not important in any case. My conclusion is that Romanino's modernity is rooted in the fact that he prefigured so many stylistic moments yet to come. There might be some controversy over this; Longhi, for instance, says that Caravaggio was not much heralded by Romanino, and that may well be true. But look at his *Saint Matthew*. It seems to me so plain, however approximatively. In a purely formal sense, Romanino prefigured aspects of

Baroque painting, of the seventeenth century, even of the nine-teenth century in a purely formal sense. Yet there is something beyond this, and it grips me to the point that I am in a bit of shock today (I would even venture to say that, after my investigation, I love Romanino more than Titian). What Romanino prefigured, most of all, is an Italy that never existed, an Italian culture that never came to pass. He prefigured Italian culture as it would have been had the Reformation also taken place in Italy, and the Council of Trent never happened.

. . .

Let me add a couple of words just to clarify as I conclude. I am certain that Romanino was a man of the Renaissance. I am quite ignorant in the realm of art history, so I cannot really respond to this objection. However, as much as I try, I cannot think of any case similar to that of Romanino. I would need at least one in order to confirm with confidence that Romanino was, if not typical, then still a man of the Renaissance. What most disturbs me is the fact that he is, in the most profound moments of his personality, rather extraneous to the Renaissance.

It is true that the Renaissance established various problems with which we still deal today – authentic, modern problems. In Italy, however, the Renaissance ended up following a path different to the one signalled by Romanino. I will accept Guttuso's assertion that 'Romanino is a man of the Renaissance in his greatness and uncertainty', but only if I can append the word 'European' to 'Renaissance'. I would say that he was not a man of the Italian Renaissance; that's how I would clarify this point. And, as for what Russoli said: no, I do not accept the notion that there are some transcendental geniuses; I cannot accept an element of mystery . . . *hic sunt leones*. Where do *these* lions come from? Since we are provided with tools to investigate, we must reject the temptation of relying on an argument like *hic sunt leones*. Romanino did possess talent, in spades. He simply did not possess the kind of talent that

produces, so to speak, a graceful kind of painting apprehended in one glance, as a complete, refined, absolute, enchanting, and almost ineffable object, like some of Lotto's works. To offer the example of another *petit maître* endowed with charismatic grace, I would mention a painter I saw exhibited two or three years ago in Treviso: Cima da Conegliano. Cima's work is absolute perfection, and in fact I consider him a *petit maître*, which is to say inferior to Romanino.

Romanino invested his talent in a painting of crisis rather than a painting of grace. But this does not mean that he wasn't gifted. Nor is it true that the poetry of a work always makes itself manifest; it simply does not work like that. I don't want to lean on Goldmann as if he were Aristotle, but, when he talks about the structural homologies between a society and the stylistic structures of a poet or a painter, he says something at once ridiculous and quite true. He says that artists and poets who are great, in terms of their gifts, are expressed by great cultures. A great painter, a poet in the full sense of the word, with all his genius and *lions* and so forth, could never be expressed by an insignificant culture (though a *petit maître* could). That is why I believe that the little world of Brescia, the province of Brescia, birthed Romanino only in the biographical sense. He is not a provincial painter; he is an international painter. He is international in a cultural sense – a sense of which he remained partially unaware and uncertain, because he did not fully grasp the consequence of what he was doing. He likely only conceived of his work in terms of personal aspirations and explorations, however dramatically felt. Romanino is an international painter who blossomed in the Alpine valleys connecting the tiny provincial world of Brescia to other, greater worlds: that of the Italian Renaissance and that of the nascent European Renaissance.

Published only subsequently in the catalogue of a 1976 exhibition, the text constitutes Pasolini's wide-ranging contribution to a panel on the early modern painter Girolamo Romani, held in Brescia on 7

September 1965. Romani, known as Romanino (c. 1485–c. 1566), was active in Lombardy and the Veneto region in the early sixteenth century. It was Longhi who, in his re-evaluation of Lombard painting, turned artists like Romanino into important northern counterparts of Venice's preeminent Renaissance school of painters. Before Longhi's work, Romanino was perceived as a provincial minor master; he is now counted among Caravaggio's significant precursors. Pasolini's appeals to literary sociology echo some of his other essays and lectures from the same years, in which he alludes to the work of Lucien Goldmann (particularly the French philosopher's notion of an 'homology' between social and literary structures) and Roland Barthes (with whom he maintained a certain indirect dialogue on questions of semiotics). Just as Pasolini had previously mobilized Contini's philology and the categories of literary stylistics to talk about painting, here Pasolini evokes French structuralism (in particular Barthes' theories of textuality), which was quickly gaining traction in the Italian academy. The phrase 'hic sunt leones' [lions here] was often inserted in pre-modern maps to designate terra incognita: *an unexplored and potentially dangerous territory.*

From 'Observations on Free Indirect Discourse' (1965)

On the side of 'stylistic taste' and 'ironic mimesis' as stylistic conditions of the Free Indirect, I would like to note a new sort of condition which, in the aristocratic *qualunquismo* of the process (that nonetheless, in [Carlo Emilio] Gadda for example, rediscovers its moral function in its own traumatic violence), implies a critical attitude, albeit an unusual one. I refer to the 'Pop' element in painting, not out of frivolity, but, on the contrary, for the strictly functional reason that painting must also be included at this point, in some way, in the brief critical bibliography on the issue. For some decades now, in fact, the presence of a Free Indirect in painting, albeit a strongly contaminated one, has been conventional: the tradition took form with the avant-garde painting of the early twentieth century (collages of newspapers and other objects mixed with the traditional painting techniques of design and colour), and it is now exploding with Pop art in particular: the object, to which the painter resorts in order to enrich his text in an expressionistic-ironic way, is similar to a spoken fragment that an author reports, recorded in a highly expressive context of literary writing.

An example in literature that corresponds perfectly to the Pop element in painting (before a certain avant-garde literature, on which

see ahead) does not exist, I believe. *But if it existed, what would it mean?* Evidently, it would have a violently ironic value: in the middle of a complex and exquisite speech we would see a piece of brutal spoken reality flung in, either of the petit bourgeois or the lower class. It would be, in short, the typical form of antibourgeois revolt within the bourgeois sphere: the same as in the early twentieth century, but nevertheless with sociologically different characteristics and, above all, with a different perspective on violence toward the future.

In other words, the bourgeois antibourgeois revolt of the early twentieth century took as its object contemporary society in its existential immediacy, for what it was there and in that moment. (That made possible an irony that was more peaceful at its core, a certain sense of optimism and confidence, not only toward its own critical operation but also toward an intrinsic self-palingenetic force of the social world being criticized; and, in fact, it was always still a matter of *good* painting.) Today, by contrast, such criticism does not aim only at the present; instead, it is apocalyptic, it foresees the future: the system of allusiveness also contains the perspectives of future statistics.

It is infinitely more expressive and ironic (and less pictorial). However, its violence is more chilling because it nullifies even itself (like someone condemned to death who takes his life before being executed).

As a Free Indirect grammatical element, the Pop element – rapid, inarticulate, unique and univocal, monolithic – is a sacrilegious presence. It is not understood by the 'speaker' through sympathy, or, to phrase it better, in the case of painting, by the 'user'. No. It is employed with the same apocalyptic objective indifference with which cultured material is employed. A tear, a fissure, takes place violently and brutally on such cultured material, from which the *other* material erupts which makes up the objectivity, the real fabric of things, which escaped the intellectual poet as well as man himself to a great extent. It has become mechanical in its use by the masses of speakers and users, who are no longer the creators of history, but the products of history.

Hence, the language is no longer that of the *character*, but that of the *reader!* The citation of a random fragment of such language (as such, monstrous with respect to the work), which was traditionally addressed to a public of characters, the same characters of a book or a painting (as long as the world was whole, that is, dominated by a humanistic idea of reality), thus sounds like a sacrilegious contradiction through its own presence, which is scandalous to the reader because he feels himself put in front of *his* true reality! This reality is absurd, then, because it belongs more to the future than to the present. The 'innocent' masses, because they are deprived of critical ties to the past, accept such a future defencelessly, and they already prefigure it in their way of life. But the mimetic intellectual, who revives this new way of life in the work, can only understand its distressing and ridiculous aspects (with respect to the past, to which he is still linked critically). He knows not how to understand the nuances and the complications (in which life is really recreated) but merely a bare syntagma, the unequivocal and terrible Pop object.

At one time, then, the mimetic intellectual in general could renounce his own language and revive the speech of another, *provided that this other was a contemporary, or, better, much better, prehistoric with respect to him* (the most beautiful Free Indirect mimeses are those of their own bourgeois or petit-bourgeois fathers of a preceding mythic generation, or those in dialect). But now *he cannot* – due to an anguish that is made bearable only when it is apocalyptically ironic, as in Pop art – *adopt the linguistic modes of whoever is further ahead of him in history*, that is, for example, the innocent and standardized masses of society in an advanced neocapitalistic phase. Thus, it can certainly be said that, by this time, the intellectual appears indiscriminately and necessarily as traditionalist. Even the avant-garde movements are traditionalistic as compared to the true reality that is already beyond the threshold of the future, at least potentially.

There are some elements of the lived Pop discourse in the Italian avant-garde movements as well. Once abolished by the most

extremist nonideological ideologists, every possible literary tradition, even the most recent (since they are as always in some sense crepuscular, sentimental, i.e., populist, aestheticizing, etc., etc.), up to the negation of literature altogether – the possibility of communicating through some written object on the one hand has become extremely restricted, limited by an infinity of normative negations which are not devoid of moralism. On the other hand, it has become extremely new.

The page has become intensely and madly substantivized, with the prevalence of lexical combinations in the most purely and scandalously monosemic state possible (if every syntactical movement always risks presenting itself as a literary movement, prefigured by tradition). To abolish literature and tradition as forms of an inauthentic establishment, it is clear that every stylistic decency must first be abolished, and then even the syntax, which has not, therefore, been disintegrated or rendered abnormal by illegal usage or, in short, in some way made sacrilegious, but, in fact, completely abolished.

The text is therefore presented as a 'written thing' outside of every syntactic shell: thus, such a text is arranged completely on one single plane, like the different strokes of children's drawings or primitive writing. Variety in the planes is created artificially with the help of typographic means and with the diverse combinations of that infinite series of nouns that are words outside of syntax.

This writing is presented as if freed from the series of forces, practically outside any possible calculation whose equilibrium maintains a classical (syntactic-stylistic) linguistic system, just as the balance among physical forces keeps the universe together. Those innumerable forces that attract or repel in all directions are, so to speak, surviving 'poles', yes, precisely through tradition, which is a series of feats as well as negations: *and as such, as well as order, it is also chaos.* Syntax is the reproduction of the order and chaos of linguistic history (the discovery of all the poles, whose forces of attraction and repulsion hold together a syntactic period, would be the reconstruction of all history, etc., etc.).

In the moment in which a writer renounces historical tradition's present and coexisting crystallizations, first and foremost he must make a simplification: that is, a reduction of the poles that hold together his 'thing', which, if it is not syntactic, is still written, and in any case thus possesses nexuses (if only mechanical ones) that make a totality out of the single monosemes. Without these forces in equilibrium, the written thing would be dissolved centrifugally simply by the force of negation.

To replace the incalculable number of poles that tradition offers to a linguistic system through syntax as a historical institution – both evolved from and tethered to all its preceding obsessions – the writers of new linguistic systems have only two 'poles' (apart from those that survive in spite of themselves, in an elementary way in the lexicon, in the semantemes, albeit dissociated, in the fragmentation of the noun–adjective, noun–verb relationships, etc., etc.). One pole is, indeed, negation, and the other is the myth of the future: their written things are presented as nonhistorical, and, together, as harbingers of an immediate future history.

In this particular linguistic case, if we are not deceiving ourselves, negation is a negation of the osmosis with Latin, and the myth is the myth of technological osmosis. Hence man is understood in his prefiguration as '*Homo technologicus*' (the classicism of Latin titles is a fatal product, albeit a secondary one, of the myth: every mythicization can only be presented as substantially classicist).

On the basis of the denial of social and linguistic values of the past and present is anchored a sort of 'mimesis' of values of the future, but, naturally, very simplistically – since every complication and depth is assured to a new ideology by its contact with the infinite ideologies of the past – while, in the case of these written 'things', the ambition of total novelty and the rejection of the past make the ideological 'poles' which hold them together have an almost childish coarseness. However, these values of the future are seen through their mythicization. They are certainly not foreseen through the always de-mythicizing methodology of science, or at least that of the real desire for knowledge. For this reason, it can be

said, perhaps in part outside of their intentions – but certainly as a result of the moralistic-negative violence of their normativity – that at least three quarters of the number of their texts without internal surfaces (Sanguinetti himself is completely frontal and flat, like a neoclassicist) is a strange form of free indirect discourse.

In other words, they write 'speaking through the voice of . . .' and the voice is that of a mythic '*Homo technologicus*' who, like an upside-down hero, is founded on the denial of all that is past and present, and at the same time offers the possibility of crazy new polysemes, replacing history with a surreptitious and sacral prediction of history.

A possible new 'stylistic condition' for the Free Indirect, then, is the hypothesis of a future world and future language – whose scientific and logical condition will never be reliable, while a certain degree of reliability can be attained through some form of writing: in our case, a kind of 'already experienced discourse'.

The language spoken by the hypothetical 'homo technologicus' and already experienced by avant-garde movements is based above all on the negation of the current language, which is expressed through an arbitrary and approximate destruction – *a fortiori*, since the real decline of a language is unpredictable: there is thus a kind of symbolic linguistic destruction through a transformation of the language into echolalia. But how? By replacing 'literary figures' that vaguely maintain their more recent hermetic-expressionistic physiognomy with analogous figures (meters, typographic aspects, etc.) made with casual, sacrilegious material. Yet, and here is the point, this material is sometimes taken in bulk, as in Pop art, from the technical systems of a world so contemporary that it trespasses on the future. Let's take from journalistic systems of mass diffusion – exactly antithetical to the classical cultural communication of the elite, etc. – and let's say through the manipulation of electronic machines (as Balestrini did in a significant way [with his computer-generated poem 'Tape-Mark I']). The result is the coexistence of a fictitiously destroyed language and a fictitiously reconstructed language in the 'already experienced discourse'. Hence, it is a

question of a hypothesis, that is, a completely reverse procedure compared to scientific ones.

So, even in the avant-garde movements of the '60s, there is that sort of scientific naiveté that characterized certain avant-garde movements from the beginning of the century. But while the Futurists, say, extolled science as a product of bourgeois society – whose petty and conservative part they condemned, but with whose aristocratic and dynamic part they identified – the avant-gardists of today, I would say, *mythicize science as applied science*, and, as such, as the modifier of society precisely in a palingenetic sense. In the avant-garde movements' collages, lexical and typographic combinations, without shadows and depths, the mimesis of the spoken language of a forthcoming man, 'redeemed' by applied science, flows as a unitary element.

In sum, the traditional language, which we can get to a point *almost* contemporary with us (writers), is a language A, that I wish, absurdly, along with the avant-garde movements, to consider as collapsed. This *almost* corresponds roughly to the first years of the 1960s, a moment in which the presence of Italy on a worldwide level of neocapitalist evolution was dramatically demonstrated (in Northern Italy: the South remaining involved in everything, as new types of basic infrastructures and a new type of urbanism – for example, in Turin immigrants no longer learn the Turinese dialect of Fiat workers, but their dialecticized and technicized Italian). Such a phenomenon has involved a diachrony between writers and reality. The purpose began to move within the linguistic sights and escaped them.

. . .

In the Italian avant-garde movements, the reasons for their 'moment zero' have an air that is also a bit archaic and which somewhat embarrasses anyone who, like me, is convinced that these new movements are a very different thing from the avant-garde movements of the beginning of the century. The 'moment

zero' understood as a metaphysical crisis – as a personal-collective debacle, etc., etc., to be explored and resolved in the darkness of the conscience, turning to anarchic and irrational psychological and socio-psychological apparatuses, and implying a 'starting over from the beginning' of vaguely Rimbaudian ancestry whose formulas are already well-prepared there, extremely and boldly vital – makes the definition of that 'moment zero' profoundly insincere . . .

Pasolini here uses Giulio Herczeg's study, The Free Indirect Style in Italian *(1963), as the basis for a wide-ranging exploration of the 'Free Indirect Style': a mode which merges the objectivity of third-person narration with the inflections of subjective speech and thought. Salient in the novels of Jane Austen, Henry James, and Flaubert (and in Italy, Giuseppe Verga and Pasolini himself), the Free Indirect appears in the full gamut of modernist literature, often as a defining characteristic. Pasolini describes it as a means of 'reanimating the speech of another'; the writer does not simply represent his figures, but channels their consciousness to the point of a 'lived imitation', an 'ironic mimesis'. He also (characteristically) insists upon the Free Indirect's 'sociological' ramifications; its very emergence, for Pasolini, is traceable to economic factors rather than formal or aesthetic ones. Falling somewhere between the extremes of other Marxist verdicts – Valentin Voloshinov's theory that the Free Indirect signals the triumph of bourgeois alienation; or Gilles Deleuze's that it promises a 'collective of the oppressed' – Pasolini's postulation is characteristically ambivalent. In his view, Free Indirect discourse suggests not a utopian merging of subjective-social positions, but, rather, the affirmation of their inexorable difference, within a shared narrative space.*

Though named by early twentieth-century linguists and critics, and subsequently studied by a range of literary scholars, perhaps no one before Pasolini had invoked the Free Indirect with regard to the cinema – a theoretical line that he also plies in the contemporaneous essay, 'The "Cinema of Poetry"' (1965). The very possibility of a

'cinema of poetry' hinges for Pasolini upon the presence of the Free Indirect, a styleme that returns film to its originary, privileged rapport with memory and dream. He roots film's 'expressive' capacity – long since banalized in commercial productions – in a capacity for destabilized subject positions, evinced through the Free Indirect. Painting and the visual arts remained touchstones for his theory of cinematic poetry and Free Indirect Style, from the 'neo-Cubism' of Jean-Luc Godard to the formalist immobility of sequences by Michelangelo Antonioni, 'as mysteriously autonomous as paintings'. In 'Observations on Free Indirect Discourse', he invokes the Free Indirect with regard to what we would now call the 'appropriationist' dimensions of collage, Dada, and Pop – an avant-garde mimesis of contemporary (neo)capitalist cultural modes in order to ironize their communicative modes from within their own (dehumanized) idiom.

I Started Painting Again Yesterday (1970)

Yesterday, 19 March, I started painting again for the first time in three decades (a few exceptions notwithstanding). I couldn't manage to do anything in pencil, or pastel, or ink. So, I took a bottle of glue and poured it directly on the paper, drawing and painting at the same time. There's probably a reason why I never decided to attend an art school or some academy. The mere thought of creating something traditional makes me nauseous – it literally makes me sick. Even thirty years ago, I made things difficult for myself. I made most of my drawings at the time with the tip of my finger, squeezing right from the tube onto cellophane. Or else I drew with the tube itself. As far as actual paintings, I did them on burlap – the more coarse and full of holes the better – primed in the clumsiest way with glue and gesso. Even still, I couldn't (or can't) claim to be an informalist painter. I'm more interested in the 'composition', in its contours, than in materials. And yet I manage to make the forms I want, with the contours I want, only if the material is resistant, impossible, and especially if it is a 'precious' one. The painters who influenced me in 1943 when I made my first paintings and drawings were Masaccio and [Carlo] Carrà – neither of whom, indeed, paid inordinate attention to materials as opposed

to form. My interest in painting suddenly ceased about ten or
twelve years ago, during the time of abstract painting's ascendency,
and then that of Pop. The interest is stirring again. Just as they were
in 1943, my painting's subjects can be nothing other than every-
day, tender, and perhaps idyllic things. Despite [Roberto] Longhi's
cosmopolitan influence – a divine authority which I adored so
much at the time I did not even pray to it – my painting is dialectal:
dialect as a poetic language. Exquisite, mysterious – the stuff of
altarpieces. I still feel the religion of things when I paint. It's as if
time hasn't passed, like a thirty-year parenthesis; I suddenly find
myself again in front of a canvas, at the very moment I gave up
painting. Among my aforementioned idols I forgot to mention
Morandi, and I can't hide my immense love for Bonnard (his after-
noons soaked in silence and Mediterranean sun). I would love to
be able to make a canvas similar to one of his Provençal landscapes
which I saw in a small museum in Prague. At worst I would like to
have been a minor neo-Cubist painter. But I could never, ever
bring myself to use chiaroscuro, or to blow colour with the spongy
purity and perfect cleanliness proper to Cubism. I need expres-
sionistic materials, with no alternative. (As you can see, even dilet-
tantes have their manias).

*Though written in 1970, this short text was first published only post-
humously in 1992, in the magazine L'Espresso (1955–), to which
Pasolini had contributed. He presents his reprise of art-making as
something coming out of the blue. Over the previous decades,
however, he had experimented on several occasions with painting,
drawing, and even collage, albeit fitfully. The previous year, for
instance, he had improvised a number of portraits of the opera diva
and actress Maria Callas as they both sat on a beach in Tragonisi,
following their collaboration on his film Medea (1969). Made from
flower pigments, wine, and coffee on paper, these works differ from
some of the works he composed subsequently, some of which resem-
ble informalist painting (in spite of their figurative titles, such as
Sandbanks beneath a Grey Sky, c. 1970). His mixed-media portrait*

of the poet Andrea Zanzotto from 1974 subordinates the sitter's facial profile to a splatter of earthy pigments – the kind of improvised experiment with materials which he describes here. Whatever the oblique resonances of his works with contemporary trends, or his reverence for aspects of 'cosmopolitan' modernism, Pasolini insists once again upon the 'dialectal' pith of his imagery: a crypto-religious reverence for the quotidian as refracted through a poetics of the local and of the material.

What Is a Teacher? (1970)

What is a teacher?

A teacher is generally understood as such only in *retrospect*. The meaning of the word thus resides in memory, as an intellectual (if not always rational) reconstruction of lived reality.

In the moment that a teacher is actually, existentially, a teacher – that is, before being construed and remembered as such – he is thus not really a teacher, in the true sense of the word.

That which he transmits is *experienced*; the perception of his worth is existential.

Longhi was simply one of my professors at university; but the classroom where he taught was different from all the rest, separate from their scholastic entropy, excepted and isolated. At the centre of this very *different* environment (different for practical reasons: namely the need to project slides) was a man who was, in reality, a bona fide man. By this, I mean that the humanity of more middling professors – his colleagues – emerged always from beneath a thick professorial crust, in the form of a coarse and unrefined fraternity, a miserly and abidingly petit-bourgeois humanity, of weak (and perhaps Fascist) flesh. No: before he was a professor (and thus a teacher) Longhi was a man, precisely because there was nothing

professorial to slough off in order to find him; he already was what he was, namely a superior individual. That is, he was a man insofar as he was a superman, an idol, a character from the *Divine Comedy*. For a student to have anything to do with such a man entailed the discovery of culture as something different from scholastic culture. The professor is a man alienated from his profession, an authority who in the best of cases sheds the authoritarian mask only to reveal another mask, that of the modest public functionary. Culture, by contrast, places upon the face of man a mask that he incarnates and which cannot be removed: a mysterious mask, as mysterious as humanity when it expresses itself, when it does not remain obtuse and petty and vile in comportment, code, convention, and society. Longhi unsheathed himself like a sword. He spoke as no one else spoke. His lexicon was a complete novelty. His irony was without precedent. His curiosity had no model. His eloquence had no agenda. For a student oppressed and humiliated by scholastic culture – by the conformism of Fascist culture – this was revolutionary. The student stammered after the teacher. The culture the teacher revealed and symbolized emerged as an alternative to the entire reality the student had known up to that point.

This text might have been conceived as an obituary for Longhi (1890–1970), who died in June of this year. It was first published in French in 1974, and subsequently in Pasolini's collected works in Italian. As we discussed in the introduction, the eulogy's key term is 'maestro', used in Italian academic circles to distinguish one's mentor (usually the thesis advisor) from other professors.

The Mongoloide at the Biennale Is a Product of Italy's Subculture (1972)

About a dozen years ago, Italy's literary scene witnessed the emergence of the *neoavanguardia* [neo-avant-garde]. It was a movement which reacted against the strain of political 'commitment' in vogue the previous decade, and it reacted in the name of a new kind of life and a new kind of rapport with society. Misery was no more, but affluence was everywhere; the big boss was no more, but technocrats abounded, etc., etc. Integration was preordained, and so it might as well be carried off with cynicism and elegance. The neo-avant-garde accepted the new values – not yet wholly defined – of neocapitalism: it placed itself in the service of a neocapitalism that destroyed, in linguistic and literary terms, the classical values of classical capitalism.

The great 'internal' revolution of capitalism initiated at the start of the 1960s – when bourgeois society revitalized itself through a kind of palingenesis – found its usual idiot and thuggish servants among the *neoavanguardia* literati. The first concern of these literati was to divest of any value – to the point of complete execration – the previous generation's writers, still bound as they were to traditions both classical and more recent, and still ingenuously steadfast in their role as court jesters (whether to bourgeois power or to its opposition).

Then '68 arrived. The student revolt engulfed and destroyed this neo-avant-garde (even as the latter cynically latched on to and became confused with the student movement). The New Left, which seemed for a moment to be born during that revolt, presented itself in literary terms as strictly utilitarian and content-based. That is, it challenged the neo-avant-garde's lack of political 'commitment' without even addressing or debating it, so marginal and frivolous did it seem. This New Left appeared to reclaim the prior literary idea of 'commitment', but with such radical crudeness as to prove downright neo-Zhdanovist.

It was from this maximalist perspective that the students rejected even the historical 1950s-style 'commitment' as ambiguous, anaemic, and compromised in its relationship both to power and to those opposed to power. Even for the students of '68, their first concern was to strip any value from the exponents of established culture, no matter the latter's particular or personal merits. Whether in its own right or in the work of its exponents, traditionalist culture (be it classical or more recent) was thus, in the brief span of ten years, divested of any value, wholly discredited. The perspectives from which this culture became 'globally' criticized – to the point its utter deconsecration – were diametrically opposed, but the result was the same.

In carrying out a purely verbal revolution, the neo-avant-garde, as I have already noted, played the game of the new bourgeoisie, seeking to rid itself of the old classical rubbish along with the new (above all the sense of 'commitment'). Yet even the students, without knowing it, played the same game: they thus did nothing other than undermine and discredit that which the powers that be call 'quasi-culture'.

But this is not the only point linking the fatuous, *arriviste*, and purely literary revolution of the neo-avant-garde to the neo-Marxist revolution of '68. What further unites these two 'revolutions' is a critical language drawn from the sociology and the human sciences of the neo-bourgeois world.

This shared linguistic ideology has afforded a kind of amalgamation between the neo-avant-garde and the student movement:

it has permitted, that is, the apolitical to enter effortlessly among the ranks of the students (who are, by contrast, politically committed) and has allowed the latter to take advantage of the readymade argument against the political commitments of an older generation. This amalgamation, utterly absurd, between the neo-avant-garde and the student movement is due, on the one hand, to the cynicism of the neo-avant-garde (or rather, their neuroses), and on the other to the students' literary ignorance.

How has Italian subculture reacted? It has reacted with the usual conformism, and with the habitual, total critical incapacity characteristic of any subculture; it has, that is, given in to the extortions of actuality and fashion.

First, it accepted the devalorization of Italian culture undertaken by the neo-avant-garde in the purely literary realm (justifying this devalorization as a historical act of the transvaluation of values). Then, it accepted the student movement's devalorization of Italian culture in the ideological and political realm (subscribing to the terrorism attendant upon such a process).

Thus, today, everything is presented as 'devalued'. It is true that the motivating factors of the neo-avant-garde have, in the intervening period, passed out of actuality; equally true is that the student movement has also since passed out of actuality. Yet Italian subculture has reified the devalorization undertaken for very different reasons by the student movement and the neo-avant-garde, respectively; and this subculture has done so for reasons all its own, reasons pertinent to its very historical existence: namely, ideological indifference (*qualunquismo*). What the neo-avant-garde and then the student movement reduced to a degree zero was easily transposed to the zero degree of petit-bourgeois Italian subculture, which received it happily. The latter has borrowed from the neo-avant-garde its facile anti-traditionalism, along with the pragmatism and utilitarianism so particular to the student movement.

Every cultural moment generates its own notion – perhaps ineffable – of the work of art. Today, when all values have been brutally reduced to their zero degree, what sort of idea about the work of

art may we locate in the head – and in the critical eschatology – of Italian subculture? Such an idea fuses the idea of the neo-avant-garde (absolute experimentalism, literariness to the point of illegibility and inaccessibility) with the idea of the student movement (the most legible and serviceable of content-driven phenomena): a simply monstrous fusion.

This monstrosity has haunted every moment of Italian life for the last several years. Indeed, even outside the realm of literature, this monstrosity of historical subculture, a fusion that combines two irreconcilable cultural perspectives, manifests itself in everyday life. Consider the extreme cases of cultural provocation – phenomena unthinkable up until a few years ago, at least in such striking numbers. The phenomenon is born of the common ground between fascism and *gauchisme*, between the *qualunquista* and the Marxist; thus, the provocateur may be physically welcomed and accepted anywhere since he monstrously mixes the most divergent positions. The case of [Gino] De Dominicis is the typical product of such monstrous confusion. In fact, he could even serve as its metaphor. For he mixes the neo-avant-garde's provocation – 'Pop' art taken to the extreme – with the neo-Marxist provocations of those innumerable little political movements, likewise carried to their extreme, and a fanciful rhetorical posturing. The handicapped young man which [De Dominicis] has exhibited is the living symbol of the idea of the work of art, which at the moment establishes the parameters of Italian cultural (and subcultural) life.

This combative piece came out in Tempo *(1944–), re-joining a larger national debate in the wake of the Venice Biennale, where conceptual artist Gino De Dominicis (1947–1998) had 'exhibited' a young man (named Paolo Rosa, but unidentified at the time) with Down syndrome as a 'work of art' (Figure 29). (Now thankfully retired from common discourse, the lamentable, dubious, and hurtful term 'mongoloide' remained, alas, widely used at the time to refer to certain disabled individuals.) The ethical polemic duly stirred up by De Dominicis' gesture provided a platform for Pasolini to express, on a national stage,*

some of his key ideas on the connection between vanguardism and neocapitalism. Indeed, his essay bears less upon De Dominicis' piece, such as it was, than upon some of Pasolini's abiding bugbears. Chief among them are what Pasolini discerned as the shifting (and even unwitting) alliances between leftist political and cultural factions whose common cause often lay, unbeknownst to their agents, at cross-purposes. Familiar from previous and contemporary writings is Pasolini's linking of the 'purely literary revolution of the neo-avant-garde' to 'the neo-Marxist revolution of '68'. His polemical scepticism regarding the origins and effects of the revolutions of 1968 (memorialized in his infamous poem 'The PCI to the Young!') extended to the largely left-wing cultural circles that made frequent common cause with the student movements. For Pasolini, by the 1960s, the conceptual gestures and formal transgressions of advanced art-making – in the visual arts as in literature – amounted to surface disruptions which left deeper structures intact, even reinforced. Indeed, neo-avant-gardism appears here described as its own strain of coercive 'conformity'.

Though most pointedly embattled against the neo-avant-garde in its literary guise (the neoavanguardia *movement which earned his scorn beginning in the early 1960s), Pasolini also often refers to a wider, interdisciplinary understanding of avant-gardism, hence our alternation between English and Italian versions of the term. The term* qualunquista *(roughly translatable as 'populist' today) derives from the* Fronte dell'uomo qualunque *(Common Man's Front), a political party founded in 1946 by writer Guglielmo Giannini for constituent assembly elections in postwar Italy. Advocating for 'common sense' and a kind of anti-politics, this short-lived but consequential movement arguably inherited most of its consensus from the by then outlawed Fascist party. Its particular brand of anti-establishment, anti-intellectual conservatism and nationalism produced the paradoxical term* qualunquismo: *a sort of anti-ideology that has since been linked to various trends in Italian politics, from the years of Berlusconian hegemony to the more recent Five Star Movement.*

Lorenzo Tornabuoni (1972)

Tornabuoni's painting is a 'technical elaboration' [Figure 34]. It follows some specific and identifiable elements, much like a commissioned work adheres to certain norms in order to achieve the objectivity of an unoriginal 'form' – not an *inventio* but rather a professional *inventum*. Here are some of its elements (though not all the same in nature, nor on the same level):

The academic element: a way of working that recalls academic exercises, not merely as an evocation and thus a purely formal element or erudite reference, but also as a measure of objective success.

The monumental element: an expansion (ironic or not) of the academic style, and thus its first deconstruction or neutralization – since we all know that a 'close-up' inevitably results in semantic distortions.

The fragmentary element: this is closely linked to the academic style; it simultaneously confirms and denies it. Indeed, classical works – the models of neoclassicism as meta-historical constants of the Academy – almost always reached us in the form of 'fragments'. The paragon of any classical perfection is necessarily a partial remnant.

The suspension of sense: typical of non-classical art (whose sense is always completed through a 'figural integration' which synthesizes an entire cultural universe). In Tornabuoni's work, the suspension of sense coincides in part with a fragmentary execution. The missing pieces physically guarantee the impossibility of complete sense.

The stabilization of privileged areas: which are usually, in this case, the head and part of the torso, the groin and the feet – as remnants of a classical monument largely lost to time.

The combination of techniques (another expedient to synthesis, but this time as a plurality, the fragmentariness of the senses): by which the privileged areas are partly painted with oil, partly drawn with pencil, etc. To this combination of material techniques is added a combination of techniques of execution: for instance, a 'clumsy' execution (like that of a schoolboy still in need of training) alongside an 'exquisite' one. Some of the brushstrokes of the oil portions appear a bit dirty and malodorous, while others bear the austere scintillating sensuality of true artistic mastery.

The evasion of space: which is the consequence of all the processes I have described thus far, because the privileged areas, intended as visionary classic fragments, distinguished by different techniques and rescued from a false temporality of erosion, must be situated in some sort of space (the space of the restorer, if nothing else!). In Tornabuoni, that space is notably eluded. Or, more precisely, it is a purely pictorial space. It aspires to a state of extreme purity, yet at the same time gives way to the cultural impurity of the *atelier*. The fragments I have described at times appear in pictorial spaces that have just been painted: for instance, yellow or ochre layered over a background and squared with it, as in an academic exercise of enlarged scale. Where purely pictorial inspiration is lacking, space needs an idea, a stroke of genius, allowing the skill and knowledge of craftsmanship and culture to compensate. The results are the *collages* and *blazons* of Tornabuoni's backgrounds in the vein of formalism, Cubism, etc. In any event, space appears always overexerted because of its 'semantic expansion'.

In order to interconnect the cultural elements partially and imprecisely listed here, Tornabuoni resorts (perhaps instinctively) to a specific cultural inspiration: one that relaunches his internal world, so circumscribed and obsessive, through the hearty and luminous spaces of the external.

With demonic intuition, Tornabuoni has thus chosen the poetics of Russian Formalism, but in the moment that immediately preceded its evolution into Socialist Realism – perhaps spurred by the provocative cult of health, and thinking more of posters than of painting. The choice is sincere, but *also* artificial. Through it, Tornabuoni succeeds in liberating a whole private and intimate world from the miserably clotted malady that Andrea Zanzotto would call a 'schizome'.

Anything that appears small as a proportional distillation of smallness (for instance a drawing on a piece of graph, ledger, or accounting paper) already contains the obscure anxiety of dilation. Yet this anxiety would not have found a cultural outlet in Tornabuoni had he not invented, out of the blue, this model of Russian Formalism as it merged into Socialist Realism; the same continuity that, with a scandalous logic, links Lenin to Stalin. This invention was strictly cultural, *precisely because it was arbitrary.*

Tornabuoni arrived at painting (which otherwise would have remained inaccessible to him, at least technically) through an enlargement of proportions stemming inexorably from the adoption of this model: the *semantic expansion* already mentioned more than once. By virtue of fragments he might have become a 'pure painter' – something he could not have dreamed of becoming before his turn to cultural *pastiche* (a few of his paintings' imperfections and uncertainties appear where space serves not as a background but as a void). Looking at these paintings' 'heroes', and at Tornabuoni's fascinating, coloured graphic work, it is easy to see his peculiar and obsessive cult of 'health'. This would remain a purely psychological (and therefore restrictive, even miserable) element were it not limited to content, which is to say the biography and the socio-physical theophany of these heroes. It is not:

Tornabuoni's cult of health is first and foremost a cult of formal health.

In the crucial moment when the '*petit mal*' is projected expansively onto a monumental canvas – site of a great formal health – a series of contradictions becomes apparent. Through the mythical crystallization of 'Formalist-Realism', Tornabuoni moves from a neo-Decadent culture of *res communis omnium* to a neo-academic culture with its fragmentary banner of Objectivity and Health. The resulting contradictions are multiple, asymmetrical, ambiguously defined, and difficult to grasp.

In the archetypal poster for a Russian film from the 1920s, for example, revolutionary workers are depicted using a lathe or wielding a weapon against the Tsarist police, with stylized yet powerful gestures. The same workers appear transfigured in Tornabuoni's painting into rowers: Olympic athletes training to defend the Italian *tricolore*. With absolute innocence, Tornabuoni derives inspiration from the Heroes of the Revolution to figure the exemplary Heroes of the Integration.

To be sure, he captures the Heroes of the Revolution in an ideal moment: as they emerge out of a 1920s poster for some formalist film to enter the (much less austere) poster for a Socialist Realist film under Stalin. They are Heroes of the Revision. As such, they can be taken quite legitimately as models for the Heroes of Italy's patriotic Integration. One must nevertheless admit that such a veritable tangle of passions, references, and allusions ultimately only eludes and discredits everything.

Many of the elements I have analysed in Tornabuoni's painting do not appear in his drawings (if we can call them that). In the latter there is *no (material) monumentality, no fragmentation, no suspension of sense, no stabilization of privileged areas, no evasion of space. Only two elements* remain: *the academic element* and the *combination of techniques*. Some of the others, like *fragmentation* and *suspension of sense*, disappear because they are so rooted in the recent tradition of drawing and sketching that they become irrelevant. Others are simply unnecessary.

From a cultural perspective, Tornabuoni's drawings and paintings represent two separate phenomena.

Proof of this lies in the fact that Tornabuoni does not need to resort, in his drawings, to the arbitrary excuse (or the cultural choice) of Soviet Formalist-Realist *pastiche*. His drawings are never based on the 'dry' techniques typical of 1920s Soviet graphics – aniline dyes, quick-dry inks, etc. In Tornabuoni's drawings, the 'schizome' appears for what it is; it is not relaunched in different dimensions or transformed into something else through the myth of Objectivity and formal Health.

The arbitrariness of Tornabuoni's principal cultural action appears for what it is in his drawings: pure arbitrariness expressed through technique. That is, through a culture that has become 'natural' and absolute following a long codification.

The element of the *combination of techniques* simply combines, in the drawings, the *academic* and the *arbitrary* elements. Such a combination takes place at both the macroscopic and the microscopic levels.

Macroscopically: the complete legibility of a portrait or a head, apparently drawn according to the most traditional conventions, *combines* with an indecipherable and magmatic background, filled in, as if by a thick and almost rudimentary curtain of pastel, on the other side of the transparent sheet. Or a self-contained drawing – complete even if 'suspended' – *combines* with matter of a different nature, like little beads glued to its surface (which evidently reproduce the geometry of certain constellations).

Microscopically: the hatching, a typical academic element. Observed with a trained eye or through a lens, the hatching reveals that its shadows aspire to unnatural geometric transformations: small, frenzied architectural masses. Within the very same tangle of hatching, the eye finds the sign to be nothing other than a capricious doodle, ineffably awkward and ineffably exquisite.

An approximative and, of course, elected (if not celebrated) portrait thus becomes devoured by that self-destructive element which is contamination. The combination of the academic and the

arbitrary leads inevitably to the predominance of the latter, which is
to say to a kind of *stupor*, which simultaneously endows Tornabuoni
with the precise and rare definition of the cultured painter.

*Born in Rome, the painter Lorenzo Tornabuoni (1934–2004) held
his first solo exhibition at the Galeria L'Obelisco, one of the capital's
most prominent and international galleries after the Second World
War, and the first to exhibit Robert Rauschenberg's work in Italy.
Tornabuoni's canvases proved altogether more conventional than the
L'Obelisco's more avant-garde fare. He pursued a flattened figura-
tion, centred chiefly upon the human body, into the 1970s and
beyond. Originally titled 'A Brief Study of Lorenzo Tornabuoni's
Painting', Pasolini's essay was printed to introduce the painter's exhi-
bitions at the Galleria Forni in Bologna (1967–) and the Galleria Il
Gabbiano in Rome (1967–). His description of Tornabuoni's robust
and athletic figures as 'Heroes of the Integration' alludes to contem-
porary theories of 'integration' by both Herbert Marcuse and
Umberto Eco, invoked here as shorthand for the hegemony of
neocapitalist culture, 'a culture that has become "natural" and abso-
lute following a long codification'. The catalogue also included an
essay by Enzo Siciliano, a playwright and critic who, in addition to
appearing as Simon in Pasolini's* The Gospel According to St.
Matthew, *would later serve as one of his first biographers. The term
'schizome' (schizoma) was invented by the Italian poet, Andrea
Zanzotto, a friend and colleague of Pasolini's. Zanzotto defined the
word, in the notes to one of his most important poems ('La Pasqua a
Pieve di Soligo', in* La Beltà, *1968), as a 'proliferation of divisions,
progressively dilating and branching out, more and more, toward the
yes and the no' (un proliferare di scissioni sempre più dilatate e
ramificate verso il sì e il no).*

Roberto Longhi's *From Cimabue to Morandi* (1974)

Thinking back to that small classroom with very tall desks and a screen behind the lectern, where I attended Roberto Longhi's courses at the university in Bologna over the academic year 1938–39 (or was it '39–40?), I feel like I am thinking of a desert island in the heart of a lightless night. Longhi himself, who always came and spoke at that lectern and then just as quickly departed, feels as unreal as an apparition. And he *was* an apparition [Figure 30]. I never could have fathomed that, before and after he spoke in that classroom, he had a private life of his own, and tended to that life. In my immense shyness as a seventeen-year-old (looking fourteen at most) it didn't even occur to me. I knew nothing of tenure, careers, interests, transfers, curricula. What Longhi said was charismatic. The fact that I was also instinctively curious about him as a man, or that he was a bit curious about me, and that I felt a profound sympathy for him (a bit reciprocal, I think), is beside the point. Our rapport was ontological and absolutely impervious to any practical specification. This might be one of the reasons why *all this* belongs to another world. Only later did I try to summon up this time and place. However, my shyness may have endured enough to prevent me from recollecting with practical effectiveness, or with any real

ability to break the idealistic veil that separated me from my teacher. One could say that, after that time in Bologna, we became friends, even if our interactions remained scarce. One could even say that Longhi became my real teacher only after that time. Back then, in that wartime winter of Bologna, he was simply the Revelation.

What did Longhi do in that cloistered room, almost impossible to find, in the campus on via Zamboni? Just some 'history of art'? The course I have in mind was the unforgettable 'Facts of Masolino and Masaccio'. I dare not say anything on the subject now. I would like just to analyse my personal memory of that course; and it is a memory encapsulated in the juxtaposition of, or distinct confrontation between, 'forms'. Slides were projected on the screen: full-scale reproductions and details from the works of Masolino and Masaccio, painted in the same places, at the same time. Cinema *acted* there, even if only as a mere photographic projection of painting. It acted when a 'shot' representing a sample of Masolino's world was dramatically 'countered' – with the continuity that is typical of cinema – by a 'shot' representing, in turn, a sample of Masaccio's world. A Virgin's mantle cutting to another Virgin's mantle . . . the close-up of a Saint or a bystander to that of another Saint, another bystander . . . The fragment of a formal world was physically, materially, placed in a montaged sequence with the fragment of another formal world: one 'form' with another 'form'.

Gianfranco Contini (should I note that it is through him that Longhi revealed himself to me as my true teacher?) has now collected, in a volume of 1,139 pages (densely printed and hence nearly three times the length of a normal book) an anthology of Longhi's writings, including, of course, 'my' 'Facts of Masolino and Masaccio'. Contini has penned the introduction, enriched by a selection of critical essays on Longhi (by Cecchi, De Robertis, Mengaldo, and Contini himself) as well as a wonderful general bibliographic note. In a civilized nation, this would form the cultural event of the year. And yet, to invoke Longhi's own mocking line on the 'philistines' (from back in 1913!), Art is not tantamount to the 'administrative control of life'.

Leafing through the book, considering how it came to be and reading here and there, I must say that, at first glance, I had some reservations about Contini's editorial work, about those aspects which he surely expected might generate some reservations on the reader's behalf. First, the lack of reproductions of the paintings to which Longhi's essays refer. Then, the non-chronological sequence of the essays (the one I mentioned for instance, written in 1913, appears toward the book's end), which forces a reader to reconstruct painstakingly, by himself, what matters the most: the history of Longhi's style. And finally, the mental architecture which emerges from that sequence of essays, which is the structure of an 'Italian history of art', from which Longhi was profoundly (but also, one must admit, ambiguously) distant. That sequence forces a reader to follow what he cares about the least: an 'Italian history of art'.

Contini does not defend his work in the introduction with the usual hypnotic elegance or jovial infallibility. Therefore, the reader has to tackle the hulking text by himself, with no help, no preparation, no method. It is an adventure. The main common thread is, of course, 'Longhi as a writer', or better, 'Longhi as a great writer, at least as great as Carlo Emilio Gadda'. Indeed, the whole text owes its essential coherence to those passages in which the greatness of Longhi as a *writer* manifests itself in all its unruly inspiration. The guiding principle of this writing is reticence. While reading Longhi as a writer, one never forgets, not even for a moment, that Longhi was a critic – one engaged, always quite dangerously, in hypotheses, discoveries, reorganizations, attributions. These are *always* based in a reading of the relevant painting, *never* in the reading of documents about the painting – documents, that is, which may provide objective information about the painting. In his attribution of a painting to a specific artist, or his reconstructions of the entire personality of that individual (as if in some gripping detective story), Longhi never resorted to external, philological data. He always limited himself strictly to the internal logic of forms. The stakes were thus always high. Hence his caution, and his irony. The

direct, formal product of Longhi's reticence (the sum of caution and maieutic irony) in his writing is the effect of 'foreshortening'. His descriptions of the paintings that he examines (and those descriptions of course form the high points in his 'prose') are all foreshortened. When it is 'translated' into Longhi's prose, even the simplest, most direct and frontal painting appears obliquely, from surprising and challenging points of view.

Linguistically, the 'foreshortening' is introduced by an hypothesis, or an invitation, or a final statement (the Q.E.D. of a theorem, but never with a triumphalist tone). All dropped in passing, hastily, merely expedient to hypothesizing or concluding a line of reasoning: the descriptions of paintings (or, better, descriptions *of the reality* that those paintings represent) take on a piercing, visionary exactitude.

The book's hidden meaning is revealed only slowly, by following the vital, exalting, tenacious, obsessive research that Longhi conducted, which essentially consists in making the truth of criticism coincide with the various shapes that reality, through the centuries, assumed in the hands of various painters. This meaning is certainly legible in the book's overall coherence, but that coherence is not limited to the series of often superb results achieved by the expressiveness of Longhi's 'prose'.

The sense of coherence in this great book of essays lies, I believe, in its 'history of forms'. By history I mean evolution, yet in the purely critical, vital, concrete sense of the word. Such an evolution obtains very slowly: even if their sequence is logical to the point of seeming preordained, its episodes possess the rhythm of 'slow motion'. Let's imagine that, instead of foreshortened in the descriptive peaks of Longhi's discourse (which also gets clogged up in Proustian 'research'), these evolving forms could present themselves to us materially, through the aforementioned slides from that mythical course in Bologna. And let's imagine that the projector, back then, could apply to those slides a laughably accelerated rhythm. The meaning of the 'evolution' of those 'forms' would be then manifested synthetically, in an almost relentless mechanical consequentiality.

What if those slides represented, in detail, the 'form' of the folds of the Virgin's mantle on her knee, or around her womb; or the 'form' of a small background landscape; or the 'form' of the face of a Saint or devotee? And what if we load in the projector, as the first slide, one of Cimabue's 'forms' (or else one of Giotto's more breathable images, or one by Stefano Fiorentino), and last of all, one of Caravaggio's 'forms'? What if we accelerate the projection? If we do that, the *evolution of forms* unfurls before our eyes as a wonderful critical film, with no beginning and no end, *and yet perfectly eschatological*. Longhi had already understood all of this when he was a young critic for the journal *La Voce*. From Alba, on 18 March 1913, he writes:

> Every time it reaches a static, corporeal saturation, Art is animated, whether by combination or imposition, by a search after motion. This is what, speaking broadly, the Egyptians represent in comparison with the Greeks, or the Gothics with the Romans, fifteenth-century architecture with classical architecture, Baroque with Renaissance ... Well, the problem of Futurism in relation with Cubism is the same that the Baroque had with the Renaissance. The Baroque does nothing but put the mass of the Renaissance in motion ... a thick and sturdy marble table is curved, pressed by a gigantic force ... The ellipse follows the circle ...

Since then, Longhi has not really cared about anything other than observing this sense of 'succession'. It is a disinterested succession, absolutely devoid of utopia, illusion, or progressive terrorism; its finality is self-defined and self-built in its substance, moment by moment, act by act, concrete invention by concrete invention. Longhi's criticism is thus extremely pure, perfectly contemplative. Its only illusion is an unrelated one: the illusion that reality can be indefinitely expressed through a series of dramatic rediscoveries (think of his rediscovery of Caravaggio!). The rest are modest historical illusions, more or less servile, more or less hypocritical.

Longhi's amazing theatrical abilities, his austere jewellery, are nothing in the face of his lucid, humble asceticism as an observer of the motion of forms.

Discussed at length in our Introduction, Pasolini's homage to his former teacher Roberto Longhi (Figure 30) appeared in the newspaper Tempo *after the publication of the large anthology,* Da Cimabue a Morandi *(1973). Published in Mondadori's prestigious 'I Meridiani' series, the anthology consecrated Longhi as a paragon of modern Italian prose – the only art historian whose work had appeared in such an eminent editorial platform. As Pasolini notes, the literary critic Gianfranco Contini – another of Pasolini's key mentors and the editor of the Longhi anthology – served to further underscore Longhi's consequence for Pasolini's hermeneutic, stylistic, and prosodic development. The prose of Carlo Emilio Gadda (1893–1973), a practising engineer and one of Italy's most celebrated authors, found extensive exposition in Contini's criticism and was also an enduring interest of Pasolini's. Evoked proto-cinematically in this text, movement ('moto') formed a central theoretical preoccupation for Longhi, who envisioned art history as a periodic alternation between two shapes: the circle and the ellipse. His trans-historical approach to this recurring contraction and dilation was extremely influential for Pasolini, and is well represented in Longhi's early texts on modernism. In particular, his essay on Boccioni's sculpture directly resorts to Baroque aesthetics to explain Futurist solutions to representing movement. This is the only full-length essay about Longhi and his teaching that Pasolini published during his own lifetime.*

Carlo Levi's Painting (1974)

I, too, have seen the exhibition at the last possible moment, due to the usual delays in the way of such occasions.

I spent an hour in the galleries, looking intensely and dramatically, dramatically ... Since I am still in shock following this dramatic encounter with Carlo Levi's work in its totality, I can only offer a brief (the briefest possible, and unfortunately chaotic) note about the drama I experienced in front of these canvases.

Upon entering the galleries, the first impression is that of normality ... then, bit by bit, through accretion and iteration – perhaps Levi's two most consistent structural characteristics – that normality becomes abnormal. In the broadest sense of the term, however, it remains normal, since one is still looking at a kind of painting that, at its core, wants to be nothing other than painting. I might not have said this ten or twenty years ago, when I already knew and admired Levi, but it is historically necessary and strangely fitting that I say it now.

We are not used to seeing a suite of canvases like these, wherein painting announces its own quiddity totally, utterly. We stand before a brushstroke that is sometimes foaming, sometimes restrained in its colour and therefore absorbed by the canvas; we

stand before the problem of the relationship between contour and fields of colour; we stand before contours so dramatic they lose their semantically intelligible sense and acquire a different one, beyond reality: trees that look like women, women that look like trees, etc.

We stand before matter, now grave, even gross, now subtle and almost ethereal. We stand before Carlo Levi's series of exceedingly pictorial cultural loves. I would say that the emblem of this painting-painting is the canvas *Narcissus*, which, as Levi remarked to me, reveals a particular kind of narcissism. There is no narcissism in Levi himself. Attardi has spoken about his paintings as a series of portraits; and, indeed, at their core, in their substance, all these portraits are self-portraits. One may ask what this accumulation of self-portraits amounts to if not a wonderful, amiable strain of narcissism. Yet this narcissism in Carlo Levi's painting has become a mental structure: the Narcissus that Levi painted is not himself, but rather a Narcissus who, by discovering the image of himself, discovers himself objectively and discovers the objectivity of reality. This is why Levi could paint in such a way and believe himself to be restoring reality through painting. He discovered that reality at once narcissistically and objectively, in a curious and ambiguous way, dramatic and fascinating in equal measure. This, then, is the first impression of normalcy that one experiences upon entering this imposing exhibition.

Something nevertheless contradicts what I have been saying so far. What is this extraordinary contradiction that renders the exhibition's visibility so dramatic? It is the presence in this painting (utterly, totally painting, as I have already said) of something extraneous to painting. I mean here something other than content – I am not counterposing content to a pictorial form, in other words. I mean something specific to the formal dimension of painting: namely, errors. In this painting there are errors. I have come up with a little list, which might ring some bells. There is a young man with a bandaged arm next to a donkey: a beautiful painting, but the bandaging on the arm is flat. It is a small error, a

discordant detail in a properly pictorial sense, a formal triviality. There is the scrawny girl, wrapped in a shawl; I think she's Melissa's girl (someone else has already mentioned her); another extraordinary, moving figure, purely painterly, and yet even here, if you observe the street beneath the girl's feet, you will notice that it is a bit rushed here and there, a bit dirty as some painters might say. Then there is a woman in mourning with a black shawl all around her, an enchanting, pictorial figure; the gillyflower on her shawl is a bit hurried too, a tad dull and bruised. There is a cannibal mother devouring her son; everything is beautiful, extraordinary, but the hands of the mother are a bit hurried. Those hands form a small error, not in terms of anatomy but in the way the chromatic pigment is spread on the canvas. There is a little dormouse, a delight; everything in the painting is beautiful, the branches of the trees behind, the undergrowth, the soil, the dormouse's little face. And yet, again, the terrain beneath the dormouse is a bit superficial, a bit dim.

There are, of course, also some paintings that resolve themselves in pure painting. The portrait of Umberto Saba for instance, or the small self-portrait of Levi with a little white cap and especially red hair (I am uncertain whether this is a self-portrait or else a portrait of someone who closely resembles Levi). In any event, anyone will notice the same elements, not only looking from canvas to canvas, but closing their eyes and recalling patterns in his body of work. In the large social paintings, like *The Struggle in Calabria* and *The Struggle in Sicily*, with their parade of suffering faces, so dejected and famished, black shawls, donkeys, etc.; in these great beautiful paintings, sometimes, in a few corners – in a forearm, in a foot, in a slice of some house seen from the outside – one finds a certain similarity to posters, a light-hearted and sudden superficiality. Thus, not everything is resolved in that pure painting I mentioned. We find ourselves therefore witness to a pictorial drama: a painting that aims to be utterly, absolutely, mysteriously painterly, but haunted with elements that contradict precisely its painterliness, its being specifically and quintessentially painting. We are,

therefore, in the presence of something mysterious, ineffable. To speak about that 'something' I can only fumble in the dark, since I am without a proper terminology, either technical or generic. This 'something' is a mystery to me, and it forms the drama that has fascinated me in this exhibition of Levi's work.

To avail myself of some genericisms I could say that these paintings, instead of being works of art, are really a testimony: a form of love, as someone has said already. And in this magma, in the magma of this love and testimony, one can agree with what Del Guercio said earlier, if a bit less forcefully. It is true that chronology is unnecessary; yet it is also, like the biographical elements that appear in Levi's paintings, necessary. Looking at them now, with him, I learned something from his own mouth: for instance, that some of the works were painted during the war, when Levi learned about the destruction – the bombing – of one of his houses, of his hometown. This surely helps me to grasp that painting better. Levi told me that other works, the paintings of shipwrecks, represent the obsessive recurrence of a memory: a shipwreck that his father drew in seven sketches, a shipwreck that was (Levi understood this only later) his father's death. This is all to say that biographical data about his life, and therefore about his relationship with the world, help to define some sequences, or passages, along with the chronology according to which the paintings were made. These lines are at the same time useful and useless, because what we have looked at is both painting and not painting.

We stand before an extraordinarily ambiguous world, profoundly ambiguous and profoundly fascinating at the same time. To say that Carlo Levi is a great painter is less a compliment than a platitude. And, so, I say that he is something other than a great painter. I conclude here because I want to leave this unresolved. Maybe the best way to define the 'something' that I described in such a generic way, and which leaves me powerless, is to resort to certain techniques, to very specific (even specialistic) kinds of critique: perhaps structuralism, or maybe the old, innocent, candid, beautiful Russian Formalism of the 1920s. To [Viktor]

Shklovsky for instance. This exhibition reveals that Levi's work is painting and not painting; it demonstrates the soundness of structuralist and formalist theories, because there is no genre in it. Levi's painting smashes the boundaries that separate painting and literature, literature and cinema, cinema and something else. It is a triumphal, explosive, vital demonstration that painting is not an artistic genre but something else: a formal universe with its own internal laws, valid only for the specific forms that Levi's paintings take.

If these internal laws govern the ambiguous and narcissistic phenomenon of Levi's painting in a profoundly, strictly, autonomous way, they do not mask the profoundly dramatic conflict between this formal universe and its contents. I believe that an attentive, structuralist, philological study of these laws now falls to Italian critics.

A large retrospective of paintings by Carlo Levi (1902–1975, see Figure 33) concluded in Mantua on 20 October 1974 with a public roundtable on which Pasolini served alongside Levi himself. An author, doctor, painter, and activist, Levi remains most widely known for his novel Cristo si è fermato a Eboli *(1945), a memoir of his internal exile under Fascism in Italy's deep, destitute South. Born to Jewish parents in Piedmont, Levi co-founded the anti-fascist Giustizia e Libertà group along with Leone Ginzburg, and also formed part of the noted 'Group of Six' painters in Turin. Levi penned a preface to, and painted the cover for, the script of Pasolini's first feature-length film,* Accattone *(1961). Having been elected to the Italian senate twice, Levi succumbed to pneumonia not long after this exhibition, at the age of seventy-three. This essay was delivered as a lecture and retains some of its casual style. Pasolini's inaugural excuse of a belated and rushed viewing sheds some light on his rather slapdash arguments; notwithstanding a genuine affection for the paintings and their author, Pasolini's précis hazards, as he notes himself, some generic and even sophomoric observations.*

Caravaggio's Light (1974)

Anything I could ever know about Caravaggio derives from what Roberto Longhi had to say about him. Yes, Caravaggio was a great inventor, and thus a great realist. But what did Caravaggio invent? In answering this rhetorical question, I cannot help but stick to Longhi's example. First, Caravaggio invented a new world that, to invoke the language of cinematography, one might call profilmic. By this I mean everything that appears in front of the camera. Caravaggio invented an entire world to place in front of his studio's easel: new kinds of people (in both a social and characterological sense), new kinds of objects, and new kinds of landscapes. Second: Caravaggio invented a new light. He replaced the universal, platonic light of the Renaissance with a quotidian and dramatic one. Caravaggio invented both this new kind of light and new kinds of people and things because he had seen them in reality. He realized that there were individuals around him who had never appeared in the great altarpieces and frescoes, individuals who had been marginalized by the cultural ideology of the previous two centuries. And there were hours of the day – transient, yet unequivocal in their lighting – which had never been reproduced, and which were pushed so far from habit and use that they had become scandalous,

and therefore repressed. So repressed, in fact, that painters (and people in general) probably didn't see them at all until Caravaggio.

The third thing that Caravaggio invented is a membrane that separates both him (the author) and us (the audience) from his characters, still lifes, and landscapes. This membrane, too, is made of light, but an artificial light proper solely to painting, not to reality – a membrane that transposes the things that Caravaggio painted into a separate universe. In a certain sense that universe is dead, at least compared to the life and realism with which the things were perceived and painted in the first place, a process brilliantly accounted for by Longhi's hypothesis that Caravaggio painted while looking at his figures reflected in a mirror. Such were the figures that he had chosen according to a certain realism: neglected errand boys at the greengrocer's, common women entirely overlooked, etc. Though immersed in that realistic light, the light of a specific hour with all its sun and all its shadow, everything in the mirror appears suspended, as if by an excess of truth, of the empirical. Everything appears dead.

I may love, in a critical sense, Caravaggio's realistic choice to trace the paintable world through characters and objects. Even more critically, I may love the invention of a new light which gives room to immobile events. Yet a great deal of historicism is necessary to grasp Caravaggio's realism in all its majesty. As I am not an art critic, and see things from a false and flattened historical perspective, Caravaggio's realism seems rather normal to me, superseded as it was throughout the centuries by other, newer forms of realism. As far as light is concerned, I may appreciate Caravaggio's invention in its stupendous drama. Yet because of my own aesthetic penchants – determined by who knows what stirrings in my subconscious – I don't like inventions of light. I much prefer the invention of forms. A new way to perceive light excites me way less than a new way to perceive, say, the knee of a Madonna under her mantle, or the close-up perspective of some Saint. I love the invention and abolition of geometries, compositions, chiaroscuro. In front of Caravaggio's illuminated chaos, I remain admiring but also, if one sought my strictly

personal opinion here, a tad detached. What excites me is his third
invention: the luminous membrane that renders his figures separate,
artificial, as though reflected in a cosmic mirror. Here, the realist
and abject traits of faces appear smoothed into a mortuary charac-
terology; and thus light, though dripping with the precise time of
the day from which it was plucked, becomes fixed in a prodigiously
crystallized machine. The young Bacchus is ill, but so is his fruit
[Figure 1]. And not only the young Bacchus; all of Caravaggio's char-
acters are ill. Though they should be vital and healthy as a matter of
consequence, their skin is steeped in the dusky pallor of death.

*The intended destination of this textual fragment, which remained
unpublished during Pasolini's lifetime, remains uncertain. We know,
however, that it was most likely penned in 1974. The 'characterological'
novelty of Caravaggio's subjects, to which Pasolini alludes in passing,
underscores some of the parallels between their bodies of work: an eye
for the unlikely sacrality of the squalid and coarse; a penchant for
boorishness to the point of blasphemy; an attraction to louts and
scoundrels of a certain type – the 'rough trade' of homosexual parlance.
But it was equally an exquisite formal sense – a search after 'new forms
of realism' – which drew Pasolini to Caravaggio's work, particularly
the peculiar accord struck in his paintings between naturalism and
stylization. Pasolini's former teacher, Roberto Longhi, remained at the
forefront of Caravaggio studies from his* Quesiti caravaggeschi
[Questions on Caravaggio] *(1928–1934) to a 1968 monograph on the
artist. Indeed, it was Longhi who had resurrected the painter from a
certain obscurity in the 1920s, arguing for the consequence of his work
to a wider European tradition from Rembrandt and Ribera to Courbet
and Manet. Pasolini professed to 'hate naturalism', and, with some
exceptions, avoided the effects of tenebrism in his cinema. It is, instead,
the very artificiality of Caravaggio's light – a light that 'belongs to
painting, not to reality' – which earns his admiration.*

Nabil Reda Mahaini: God's Flag (1975)

The pleasure of the eyes. Childhood. Old age. The artisan is either old or a child. The Muslim intellectual is either old or a child. Perhaps even if he studied in Paris; certainly, if he studied in Italy. A respectable childhood (it has to do with the senility of religion), a humble old age (it has to do with the infancy of religion).

Dematerialization of all materials. When he does what he used to do as a boy, the old man is never materialist. His pictorial matter amounts to a purely optical effect. In the matter itself is the body, the unrepresentable. Of all that is bodily, one can only represent the gaze of a child. Reality is nothing but God's flag. No wind may ever blow it.

What children learn, adults know. Useless knowledge. We need an alternative. What adults know, old people forget. We need something to cling to. It's a deceptive and arbitrary game. But the hand of the old man gives him an almost pompous authority. Better when it's made of pure colour on hard surfaces. The adult brags about believing in God; the child and the old man make little flags to hang in his honour.

Palm trees. Turkish baths. The smell of saffron. The smell of piss. Even fat Muslim authorities possess the naiveté of children.

Even when they drink whiskey at a vernissage with all the conse-
quent vulgarity, they are naively and visibly happy if . . . Nabil
repeats the gestures of a cunning old artisan from three or four
centuries back. And he has the same candour. His repetition falls
beyond any chronology. The deceptions and arbitrariness of the
game increase exponentially. Everything is crystallized in time
itself. There is no risk that wind may start blowing. God's flag
hangs absolutely still.

*Alongside an essay by Dacia Maraini, Pasolini's short text – a piece
of poetry-in-prose – formed part of the catalogue of Nabil Reda
Mahaini's debut exhibition in Rome, which opened a few months
before Pasolini's death. The Damascus-born Syrian artist was settled
in Italy, bilingual, and had translated a number of contemporary
Italian writers into Arabic, including Pasolini himself. Little trace
remains of his paintings. A filmmaker in his own right, Mahaini
interviewed Pasolini about his* Decameron *for the journal* Cinema
in 1972, and the two worked together on the sets of Medea *and*
Arabian Nights. *Mahaini went on to direct the* Al Sahyunnia
Haraka Unsurria *('Zionism Is a Racist Movement', 1976), preserved
in the BFI archives and featuring Alberto Moravia and the journalist
Sandro Viola, among others.*

Andy Warhol, *Ladies and Gentlemen* (1975)

While talking to Man Ray about my film *Salò, or the 120 Days of Sodom* [1975], there was a moment when he misunderstood me. Man Ray is lucid, intelligent, observant. He is as fresh in his gestures as he was forty years ago. Nothing should slip past him.

Rather than a lack of comprehension, what I experienced with him was a kind of void, a certain obscurity. Where did it come from? I had told him that I set de Sade's novel [*Les Cent Vingt Journées de Sodome*] in 1945, in Salò. It was this that he didn't understand. He didn't understand it because it had escaped him that 1945 had been a particularly significant year. (The end of a war; well, okay, but wasn't 1918 the end of another?) Above all, it escaped him that Salò had been the capital of a small Fascist republic. In fact, instead of 'Salò' he thought – to my utter delight, for whatever it's worth – that I was saying '*salaud*'.

Would Andy Warhol have understood me any better? I have no idea whether Warhol, like Man Ray, is a devotee of de Sade. His transvestites [Figure 36] have a plucky nerve which is not exactly Sadeian. But does 1945 mean anything to Warhol? Does the name Salò ring any bells for him?

I realize this is a bit of a rhetorical question. I ask it only because in it converge a series – or rather a tangle – of other questions in turn. Can history be divided in Warhol's world? Can there be a moment in which one mode of being finishes and another begins? Can there be a historical division of the universe we inhabit, and, thus, of the tiny, precious concentrated universe in which we work? Can dividing lines extend to separate men, and in particular, their respective consciousness? More specifically still, may they separate the ideological terrain of their consciousness? Is there anything that might break down the relentless uniformity which the artist's despoiling mind – out of sheer amusement – throws into complete uncertainty, derides or worships, venerates or renders useless?

A message reaches America from Europe, which implies all these divisions, these disparities, these oppositions at the heart of reality. For this very reason, it remains a mystery. At the same time, a message from America reaches Europe, implying uniformity, homogeneity, oneness, all stemming from entropy; and, for this reason it proves even more mysterious still.

I have before me Warhol's silkscreen prints and several paintings. The impression they give is that of a fresco from Ravenna depicting various isocephalic figures, all of them, of course, posed frontally. The figures are iterated to the point of losing their individual identities and becoming, like twins, recognizable only by virtue of their clothing's colour.

The apse of the cathedral erected by Warhol – and then scattered to the wind like so many cut-out, isocephalic and iterated figures – is in fact Byzantine. The archetype of the various figures is always the same: perfectly ontological.

It is the quality of American life which would seem to render it the equivalent of the authoritarian sacrality of official Christian painting, its aim being to furnish the metaphysical model of every possible living figure. There are no alternatives to such a model, only variations thereof. Notwithstanding the culture's widely recognized pluralism, the American individual is singular. In short, the Model holds more sway than the infinite number of real individuals who

might be walking down 42nd Street at seven o'clock on a summer evening. Even if the social sample is narrowed down to habitués of the Golden Grape nightclub, it hardly defies the Model except in reducing its variation to a minimum, an obsessive iteration. The Obsession. The first and last names of Warhol's transvestites don't matter, their dates of birth are irrelevant; for, they become absorbed into the indivisibility of the Person who prefigures them, taking their place alongside the other archetypal Persons in the pantheon of American Entropy. Let us look at one of Warhol's *Transvestites* and the circumscribed coterie of her (innumerable) variants. When we learn that one 'particular' transvestite is named Candy Darling, and that she died in hospital of cancer a day after throwing a party for her 'girlfriends', featuring an extravagant number of white roses . . . we are apprised of facts which do nothing to change the prefigured and predetermined Person on the silkscreen.

Of what do such variations consist? They can be ascribed to two kinds or branches of technique: (a) photographs of the sitter (enlargement, serial screen prints), and (b) the colours of the enlargements. These are a matter of two 'applications', the one laid over the other. Reality (physical, psychological, sociological) is first made to erupt onto the white surface; and then, over its last, threadbare scraps are pasted the funereal *affiche* which fixes it in an inextinguishable moment of pure vitality. Acrylic pigments – though pure and wholly non-material – are slathered over the surface containing the dilated likeness with seemingly arbitrary strokes of colour. But this is less a question of impasto than of pasted cut-outs. The prints fuse everything in a further surface. The choice of form and colour of the 'pasted cut-outs' is entrusted to a sort of calculated and yet almost automatic inspiration. The contours of the cut-outs play against the realistic forms of the photographic images, redoubling them, setting them off balance, intensifying them. The superimpositions appear always off kilter vis-à-vis the respective anatomies, yet also subordinated to those same anatomies (with a privileging of eyes, mouths, hair, and background). The most patent cultural touchstones for such effects

are advertising posters and formalist *affiches*, along with some flourishes taken from Fauve painting.

With regard to the first technical stratum – involving the photographs – we can observe that the photographs appear obsessively identical: always frontal or three-quarters view, never in profile; always affected, never casual; always posed in the manner of movie stars, never in the offhand manner of everyday life. The effect bears a whiff of psychology, but only relatively.

In fact, the features (and their connotations) speak a psychological language in their own right, despite the effort at self-erasure (even before being photographed or painted) in their role as human clichés. Is not the effort of these transvestites to appear absolutely triumphant, moving and quixotic in their humanity? The effort is as far as they get, in any case. For, the 'Different' may triumph within their permissive New York ghetto as long as they don't stray from a tolerable and identifiable behaviour. The feminine superciliousness of these men is nothing but the grimace of the victim, aiming to excite their executioner with a clownish, regal dignity. And it is that grimace which renders Warhol's *Transvestites* psychologically identical, like Byzantine dignitaries in a star-strewn apse.

Thus, even Warhol's universe is, in a sense, redoubled, a drama of opposites. In opposition are two ontologies: one formal and one psychological. Against a series of scumbles (coloured cut-outs), whose structure is determined a priori (even when left partly to chance), is opposed a series of photographic portraits whose significance is equally predestined and predetermined.

Warhol's message to the European intellectual issues from a sclerotic, uniform universe in which the only liberty belongs to the artist who wields that freedom with real contempt.

The representation of such a world excludes the very possibility of dialectics. It is at once violently aggressive and desperately impotent. There is thus, in the perversity of its cruel 'game', astute and insolent, a real and incredible innocence.

<p align="center">* * *</p>

Andy Warhol debuted his latest works – silkscreens and prints based on photographs of Latinx and Black drag queens and transgendered individuals – at Ferrara's Palazzo dei Diamanti in the fall of 1975, in his first major exhibition on Italian soil. Published just before his savage murder, Pasolini's essay formed a rather peculiar introduction to the show. Mordant, rhetorical, and verging on the disdainful, the text also betrays a glimmer of almost morbid fascination and appreciation. Despite his apparent recoil from Warhol's orbit, Pasolini had in fact curated the Italian dubbing of the latter's film Trash *(1970), and the photographer who documented Warhol's Italian sojourn – Dino Pedriali – had just worked with Pasolini on a number of images destined for his unfinished novel,* Petrolio. *Pedriali had also recently published a book of portraits of the artist Man Ray. He introduced the latter to Pasolini, who was considering using the American artist's famous painting of the Marquis de Sade on the poster of what would prove Pasolini's last film,* Salò, *or the 120 Days of Sodom. Pasolini's most savage and unforgiving film transposes the Marquis de Sade's eponymous novel to the city of Salò. Though Man Ray confused it for its homophonic French cousin, 'salaud' (bastard), the Italian name identifies the former capital of Mussolini's rump Fascist 'Republic', mounted in the waning days of the Second World War.*

Pasolini's estimation here of American society (and sense of history) diverges strikingly in its nihilism with his observations from a decade earlier. A first trip to New York City in October 1966 witnessed him (in the essay 'Civil War' and elsewhere) hail America's counterculture as vital and vigorous in its non-Marxist sense of social revolution: unburdened by the internecine baggage of the European left, yet redolent of the Italian anti-fascist resistance in its 'intersectional' (to use a more current formulation) potential (immigrants, students, Black communities, women, etc.). A decade later, American culture – and Warhol's magnifications thereof – epitomized for Pasolini an entropy at once serialized, sterile, and 'sclerotic'. In a review for the prominent Turin-based journal Bolaffiarte, *the critic Giancarlo Salzano queried of the same exhibition, 'Why*

Are Warhol's Transvestites Black?' For all of Pasolini's concern for
questions of race in America, such a probing question does not enter
into his purview here. *The term 'transvestite' was common verbal
currency, impervious to the nuances of (trans)gender and other
dimensions of identity. Though seemingly dismissive at first blush,
Pasolini's lines on Candy Darling (1944–1974) – a recently deceased
transgender actress and Warhol 'Superstar' – underscores the extent
to which the individuality and identity of other subjects in the* Ladies
and Gentlemen *series appeared suppressed. Some of these individu-
als have since been identified, including the gay liberation activist,
drag queen, and sex worker Marsha P. Johnson (1945–1992).*

Editorial History of the Texts

For Manzù's *David*
First edition: *Poesie a Casarsa*, Bologna: Libreria Antiquaria Mario Landi, 1942.

Volumes and anthologies: *La meglio gioventù*, Florence: Sansoni/Biblioteca di Paragone, 1954 [with accompanying Italian translations by Pasolini]; *Tutte le poesie*, vol. 2, ed. W. Siti, Milan: Mondadori, 2003 [includes several variations]; *La nuova gioventù: Poesie friulane* (1941–1974), Turin: Einaudi, 1975.

Other translations: 'David', a different poem from the same series, in *The Selected Poetry of Pier Paolo Pasolini: A Bilingual Edition*, trans. Stephen Sartarelli, Chicago: University of Chicago Press, 2014.

Notes on George Besson's 'French Painting 1900–1940'
First edition: *Il Setaccio* III:6 (May 1943).

Volumes and anthologies: in *Pasolini e 'Il Setaccio'*, ed. M. Ricci, Bologna: Cappelli, 1977; *Saggi sulla letteratura e sull'arte*, ed. W. Siti and S. De Laude, Milan: Mondadori, 1999.

On Light and the Painters of Friuli
First edition: *Il Messaggero veneto*, 21 September 1947.
Volumes and anthologies: Siti and De Laude, *Saggi sulla letteratura e sull'arte*.

An Anthology of Zigaina's Paintings
First edition: *Il Mattino del Popolo*, 15 January 1948.
Volumes and anthologies: Siti and De Laude, *Saggi sulla letteratura e sull'arte*.

Paintings by Zigaina
First edition: *Il Mattino del Popolo*, 7 December 1948.
Volumes and anthologies: Siti and De Laude, *Saggi sulla letteratura e sull'arte*.

Picasso
First edition: *Botteghe Oscure* XII (November 1953).
Volumes and anthologies: *Le ceneri di Gramsci*, Milan: Garzanti, 1957 (republished numerous times; definitive critical edition in *Tutte le poesie*, vol. 1, ed. W. Siti, Mondadori: Milan 2003).
Main translations: [Czech] in *Gramsciho popel*, trans. Vladimír Mikeš, Státní nakladatelství krásné literatury a umění, Prague, 1963; [German] in *Gramscis Asche*, trans. Toni and Sabina Kienlechner, Zurich: Piper, 1980; [French] *Poésies (1953–1964)*, trans. José Guidi, Paris: Gallimard, 1980; [Portuguese] *As cinzas de Gramsci*, trans. Egito Goncalves, Belo Horizonte: Drumond, 1987; [Spanish] *Las cenizas de Gramsci*, trans. Stéphanie Ameri and Juan Carlos Abril, Madrid: Visor, 2009.

Dialectal Painting
First edition: *La Fiera Letteraria*, IX:23 (5 June 1954).
Volumes and anthologies: Siti and De Laude, *Saggi sulla letteratura e sull'arte*.

From 'My Longing for Wealth'

First edition: 'Il mio desiderio di richezza' [La Ricchezza, 1955–1959] in *La religione del mio tempo*, Milan: Garzanti, 1961.

Volumes and anthologies: *Poesie*, Milan: Garzanti, 1970; *Tutte le poesie*, vol. 1, ed. W. Siti, Milan: Mondadori, 2003.

Other translations: *Roman Poems*, trans. Lawrence Ferlinghetti, San Francisco: City Lights Books, 1986; *The Selected Poetry of Pier Paolo Pasolini: A Bilingual Edition*.

Zigaina's Painting

Likely written in 1955; never published.

Italian editions: Siti and De Laude, *Saggi sulla letteratura e sull'arte*.

Toti Scialoja

First edition: *Toti Scialoja alla Galleria del Teatro*, Galleria del Teatro, Parma, 18–27 May 1955.

Volumes and anthologies: Siti and De Laude, *Saggi sulla letteratura e sull'arte*.

Fabio Mauri

First edition: *Fabio Mauri*, Galleria L'Aureliana, Rome, 10–21 June 1955.

Volumes and anthologies: Siti and De Laude, *Saggi sulla letteratura e sull'arte*.

Renzo Vespignani

First edition: Written as a presentation for Vespignani's exhibition at the Galleria L'Obelisco in Rome, 16 November 1956.

Volumes and anthologies: Siti and De Laude, *Saggi sulla letteratura e sull'arte*.

'Piero's Frescoes in Arezzo'

First edition: *Il Contemporaneo*, 31 August 1957.

Volumes and anthologies: *La religione del mio tempo* (republished many times, a definitive critical edition is in Siti, *Tutte le*

poesie, vol. 1). Excerpted in *Pier Paolo Pasolini 'Una vita futura'*, ed. L. Betti, G. Raboni, and F. Sanvitale, Milan: Garzanti, 1985.

Other translations: [French] in *Poésies (1953–1964)*, trans. José Guidi, Paris: Gallimard, 1980; [English] *The Selected Poetry of Pier Paolo Pasolini: A Bilingual Edition*.

Two Poems for Federico De Rocco
First edition: 15 February 1959.

Volumes and anthologies: Paolo Rizzi and Virgilio Tramontin, *Federico De Rocco*, Pordenone: Elio Ciol, 1969; Giancarlo Pauletto, ed., *De Rocco: opera grafica: con tre testi e due lettere di Pier Paolo Pasolini*, Pordenone: Concordia Sette, 1984.

Renato Guttuso: 20 Drawings
First edition: *20 disegni di Renato Guttuso presentati da Pier Paolo Pasolini*, Rome: Galleria La Nuova Pesa-Editori Riuniti, 1962.

Volumes and anthologies: The poem at the text's end, subsequently titled 'Guttuso's Red', published in *Rinascita* XIX:42 (13 October 1962); slightly different version included in *Omaggio a Guttuso*, in *Nuovo Piccolo*, 1 (1964).

Venting about *Mamma Roma*
First edition: *Vie Nuove*, no. 17:40, 4 October 1962.

Volumes and anthologies: *Le belle bandiere: dialoghi 1960–1965*, ed. G. C. Ferretti, Rome: Editori Riuniti, 1978; *I dialoghi*, ed. G. Falaschi, Rome: Editori Riuniti, 1992; *Il mio cinema*, ed. G. Chiarcossi and R. Chiesi, Bologna: Edizioni Cineteca di Bologna, (excerpt).

Other translations: [French] in *Dialogues en public 1960–1965*, trans. F. Dupuigrenet Desroussilles, Paris: Editions du Sorbier, 1980; [Spanish] in *Bellas bandieras*, trans. V. Gomez Olive, Barcelona: Planeta, 1982; [French] in *Écrits sur la peinture*, ed. H. Joubert Laurencin, Paris: Carré, 1997.

From 'Technical Confessions'
First edition: *Paese Sera*, 27 September 1964 (parts); *Cineforum* 40
(December 1964), (excerpts). First complete edition in *Uccellacci e
uccellini. Un film di Pier Paolo Pasolini*, Milan: Garzanti, 1966.
Volumes and anthologies: *Per il cinema*, ed. W. Siti and F.
Zabagli, Milan: Mondadori, 2001.
Other Translations: [French] in Laurencin, *Écrits sur la peinture*.

The Art of Romanino and Our Time
Pasolini's contribution to a public debate held in Brescia in 1965. Type-
written text preserved in Brescia, Archivio dei Musei di Arte e Storia,
Cartella 114 (Mostra del Romanino), fasc. Testi della tavola rotunda.
Volumes and anthologies: E. Balducci, G. A. Dell'Acqua, R.
Guttuso, P. P. Pasolini, G. Piovene, F. Russoli, *L'arte del Romanino e
il nostro tempo*, Brescia: Grafo, 1976 (proceedings); Siti and De
Laude, *Saggi sulla letteratura e sull'arte*; see also Tommaso Mozzati,
'Pasolini, la D.C., la conferenza su Romanino (in una redazione
inedita)', *Storia della critica d'arte*, Milan, December 2021.

From 'Observations on Free Indirect Discourse'
First published in *Paragone*, June 1965.
Volumes and anthologies: *Empirismo eretico*, Milan: Garzanti,
1972; Siti and Zabagli, *Per il cinema*.
Other translations: [French] in *L'expérience hérétique. Langue et
cinéma*, trans. A. Rocchi Pullberg, Paris: Payot, 1976; [German] in
Ketzererfahrungen. Schriften zu Sprache, Literatur und Film, trans.
R. Klein, Vienna: Hanser, 1979; [English] in *Heretical Empiricism*,
ed. L. K. Barnett, trans. B. Lawton and L. K. Barnett, Bloomington:
Indiana University Press, 1988; [Spanish] in *Empirismo heretico*,
trans. E. Nicotra, Cordoba: Brujas, 2005.

I Started Painting Again Yesterday
Written in 1970, published posthumously.
First published in *L'Espresso*, 19 January 1992; reprinted in
Achille Bonito Oliva and Giuseppe Zigaina, eds., *Disegni e Pitture*

di Pier Paolo Pasolini, Basel: Balance Rief SA, 1984; and Loredana
Bartoletti and Wlodek Goldkorn, *L'Espresso Pasolini*, Rome:
L'Espresso, 2015.

What Is a Teacher?
Likely written in 1970 as an obituary for Roberto Longhi.
 Italian editions: in Siti and De Laude, *Saggi sulla letteratura e
sull'arte.*
 Other translations: [French] in Laurencin, *Écrits sur la
peinture.*

The Mongoloide at the Biennale Is a Product of Italy's Subculture
First edition: *Tempo*, 25 June 1972.
 Volumes and anthologies: Siti and De Laude, *Saggi sulla lettera-
tura e sull'arte.*

Lorenzo Tornabuoni
First edition: Composed as a presentation for Tornabuoni's
exhibition, Il Gabbiano gallery in Rome, 6–30 June 1972, and
published in the catalogue: *Tornabuoni, testi di Pier Paolo
Pasolini e Enzo Siciliano*, Rome: Galleria d'arte 'Il Gabbiano',
1972, pp. 4–7.
 Volumes and anthologies: Siti and De Laude, *Saggi sulla lettera-
tura e sull'arte.*

Roberto Longhi's *From Cimabue to Morandi*
First edition: *Il Tempo illustrato*, 18 January 1974.
 Volumes and anthologies: *Descrizioni di descrizioni*, ed. G.
Chiarcossi, Turin: Einaudi, 1979; Siti and De Laude, *Saggi sulla
letteratura e sull'arte.*
 Other translations: [French] in *Descriptions de descriptions*,
trans. R. de Ceccatty, Marseille: Rivages, 1984; [French] in
Laurencin, *Écrits sur la peinture.*

Carlo Levi's Painting
Pasolini's lecture on the occasion of Carlo Levi's exhibition at Palazzo Te in Modena on 20 October 1974.
 Volumes and anthologies: Siti and De Laude, *Saggi sulla letteratura e sull'arte.*

Caravaggio's Light
Likely written in 1974 as part of an early version of Chiarcossi, *Descrizioni di descrizioni.*
 Volumes and anthologies: Siti and De Laude, *Saggi sulla letteratura e sull'arte.*

Nabil Reda Mahaini: God's Flag
First edition: 'La bandiera di Dio', in *Quadri d'Oriente, testi di Pier Paolo Pasolini e Dacia Maraini*, Libreria-Galleria Godel, Rome, May–June 1975.
 Volumes and anthologies: Siti and De Laude, *Saggi sulla letteratura e sull'arte.*

Andy Warhol, *Ladies and Gentlemen*
First edition: Written as a presentation of Andy Warhol's exhibition in Ferrara, *I travestiti neri*, palazzo dei Diamanti, October 1975. Published in *Warhol. Ladies and Gentlemen*, Milan: Galleria L. Anselmino, 1976.
 Volumes and anthologies: Siti and De Laude, *Saggi sulla letteratura e sull'arte.*
 Other translations: [French] trans. F. Ayadi in *Lettres françaises*, 11 (June–August 1991); [French] in Laurencin, *Écrits sur la peinture* (Ayadi's translation); [English] in *Andy Warhol: Ladies and Gentlemen*, trans. R. Stringer, New York: Skarstedt Gallery, 2009.

Acknowledgements

We thank Maria Grazia Chiarcossi for her assistance with Pasolini's estate, and those at Verso who helped this project along with good will and consummate skill: Sebastian Budgen, Jeanne Tao, and copy editor Tim Clark. Other individuals contributed to its long gestation in small but significant ways, including Luca Peretti, Sarah Atkinson, Francesco Galluzzi, Jane Tylus, Stefano Chiodi, Jacopo Galimberti, McKenzie Wark, Daniel T. Grimes, Ava Shirazi, Kenyse Lyons, and Lina Bolzoni. Finally, our sincere gratitude to T. J. Clark for his *complicità*.

Index

tableaux vivant, 38
Tagliamento river, 9, 12. *See also*
 Friuli
Tavagnacco, Guido, 55, 56
Tel Quel group, 32
Tempo (newspaper), 159, 172
Terence (Roman playwright), 87
Tessa, Delio, 81
Thomas, Dylan, 91
Titian, 13, 130, 133, 136, 139
Togliatti, Palmiro, 29
Toniutti, Massimo, 57, 58
Tornabuoni, Lorenzo, 33, 161–6
Toso, Nando, 55–6
Tramontin, Virgilio: 58
Trecento painting, 14. *See also*
 Renaissance, Italian
Trombadori, Antonello, 35, 117

Udine, 20, 58, 63, 65, 68, 104. *See also*
 Friuli
Ungaretti, Giuseppe, 65
L'Unità (journal), 107, 109, 117

Valle Giulia, 25, 69. *See also* Rome
Valori Plastici (journal), 22
Van Dongen, Kees, 51
Van Gogh, Vincent, 50
Velázquez, Diego, 71
Venice, 13, 66, 104, 105, 119, 124, 133,
 141
Venice Biennale, 20–1, 84, 118, 156–9,
 194
Venetian painting, 14, 115, 132, 133,
 134
Verga, Giovanni, 149. *See also*
 Verismo

Verismo, 80. *See also* Verga,
 Giovanni
Vespignani, Renzo, xii, 23, 95–8
Vie Nuove (journal), 28, 30, 118, 123,
 124
Virgil, 15n, 61–4
Vlaminck, Maurice de, 47, 51
Vidal, Gore, 3
Vivaldi, Antonio, 123
Voloshinov, Valentin, 149
Vuillard, Édouard, 52

Warhol, Andy
 Ladies and Gentlemen series,
 183–8
Wark, McKenzie, 7n12, 35n, 36
Welles, Orson, 4, 6

Zanzotto, Andrea, 153, 163, 166
Zhdanovism, 157
Zigaina, Giuseppe, xii, 10, 57, 58,
 60–4, 65-68, 84, 85–8, 96
 Big Heads, 61
 Concert, 62
 Crucifixion, 62
 Dead Horse and Men with Lanterns,
 67
 Dead Horse with Its Rider n. 1, 66
 Fishermen, 68
 Flautist, 68
 Head, 57
 Marriage, 62
 Men Killing Horses, 68
 Prostitute, 60
 Sleep, 62
 Workers, 68